WRITING ART HISTORY

WRITING ART HISTORY

Disciplinary Departures

MARGARET IVERSEN
AND STEPHEN MELVILLE

UNIVERSITY OF CHICAGO PRESS : CHICAGO AND LONDON

Margaret Iversen is professor in the Department of Art History and Theory
at the University of Essex, England. She is author of *Alois Riegl: Art History
and Theory* (1993) and *Beyond Pleasure: Freud, Lacan, Barthes* (2007).
Stephen Melville is professor emeritus of the history of art at The Ohio State University.
He is the author of *Philosophy Beside Itself: On Deconstruction and Modernism*
(1986) and *Seams: Art as a Philosophical Context* (1996), and coauthor, with Philip
Armstrong and Laura Lisbon, of *As Painting: Division and Displacement* (2001).

The University of Chicago Press, Chicago 60637
The University of Chicago Press, Ltd., London
© 2010 by The University of Chicago
All rights reserved. Published 2010
Printed in the United States of America

19 18 17 16 15 14 13 12 11 10 1 2 3 4 5

ISBN-13: 978-0-226-38825-0 (cloth)
ISBN-13: 978-0226-38826-7 (paper)
ISBN-10: 0-226-38825-5 (cloth)
ISBN-10: 0-226-38826-3 (paper)

Library of Congress Cataloging-in-Publication Data
Iversen, Margaret.
Writing art history : disciplinary departures / Margaret Iversen and Stephen Melville.
p. cm.
Includes bibliographical references and index.
Summary: Since art history is having a major identity crisis as it struggles to adapt to contem-
porary global and mass media culture, this book intervenes in the struggle by laying bare the
troublesome assumptions and presumptions at the field's foundations in a series of essays.
ISBN-13: 978-0-226-38825-0 (cloth : alk. paper)
ISBN-13: 978-0-226-38826-7 (pbk. : alk. paper)
ISBN-10: 0-226-38825-5 (cloth : alk. paper)
ISBN-10: 0-226-38826-3 (pbk. : alk. paper) 1. Art—Historiography. 2. Art—History—Philosophy.
I. Melville, Stephen W. II. Title.
N7480.I84 2010
707.2'2—dc22
2010004262

It is sometimes thought that the literature which has been the subject of the present book provided methodologies of art history. It should have become clear that this is a thorough misunderstanding. For what would it provide methods for doing which it did not itself do?

MICHAEL PODRO, *THE CRITICAL HISTORIANS OF ART*

We are wide open to scrutiny. There are no experts with special authority: there are specialists . . . able to initiate explanations as non-specialists cannot, but they must submit to lay judges of their explanations.

MICHAEL BAXANDALL, *PATTERNS OF INTENTION*

CONTENTS

PREFACE

This book had its origins in conversations that began at a 1987 Summer Institute on Theory and Interpretation in the Visual Arts, organized by Michael Ann Holly, Norman Bryson, and Keith Moxey and funded by the National Endowment for the Humanities. These conversations gained a further determinative impetus from a year's Leverhulme visiting professorship in 2001, which brought us together for a year at the University of Essex. Another opportunity for discussion about the shape of the book was provided by a fellowship at the Sterling and Francine Clark Art Institute, Williamstown, Massachusetts, during the summer of 2005. The most immediate impulse for its writing was the realization that we did not want to take up an invitation to write an "introduction to art history and theory" and that our reasons for not wanting to do so were also reasons for trying to do something else.

Our debts over some twenty years of writing and discussion exceed any possibility of adequate registration, but a few of the mostly deeply shared demand address. The first is surely to Michael Podro, whose teaching and book *The Critical Historians of Art* reopened the paths that bind historiography, theory, and philosophy to one another. A second, equally surely, is to Michael Baxandall, whose visual and writerly lucidity remains a standard for our clumsier wanderings in ranges of speculation he was content to engage in more subtle ways. It is hard not to see their dying within months of each other in 2008 as marking a particular moment for contemporary art history. This book is dedicated to their memory.

A third debt is to Michael Ann Holly, who has done so much in her own intellectual work and through the various institutions she has created or transformed to keep open the terrain on which this book unfolds. We cannot imagine what shape theoretical reflection in art history might have assumed apart from her absolute and endlessly generous commitment to conversation and controversy.

Art history has over the past several decades been a field of extraordinary achievement, and the present book is driven to a high degree by a

sense of the difference made by the work of such figures as Svetlana Alpers, Tim Clark, Hubert Damisch, Michael Fried, Joseph Koerner, Rosalind Krauss, Leo Steinberg, and others, many of whom receive some more or less sustained treatment within the book but all of whom inform it fundamentally in a multitude of ways. One of our goals has been to create a context within which their achievements become more fully appreciable and the terms of those achievements become more central to the discipline's self-understanding than is currently the case.

WE ALSO HAVE OUR more personal debts. Although we have already paid tribute to Michael Podro, Margaret Iversen would like to thank him, belatedly, for being her mentor since the mid-1970s when she was writing a PhD at the University of Essex under his supervision. The memory of his graduate seminars is still fresh: We were crowded around an oblong table, Michael sitting in a large black swivel chair at the head. The light in the room was low, so we hunched over our copies of Kant's *Critique of Judgment* as Michael read and made us think. Other colleagues at Essex have been generous along the way, most especially in the context of this book Thomas Puttfarken, now also sadly departed. Another colleague, and spouse, Jules Lubbock, was always ready to engage with my ideas and challenge them. I am most grateful to him.

Stephen Melville would like to thank Margaret Iversen for urging this project in the first place. Much of the thinking that has gone into these essays was explored and worked over in courses taught at The Ohio State University, and I'm grateful to the students and colleagues who shared in them. Ruth Melville has had everything to do with this book's coming to completion; I cannot thank her enough.

WE ARE JOINTLY GRATEFUL for support from our respective universities that made the book possible by allowing time for research, and more particularly to the College of Arts and Sciences at The Ohio State University for its help in defraying the costs of illustration. We had crucial assistance in the preparation of the manuscript from Matthew Bowman at Essex and Greer Pagano at Ohio State. We are also very grateful to the efficient staff at the University of Chicago Press, particularly our editor, Susan Bielstein.

What's the Matter with Methodology?

How does a field like the history of art come into being?

If one looks at the standard art history curriculum in universities, the answer looks easy: there is art; it is widely spread out in time and space; and art history is the study of this object with due attention to its historical and social specificity (thus the discipline's characteristic curricular articulation by period and geographical location). But when we look at this curriculum a little more closely, its shape becomes noticeably blurrier. Some of its primary terms do seem to answer well to the general picture—Northern Renaissance, for example—but others seem to have a rather looser relation to the presumed underlying scheme. "Baroque" does indeed seem to name a chunk of time—some people would say, unhappily, that in the end that's all it does—but the term was intended, and for many people still does function to at least some extent, as a style name above all, and the relation between a style—a difficult enough notion by itself—and a historical period remains obscure. And as we move forward from the Baroque, whatever it is or was, matters become only more obscure as the shape of art's history seems to bend more and more toward particular names offered by particular groups of artists—"Realism," say, or "Impressionism"—many of which amount to interpretations of or at least positions in relation to something we tend to call "Modernism," without our having any very clear sense of what kind of name *that* is. More recently, we've found ourselves repeatedly tempted to speak of something called "Postmodernism," a label that inherits all that is obscure in its presumed predecessor and is often seen to either complicate or dissolve these various questions about art's historical shape by laying claim to a distinctively posthistorical condition.

Within these curricular terms further difficulties tend to surface very quickly: the medieval makers of the objects that art history studies described neither themselves as artists nor the objects they made as art, and students

of Asian art will often feel that the objects and practices to which they attend are repeatedly falsified or betrayed by the categories of distinctively Western art-historical thought. Classroom—and other—discussions of these issues rapidly become muddy and even bad-tempered: many historians of Asian art do, for all practical purposes, exactly the same kind of interpretive work as most of their Western counterparts while nonetheless feeling that their apparatus and interests require some fundamentally different articulation from that assumed by students of Western art. At times this can feel like an argument about the relevance of the term "art," and at other times it can feel like an argument about "history" as a peculiarly Western shape of or frame for meaning. It's typical of these arguments that this uncertainty about the applicability of either or both of the terms that give the discipline its name to objects fostered outside of their explicit historical or cultural presence will not feel itself resolved by writing those objects off to anthropology or religious history; typically too the institutionalized study of art history has finessed the actual arguments here in favor of an underlying attitude—"a conviction of the dignity of man, based on both the insistence on human values (rationality and freedom) and the acceptance of human limitation (fallibility and frailty)"[1]—which orients the discipline to "insight into the manner in which, under varying historical conditions, essential tendencies of the human mind [are] expressed by specific themes and concepts."[2] While one may find oneself driven to such assertions in defending a certain view of the scope and practice of art history, it's notable that the view itself offers no particular reason why such an attitude is best or even appropriately crystallized into the particular shape of the discipline it is called on to justify. That shape remains at once arbitrary and obvious. What else could art history be? What other shape could it have?

QUESTIONS ON THIS order were once the stuff of major art-historical reflection—the substance of implicit and explicit exchanges among such figures as Heinrich Wölfflin, Alois Riegl, Aby Warburg, and Erwin Panofsky. By and large these conversations now strike most art historians as largely matters of prehistory, and so our feel for their shape and stakes tends to be weak. But that sense is itself a consequence of a particular intellectual and institutional settlement of just those conversations, so one aspect of this book is broadly diagnostic, trying to bring into view the terms and possible costs of that settlement. Our claim is that one of the major costs has been the

reduction of all forms of theoretical reflection on art history to matters of "method." The larger goal is to renew that order of discussion on the shifted ground of contemporary art-historical theory and practice.[3]

If the questions we are interested in are already there in the writings that founded the modern discipline of art history, they seem to have gained a certain salience amid a fairly widespread contemporary sense of significant change or crisis within the field—a sense sometimes felt as a significant alteration in art's relation to its own past and sometimes as an alteration in the art historian's relation to his or her object. The first of these is surely related to the recent burgeoning of art-historical interest in recent and contemporary art, while the latter appears variously expressed in the rise of "theory," in a certain historiographic turn within parts of the discipline, and in the emergence of various alternatives or quasi-alternatives to art history mostly clustered under the rubrics of "visual studies" and "visual culture." All of these have been familiar bits of the landscape for a while now, but their familiarity is no indication that they have been made active sense of. Our own feeling is that we don't in fact know what is distinctively new on this terrain and what only appears new while actually continuing to run along in well-established grooves, and it has seemed to us that one way to do that job of making sense is to bring the elements of contemporary theory into much closer contact than they typically have been with the older reflections on the discipline. This is a far from arbitrary coupling: both the modern discipline of art history and broad swathes of contemporary theory emerge in intimate dialogue with Hegelian and post-Hegelian thought, so what has to be shown is, in effect, how and where they are already speaking to one another.

A general motive for the book is a sense that contemporary art history operates for the most part with a distinctly impoverished sense of its own possibilities—and does so despite what might seem the massive enrichment of its methodological apparatus under the impact of contemporary "theory." This is to say that the possibilities in which we are primarily interested are not methodological but bear more directly on the object and objectivity—the shape or shapes—of the discipline itself. Given the recent and continuing emergence of a "visual studies" or "visual culture" variously conceived as subsuming, adjacent to, or competing with art history, such questions seem to us to have a certain urgency. Since "theory"—or a certain grasp of it—has played a significant role in bringing visual culture into being,

this is inevitably also a book about "theory," or at least the various ways in which its particular news might be best understood. If literary study by and large received French theory on the ground of what was widely perceived as a debilitating absence of proper theory in the field, art history encounters it—or at any rate should encounter it—from within an already rich set of internal theoretical and philosophical reflections that, in fact, share significant stretches of intellectual history with the bodies of thought now compounded under the general rubric of "theory." In this sense, an exploration of the disciplinary possibilities of art history has a distinctive capacity to address "theory" and to ask questions about the different shapes it might assume for the field. Where it is seen primarily as a matter of methodology, the question of writing, when it emerges, will appear first of all as a question about methodological self-consciousness and so seem to entail a reflexive attention to something like the historian's position or identity. This is an understanding of theory with which we are more or less systematically at odds, taking it as an explicitly skeptical variation on the disciplinary understanding that generates the call for method in the first place.

Our way of taking these things up has, of course, its narrownesses: we are interested in a fairly particular intellectual tradition within art history (the one set in motion primarily by Hegel, and particularly, but not exclusively, as it is taken up and transformed by a body of French thought emergent in the 1950s and after), and although we offer no particular narrative of these matters, our sense of how this tradition matters to art history tends to make much of the way various issues and stakes get sorted out in the 1920s and 30s. Implicit in both of these remarks is the further possible narrowness embedded in our assumption that intellectual traditions count—are a good enough way of addressing a discipline's history and of making out or reopening some of its possibilities.

What we are calling "possibilities" in this way are not, presumably, things that lie outside of art history—as if taking them up meant doing something other than what art history does or has done. The question we are trying to ask is about how art history might become itself or how it might discover less baffled views of its own practices. There's a sense in which we aim at a sort of radical provocation—as if we are claiming that art history is yet to be invented (and we *are* claiming that) and that no one is more responsible for the future of art history than the individual art historian (and we are indeed also claiming that)—but we are also claiming that there is no other place

for this invention than art history and that one major means of such invention is just the reading of art history's writing. For this one might imagine a quasi-therapeutic model: *ne cedez pas sur ton desir!*[4] But one might also explore a view of disciplinarity along the lines of Stanley Cavell's idea about "medium" in a modernist situation—as something to be invented out of itself and without criteria.[5]

The *Lectures on Fine Art* of G. W. F. Hegel appear to lay the groundwork of a recognizable art history in something like these terms.[6] Certainly they were taken as such a starting point by those we now think of as founders of the modern university discipline. One easily recognizes in Hegel's lectures any number of motifs that continue to haunt, for better or for worse, the field we currently occupy: a strong, essentially European, narrative of art's continuous development up to a problematic present, an active worry about the meaning and possibilities of modern art, coming to a particular point with Hegel's claim that "art is now for us essentially a thing of the past," a particular valorization, characteristic of nineteenth-century German thought and more particularly grounded in Johann Joachim Winckelmann's earlier writings on Greek art, of ancient Classical sculpture as the moment of art's fullest and most valuable achievement, and a continuous recourse to concrete accounts of particular works are among the most salient features of Hegel's two volumes of lectures. Some of this deserves a second, more historically aware look: if Hegel can be said, accurately enough, to marginalize non-Western art, it also is the case that he is among the first to attempt to give a serious and sustained account of it, just as he belongs to the generation that offered the first serious and sustained accounts of Asian thought (tellingly, the Bhagavad Gita is a text Hegel treats not only historically but also directly philosophically), and if we are now unsurprised to see Dutch art in our textbooks, it's probably important that Hegel was among its early champions and was particularly struck by the emergence within it of genre painting.

Hegel began offering his lectures on aesthetics in 1820 and offered versions of the course three more times before his death in 1831 (the English translation is part of a complex compilation of notes now in the process of being unwound into individual courses by German scholars). Those same years saw the construction of what is generally recognized as the first modern art museum, Karl Friedrich Schinkel's Altes Museum in Berlin. Hegel's lectures were given at the University of Berlin, founded in 1809 and, like

Schinkel's museum, commonly recognized as the first of its kind—which is to say, the first of our kind. Hegel, long an active proponent of educational reform in Germany, had joined its faculty in 1818.[7] This institutional confluence is reasonably taken as a part of the conditions that make possible Hegel's offering of what amounts, in retrospect, to the first recognizable course in the history of art. Hegel's own view of this institutional context is an interestingly mixed matter: he was explicitly aware of and heavily invested in the emergence of a new type of university, although it is striking that the institution of such central importance to him finds no explicit place within his philosophy. He was also very aware of the general world of European collections and galleries, including such details as where admission was or wasn't charged and what difference one's status as a university professor made to one's access to such collections; he involved himself actively in efforts to bring one such collection to Berlin; and he made free use of metaphors we now read as relating essentially to the logic of the museum. But at the same time, he does not seem to have seen the modern museum as a new and distinct institution requiring particular thought or justification. The year of the Altes Museum's completion, 1830, was for Hegel very much a political year, consumed both by his assumption of the rectorate at the university and by his active engagement with the consequences of the July Revolution in France and the fate of the Reform Bill in England. He is not known to have ever entered the new museum.[8] Still, Hegel looks very much like our institutional contemporary.

For Hegel, art was a form of thought, and so addressing art called for no particular method beyond that called for by thought itself in its continuous movement and transformation. This is not, Hegel says, a matter of method, because the terms are those generated by thought itself. This subordination of interests in method or epistemology more broadly to a certain way of working through an object gave rise to a distinctive post-Hegelian tradition oriented to questions of ontology and interpretation, writing and reading, one particular outcome of which is the complex body of French thought that has been such a strong influence on art history in recent decades. It's on this general terrain that the various essays in this book unfold.

There is no place within Hegel's lectures for separate remarks on theory or method, and so presumably there would be no place in a "Hegelian" department of art history for the specialized "methods" courses that are now so common in our own departments and that have served as the primary

locus for the reception and dissemination of contemporary theory. These courses vary considerably, but they usually consist of a heterogeneous compilation of "approaches," sometimes sufficiently broadly construed as to allow some acquaintance with, say, Wölfflin or Panofsky (fuller acquaintance is most often reserved to a separate course in historiography). Such methods courses will likely include a strong showing of alternative, explicitly politically motivated, approaches such as the social history of art or feminist art history, and will include as well an interdisciplinary component that involves psychoanalysis, semiotics, and philosophical aesthetics. This latter grouping is what is most often collectively referred to as theory and often responds to developments in literary and film studies. In some cases, and more cynically, these courses are driven by the demand of deans or of funding bodies that the humanities conform to the model of the social sciences with their explicit reliance on a body of skills, protocols, and methods to which scholars must adhere. Whatever the original intention, the disciplinary bazaar of the typical art-historical theories and methods course is bound to give the impression that here is where one will be equipped with the necessary tools to do the job of an art historian.

This is no doubt a caricature, but it will serve as a rough sketch of the situation this book means to address. Whatever their differences, the very idea of a "methodology" course or book suggests that there is a field of freestanding objects (visual art and architecture) and that certain specialist tools and techniques must be wielded by the art historian in order to study them. In other words, the underlying assumption is that "method" bears an external relation to both the subjects and the objects of art history. It is one of the aims of this book to put that idea to the test. Historical surveys of the actual development of the discipline are less susceptible to this sort of misrecognition, because the idea of a tradition implies a continuous writing and rewriting of the discipline and always contains within it the thought of a projected future that must bear an integral relation to what has gone before. One is presented, then, not with an array of alternatives but with the continuous unfolding of a complex conversation. Such a survey will also reveal the changing shape of a discipline that in its formative years gave weight predominantly to the Renaissance and Baroque periods and which now gravitates toward twentieth-century and contemporary art. The conclusion to draw from this is that the history of the discipline has created the field of objects. Furthermore, it implies that these objects are not "bare";

they are covered by certain descriptions and caught up in particular, some-times long-standing, debates—some of which we reengage in the chapters that follow.

The subjects of art history are equally internal to the discipline. Students, young scholars, come to the discipline with particular intellectual forma-tions and personal investments, particular ways of seeing, styles of think-ing and writing. One problem with "methodology" is that it suggests the plausibility of putting all that aside to download the discipline—typically in two steps: first the archive or canon, then the method or methods. In short, it suggests that "transferable," abstract methods and skills can be extracted from the texture of art-historical writing. The stress we place on *writing* art history is intended to counter all these assumptions. It proposes a model of thinking about our discipline that is different from the implicitly mechanis-tic one summed up by *methodology*.

In doing this we are presumably asking art history to change in signifi-cantly deep ways, but not by becoming something other than art history. We are evidently aimed at making out dimensions and possibilities unacknowl-edged or unrecognized by the discipline, and so one underlying question must be about how something like a discipline might become other than it knows itself to be. The question itself seems a distinctly modern one, asked out of some deep uncertainty about the grounds or justice of any received form of thought or practice (and it may be worth noting that it is no more—and no less—obscure than a question of how one might manage *not* to become other than one knows oneself to be). One early and repeated lesson of modernism in the arts is that becoming unrecognizable to ourselves—as persons, as forms of art, as social formations—is indeed something we can do, one of our major possibilities, and that by itself this may well mean—and certainly guarantees—nothing. Presumably we should ask—cannot but ask—something similar of claims about an art history (or for art histories) other than the one in which we currently recognize ourselves and our activi-ties. The primary focus of this book is accordingly on the conditions under which art history claims an object at all; it aims at thickening or enriching the discipline's imagination of its possible objectivity and so can take no particular imagination of objectivity as normative. What we offer here are above all readings of art history, conducted with a view to making out a range of possible transformations in it. This has posed certain writerly dif-ficulties: if "introductions" to theory or historiography can assume a certain

clarity about their starting point and proceed by variously summarizing and paraphrasing the often difficult texts they treat, "reintroductions" are saddled with beginning in the midst of texts and readings already in circulation, and they can unfold only by tracking those texts ever more closely. The straightforward and the complex find themselves at times uneasily compounded.

IT WILL TAKE NO more than a few quick glances at the pages that follow to notice that this book has two notably distinct authors who are not engaged in presenting a single, unified argument and who differ quite strikingly in style, central intellectual concerns, and modes of negotiating between discursive and visual materials.[9] It will take perhaps a little more reading to notice that neither author presents across the body of his or her individual essays anything that amounts to a unified argument or tightly coherent theoretical position. No doubt each of our sets of essays reflects, quite strongly, a particular orientation within the field of the book's concerns, and it may be that they reflect something more than that—but we have not asked them to do so. Rather, we have wanted to put together a set of closely intermeshed explorations of a range of topics of substantial art-historical interest and driven overall by a few fundamental commitments. The most important of these commitments is to the thought that art history happens, and matters, as writing (and so also that one way of thinking about art history is by an active engagement in reading, a consequence that actively shapes each of our chapters). A second commitment is to the thought that however serviceable it may be much of the time, the distinction between art history and art criticism is not particularly deep—not deep enough, in any case, to play a role in defining art history: what art-historical writing does is show its object, and showing that is inevitably also the performance of a judgment. Both of these assumptions are addressed explicitly at any number of points throughout the book. A third commitment that is perhaps not as persistently explicit is to the proposition that art history is a specifically and consequentially modern discipline. This is no doubt related to our shared substantive interests in modern and contemporary art, but the exact nature of that relation, either overall or in each individual case, remains significantly open-ended. Whatever the modernity of the discipline may amount to, it does not play out in a devaluation of the study of "nonmodern" art, however it may be defined.

We've tried to put the book together in a way that makes for sensible and interesting consecutive reading, and we've tried also to weave a fairly rich texture of cross-reference through or across it. But as a set of "explorations" the whole necessarily remains essentially a matter of essays, and we expect—mean—it to remain approachable on such terms. We think we've chosen and ordered a set of topics that move interestingly across a range of issues important to contemporary art history and so open out a number of possibilities for reimagining their stakes and terms; we certainly would not want to claim to have exhausted the field of such concerns.

ONE OF THE CONNECTING threads running through this book is an argument with Erwin Panofsky. We hope that our arguments here are sufficiently clear and pointed that they do not appear as mere Panofsky-bashing. At the same time, we do think these arguments still need making; Panofsky's understanding of what constitutes art history is so deeply embedded in our thought that we are scarcely aware of it and tend to imagine that we have somehow moved further beyond his fundamental terms than we actually have. Even those who do not invoke his name carry in their heads a certain picture of the art historian at work, and often positions advanced as if in opposition to him do little more than carry his underlying framework into areas he could not have imagined for it.[10] This is hardly accidental: Panofsky's vision of art history is in fact extraordinarily compelling and built out of a deep attachment to a particular construal of a particular range of objects central to the discipline. In chapter 2 we show that Panofsky positions the art historian at the apex of a perspectival apparatus from which detached vantage point he surveys a field of already-constituted objects. The apparatus, that is to say, his methodology, creates a particular kind of objectivity dependent on something called "historical distance," a particular way of describing and locating an otherness fundamental to any art-historical inquiry. Yet the discipline might be imagined very differently. The art historian might rather be found encountering objects that are already in themselves self-critical, so that writing about such objects becomes a matter of attending closely to them. While Panofsky makes description and identification the bedrock of interpretation, we would counter that, given the nature of our objects, description not only is already interpretation but is also as much outcome of as precondition for interpretation. Michael Baxandall's work is offered as a model of a writing alert to such play, and our reading of

his *Patterns of Intention* is, in turn, offered as a model of the sort of attention the best art-historical writing requires and deserves.

The next chapter, "On the Limits of Interpretation," continues the critique of Panofsky, this time on the ground of his particular conception of iconology. The general model of interpretation delineated in his "Iconography and Iconology" is here put to the test by comparing the very different readings of Albrecht Dürer's *Melencolia I* offered by Aby Warburg, Panofsky, and Walter Benjamin. We aim to show that the differing views are not a matter of arcane iconographical interpretation but rather of different conceptions of the field of art history. The themes of detachment and attachment, distance and intimacy, raised in chapter 1 recur here. Warburg conceives of cultural history as marked by a dialectical movement between the extremes of demonic possession and lifeless detachment. For him, Dürer's print is poised between these poles: it finds a space for profound thought in the arms of a malign humor and the astral demon Saturn. Panofsky's Neoplatonic interpretation, in contrast, understands the allegorical figure as the image of the artist frustrated by her inability to transcend the physical and phenomenal worlds and so attain knowledge of the pure, abstract Ideas. Panofsky thus substitutes an epistemological model for Warburg's sense of the power of the image both to enthrall us and to create room for thought. Both Warburg's and Benjamin's sense of the work links it to the intimate themes of depression, madness and death, carefully kept at a distance by Panofsky—as if they threatened to implicate the art historian.

"What the Formalist Knows," our third chapter, returns to an issue broached in chapter 2, the continuity between art history and criticism, and does so in the context of a reevaluation of Heinrich Wölfflin's celebrated but now unfashionable book *The Principles of Art History*. In this rereading, Classical and Baroque are no longer understood as discrete descriptors of particular periods of the history of art. Rather, the terms are shown to bear a relation to each other rather more like the distinction in language between the literal and the figural. We also bring out what might be called Wölfflin's modernity. He makes us aware of the continual transformation of style and the way the present recognizes itself as breaking from the past, while also realizing that the present will soon become part of what is called tradition. Just as the line drawn between the literal and the figurative is constantly shifting, so too do the lines between what we take to be "Renaissance," "Baroque," and "modern." Equally, just as there is no original literal language

that then gets a figural gloss, there is no straightforward vision of things that then develops a rhetorical turn, say, in painting. What the formalist knows is that human vision is through and through rhetorical, that is, conditioned by language.

Art history's broad turn away form "formalism" has been very far from putting an end to its concentration on vision; indeed, much of the interest of contemporary European thought in art history has centered just there. Chapters 5 and 6 engage with different aspects of this interest. The chapter called "The Spectator" begins with an account of the groundbreaking work of Alois Riegl on the role of the spectator, focusing particularly on his reading of Rembrandt's *Syndics of the Amsterdam Drapers' Guild*. Riegl adopts Hegel's distinction between the statue's self-contained autonomy and painting's dependence on or solicitation of the beholder; the first closes in on itself, while the second exists for others. Riegl turns Hegel's phenomenology of our experience of the statue and painting into two major types of pictorial composition: while Italian Renaissance composition can be described as "internally coherent" in its narrative closure, Dutch group portraiture develops a form of "external coherence" that includes the viewer. Leo Steinberg revives Riegl's distinction in his exemplary analysis of Picasso's *Demoiselles d'Avignon* and in his reading of Velázquez's *Las Meninas*. The chapter also considers the relation of the critical writing of Michael Fried and Robert Morris to Hegel's broad typology of the composition of a work of art. One thing that is demonstrated here is the extent to which Hegel's art theory continues to inform the best art-historical writing.

"The Gaze in Perspective" continues the theme of the different positions the viewer takes in relation to a work of art. It is a study of the twentieth century's recurrent critiques of perspective construction. The way in which perspective makes the represented world conform to the position of the spectator is said to encourage an illusory sense of visual mastery. The gaze it creates is disembodied, monocular, and distanced. An early and very influential exponent of this view was Maurice Merleau-Ponty, whose appreciation of Cézanne centered on his ability to depict "lived perspective." More recently, film theorists influenced by Jacques Lacan have equated perspective with the mirror stage of infantile development, when the subject mistakenly recognizes himself as autonomous and in control. However, the French art historian Hubert Damisch has challenged this view, arguing persuasively that perspectival representation has precisely the opposite

subjective effect. For him, perspective positions the viewer in such a way as to shatter any pretension to autonomy. The visual grammar of perspective is comparable to Lacan's conception of language or the symbolic order that precedes and determines the subject's relations with the world.

The next two chapters address the issue of the particular difficulties raised by writing about visual works of art. Does the fact that the medium of critical discourse is linguistic while the objects of our inquiry are not have certain consequences? Chapter 7, "Seeing and Reading," surveys some of the most important reflections on this question. We show how critical writing oscillates between a robust attitude that aims to read the work of art as if it were a text and one that takes this practice to task for betraying the specifically aesthetic, sensory, nonlinguistic nature of our experience of the visual work of art. We set the stage for this debate by introducing Jean-François Lyotard's 1971 attack on structuralism and poststructuralism, *Discours, figure*. His strategy, which is broadly deconstructive, is to point out the extent to which language is dependent on reference and phonic or legible substance. Following Merleau-Ponty, he also criticizes the way Western visual representation is penetrated by discourse. One of Lyotard's readers was Roland Barthes, whose career, we argue, is marked by his ambivalence about whether to take up the discursive or figural side, that is, whether to adopt a poststructuralist or phenomenological position. Critiques of the paradigm of structural linguistics often make reference to the American philosopher Charles Sanders Peirce, whose work was usefully mediated by Roman Jakobson. Both advanced the idea that language has iconic and indexical as well as symbolic dimensions. This opened the way for art historians such as Meyer Schapiro to explore the hybrid nature of the visual sign.

While Hegel plays an important part in many of the preceding chapters, he takes center stage in chapter 8, "Plasticity: The Hegelian Writing of Art." The chapter confronts the issue at stake in much of what we have written: Is a history of art that takes its bearings, as it once did, from Hegel's *Lectures on Fine Arts* one that is worth recovering? Beyond immediate objections to his Eurocentrism or his totalizing historical teleology, does his work still carry an understanding of art indispensable for the future of art-historical writing? By tracking the shape of Hegel's theory of art's historical development, we show that the achievement of Classical sculpture, its "plasticity," occupies a space that is later taken up, after the end of art, by philosophy. Art's important role in history, on this account, seems to be to discover a

content together with an adequate concrete form. The recognition of the plasticity of thought and language ties the theme of this chapter back to the preceding one. Both aim to show that language is continuous with the condition of art and not an arbitrary imposition on an otherwise mute and purely visual art object. Continuous, but not coincident; we still struggle to make our language stick to works of art.

The final chapter turns to the way the contemporary university impinges on how art history is done. Whatever one may finally want to say about Panofsky's role in shaping a certain understanding of art history, that understanding is now massively reinforced by the ongoing professionalization of the subject—and of the humanities and the university in general—in which methodology becomes ever more dominant and more exclusively defining of the terms of inquiry. We argue that this development coincides with the more general dominance of what Heidegger called "technology" and characterized in terms of the reduction of the world to a stock of available and, as it were, merely denumerable items.

The issue here is not about the real value and difficulty of scholarship—of knowing what one is talking about, of discovering new facts, of attending closely to works and contexts, of finding real problems at the heart of received knowledge, and so on; that is the day-in day-out work of art history as it is of any field of inquiry. The question is what becomes of all that under a particular regime in which the instrumentalization of knowledge and skepticism go hand in hand and where "curriculum" amounts to no more than an inventory of goods on offer, such that the question of what object it claims or articulates can no longer be raised except in terms of the specializations within which each member of staff administers the terms of his or her career.

To try to imagine the real work of reading and writing within the practice of art history is to explore its capacity to sustain an object in the face of modernity's ongoing work of dissolution; it's just such imagining that we've tried to start here.

Historical Distance
(Bridging and Spanning)

THE CONSTRUCTION OF DISTANCE

We begin from the thought that the field of art history is far from level ground: particular periods, places, and kinds of art stand out with varying degrees of prominence, while other periods, places, and kinds of art drift toward the margins of the discipline. In recent years this unevenness has become controversial, resulting in new ways of doing art history, often coupled with attention to the underregarded regions of the field, and in disciplinary challenges to the structure of the field as a whole, most frequently under the rubric of visual culture or visual studies.

Within the modern discipline of art history the Renaissance has always been the largest object in the landscape. It is the period many tend to see as representing the highest achievement of Western art, but it is also, more importantly, the period in which recognizable modern claims about "art" and "artists" first come fully into view against the medieval background of largely artisanally produced works tightly integrated with their social, largely religious contexts. It is also the period in which the art historian finds the first texts that reflect an activity recognizably related to the work of the modern art historian—Vasari's *Lives of the Artists* is a valuable documentary source for our understanding of Renaissance art, and art historians are also sharply inclined to recognize Vasari himself as a founder of art history. There is a strong sense in which art history—a distinctively modern discipline whose own history is so closely intertwined with that of the modern university that emerges with it in the nineteenth century—takes the form of a "return" to its presumed Renaissance origins, and it seems hardly accidental that so many of the figures that contribute to its founding—Berenson, Morelli, Wölfflin, Pater, Burckhardt—were, in whole or substantial part, what we would now call "Renaissance specialists."

Particularly important among these figures, especially in the United States, is Erwin Panofsky. Panofsky took the Renaissance not only as the paradigmatic object of art-historical knowledge but also as the primary model for the shape of that knowledge, as if the Renaissance were the mirror in which the art historian first grasped his or her own image. That something of this sort should be the case was far from obvious when Panofsky began writing. Indeed, his nearest major predecessors—Alois Riegl, Heinrich Wölfflin, and Aby Warburg—had all, in different ways, advanced views of art-historical principles and practice that looked primarily outside the Renaissance—to various accounts of the Baroque, and more particularly the Northern Baroque in the cases of Riegl and Wölfflin, and to "the primitive" in Warburg's instance (we will look more closely at some of these positions in later chapters). While Panofsky sometimes confronts his predecessors directly—as in his 1920 essay "The Concept of Artistic Volition," which attempts to show that Riegl's rather Hegelian notion of the *Kunstwollen* can only have a psychological sense[1]—he more typically uses particular accounts of particular objects or practices as levers with which to shift the apparent foundations of the discipline into a different position. Albrecht Dürer is one of his most important such levers; by the late nineteenth century Dürer was firmly established as a paradigmatically "Northern" artist, the figure who carries the work of the Italian Renaissance back across the Alps and in doing so carries it beyond itself, engendering a new tradition. Panfosky, however, reverses this reading of Dürer's Italian travels: for him Dürer is the artist who explicitly secures the achievements of the South and so makes that achievement binding and normative for subsequent art.[2] Panofsky's more specific interest in Dürer is thus, first of all, in Dürer's theoretical contributions—his systematic work on both the canon of human proportions, on which Panofsky writes a major essay in 1921, and perspective, which he takes up in a pivotal essay from 1925, translated into English only in 1991.

While the scholarly apparatus of both essays has all the density typical of Panofsky, the crucial conclusions are cleanly stated. In the case of the essay on human proportion, it is that Dürer finally arrives at a canon that grants due regard to the "visual impression of the beholder" and so demonstrates that "it is the Renaissance which, for the first time, not only affirms but formally legitimizes and rationalizes these three forms of subjectivity."[3] "Perspective as Symbolic Form" offers, as it were, the necessary pendant: "Once

again this perspectival achievement is nothing other than a concrete expression of a contemporary advance in epistemology or natural philosophy. . . . The result was a translation of psychophysiological space into mathematical space; in other words, an objectification of the subjective."[4] In Dürer, we find the Renaissance, which is to say an essentially modern, epistemological balance of subject and object made theoretically explicit and secure: the Renaissance knows what it is to see, and sees what it is to know.

Panofsky is equally clear in the larger conclusions he draws from this. The essay on human proportions puts its point this way: "Those who like to interpret historical facts symbolically may recognize in this the spirit of a specifically modern conception of the world which permits the subject to assert itself against the object as something independent and equal,"[5] and the essay works its way to conclusion by entering an oblique warning against a presumably pseudo-modern turn toward arbitrariness:

> The styles that may be grouped under the heading "non-pictorial" subjectivism—pre-Baroque Mannerism and modern "Expressionism"—could do nothing with a theory of human proportions, because for them the solid objects in general, and the human figure in particular, meant something only in so far as they could be arbitrarily shortened and lengthened, twisted, and, finally, disintegrated.
>
> In "modern" times, then, the theory of human proportions, abandoned by the artists and the theorists of art, was left to the scientists—except for circles fundamentally opposed to the progressive development which tended toward subjectivity.[6]

"Perspective as Symbolic Form" opens by invoking Ernst Cassirer on "symbolic form" in a way that not only sets the terms of the essay's largest argument but also usefully glosses the earlier essay's remark about "those who like to interpret historical forms symbolically": "[perspective] may even be characterized as (to extend Ernst Cassirer's felicitous term to the history of art) one of those 'symbolic forms' in which 'spiritual meaning is attached to a concrete, material sign and intrinsically given to this sign.'"[7] The morals Panofsky draws are again highly general and aimed at establishing a particular model of objectivity for art history:

> Thus the history of perspective may be understood with equal justice as a triumph of the distancing and objectifying sense of the real, and as a triumph of the distance-denying human struggle for control; it is as much a consolida-

tion and systematization of the external world, as an extension of the domain of the self. . . .

Perspective, in transforming the *ousia* (reality) into the *phainomenon* (appearance), seems to reduce the divine to a mere subject matter for human consciousness; but for that very reason, conversely, it expands human consciousness into a vessel for the divine. It is thus no accident if this perspectival view of space has already succeeded twice in the course of the evolution of art: the first time as the sign of an ending, when antique theocracy crumbled; the second time as the sign of a beginning, when modern "anthropocracy" first reared itself.[8]

As Michael Podro has succinctly put it, "the Renaissance perspective construction lies both within the range of historical constructions and is also a transhistorical reference point."[9] The result is the discovery within art's history of the conditions of its art-historical objectivity: art history puts its object in perspective.

Perspective is, of course, a means for negotiating the spatial relation between subject and object, and when we take it as a more general epistemological model for the relation of subject and object we commit ourselves to an essentially spatial conception. Michael Podro, in his study of Panofsky's early writings, points briefly to two essays that importantly extend that model to the field of history—"Albrecht Dürer and Classical Antiquity" (1921–22) and "The First Page of Giorgio Vasari's 'Libro': A Study on the Gothic Style in the Judgment of the Italian Renaissance." The first of these argues, in keeping with Panofsky's general use of Dürer during this time, "that Dürer came to understand classical art not by direct confrontation with it, but by the mediation of Italian Renaissance re-interpretation,"[10] thus setting the Renaissance interpretive stance toward history in implicit relation to the epistemological attitude embedded in the practice of perspective as Dürer theorizes it. "The First Page of Vasari's 'Libro'" makes the connection between historical stance and epistemological attitude fully explicit. While the essay's scholarly argument is long, dense, and circuitous, its overall shape is both clear and simple. What Panofsky has before him is a drawing to which has been applied a pen and bistre paper frame that includes an attribution of the drawing to Cimabue.[11] There is clear evidence that the drawing belonged to Giorgio Vasari and that the paper frame is of his making, and Panofsky's central question is what we are to make of this frame applied by this hand to this particular drawing. The answer to

this question is that "Vasari's inconspicuous 'Gothic' frame bears witness, at a relatively early date, to the rise of a new attitude toward the heritage of the Middle Ages: it illustrates the possibility of interpreting mediaeval works of art, regardless of medium and *maniera*, as specimens of a 'period style.' . . . Vasari's frame marks the beginning of a strictly art-historical approach which . . . is focused on the visual remains and proceeds, to borrow Kant's phrase, in a 'disinterested' manner."[12] While the appeal to Kantian "disinterest," particularly in relation to the essay's titular invocation of "judgment," might seem to refer to aesthetic judgment as Kant describes it, what we have here is in fact a deep and thoroughgoing rejection of such judgment, at least as it might be thought relevant to the practice of art history. The point of the essay is that Vasari's judgments, like those of the art history he inaugurates, are "relative and absolute at the same time"—exactly the argument Panofsky had made for Renaissance perspective—because epistemologically well grounded. That is, Vasari's frame bears witness to the Renaissance emergence of "what we may call a historical point of view—historical in the sense that phenomena are not only connected in time but also evaluated according to '*their* time.'"[13] Such estimation by the standards that inhabit a particular time is precisely not a judgment of taste but an act of knowing and so also not "disinterested" in Kant's aesthetic sense: a flower we find beautiful is, according to Kant, one we at best barely recognize as a flower at all, so struck are we by its being precisely and uniquely what it is, whereas the period recognition of a work of art is above all a matter of knowing its proper historical and cultural measure (the measure Vasari's frame effectively is for the Cimabue drawing it encloses).

By the time of "Iconography and Iconology," Panofsky is able to reduce the intricate chain that binds all these early essays together to formulations as direct as this:

> For the medieval mind, classical antiquity was too far removed and at the same time too strongly present to be conceived as an historical phenomenon . . . [N]o medieval man could see the civilization of antiquity as a phenomenon complete in itself, yet belonging to the past and historically detached from the contemporary world—as a cultural cosmos to be investigated and, if possible, to be reintegrated, instead of being a world of living wonders or a mine of information. . . . Just as it was impossible for the Middle Ages to elaborate the modern system of perspective, which is based on the realization of a fixed distance between the eye and the object and thus enables

the artists to build up comprehensive and consistent images of visible things; so it was impossible for them to evolve the modern idea of history, based on the realization of an intellectual distance between the present and the past which enables the scholar to build up comprehensive and consistent concepts of bygone periods.[14]

It's important, however, about "Iconography and Iconology" that this succinct summary no longer appears as a way of discovering the embeddedness of art-historical objectivity within the Renaissance but as a particular instance of iconographical and iconological method; the dependence of that method on the instance in question is at once clearly visible and displaced or concealed.

The stakes in moving from the German writings of the 1920s to Panofsky's major American statement of art-historical method become clearer if one sees the writings of the 1920s in their immediate intellectual, and particularly philosophical, context. During this period Panofsky is, in effect, writing just along the edge of Germany's most salient philosophical divide, between a neo-Kantianism that finds its most definitive voice in Ernst Cassirer and a distinctly more radical philosophical impulse—the "fundamental ontology" of Martin Heidegger—that also takes Kant as a central reference but of a very different sort. It's helpful to hear Panofsky's remarks about perspective—for example, that it "creates distance between human beings and things . . . but then in turn it abolishes this distance by, in a sense, drawing this world of things, an autonomous world confronting the individual, into the eye"[15]—alongside Heidegger's presentation of "de-distancing" (*ent-fernung*, also sometimes rendered as "dis-severance"): "De-distancing means making distance disappear, making the being at a distance of something disappear, bringing it near. Da-sein [Heidegger's preferred word for human being] is essentially de-distancing. As the being that it is, it lets beings be encountered in nearness. De-distancing discovers remoteness. . . . Only because beings in general are discovered by Da-sein in their remoteness, do 'distances' and intervals among innerworldly beings become accessible in relation to other things."[16]

Heidegger and Panofsky are evidently both addressing the same general kind of fact, one that has to do with the way in which human beings have a capacity to make sense of distance, that is, to both recognize it and in doing that also do something like overcome it. And they both understand

this capacity as integrally bound up with the possibility and necessity of interpretation. (One might then try comparing this human capacity with a cat's success in pouncing on a bit of trailed string: this too is a successful negotiation with something like distance and its overcoming, but it seems purely a reflex or motor negotiation in which, one is inclined to think, "distance" does not figure as such—cats, Heidegger might say, cannot be said to "discover remoteness.") Given this proximity, it can be tempting to say that Panofsky's treatment of perspective can be understood as a particular crystallization of Heidegger's more general notion of "de-distancing."

But this is in fact just where the disagreement lies. For Heidegger, "de-distancing" is a dimension of what we are, whereas for Panofsky perspective is a tool we might or might not take up—a figure for method and not for existence. Heidegger thus stands to Panofsky very much as Hegel placed himself in relation to Kant in the opening pages of the *Phenomenology of Spirit*, as he explores what he takes to the Kantian temptation to imagine cognition as a kind of tool whose reliability is in question and thus must be ensured:

> It would seem, to be sure, that this evil could be remedied through an acquaintance with the way in which the instrument works; for this would enable us to eliminate from the representation of the Absolute [Hegel's word for "what truly is"] which we gained through it whatever is due to the instrument, and thus get to truth in its purity. But this "improvement" would in fact only bring us back to where we were before. If we remove from a reshaped thing what the instrument has done to it, then the thing—here the Absolute—becomes for us exactly what it was before this [accordingly] superfluous effort. On the other hand, if the Absolute is supposed merely to be brought nearer to us through this instrument, without anything in it being altered, like a bird caught by a lime-twig, it would surely laugh our little ruse to scorn, if it were not with us, in and for itself, all along, and of its own volition. . . . Or, if by testing cognition, which we conceive of as a medium, we get to know the law of its refraction, it is again useless to subtract this from the end result. For it is not the refraction of the ray, but the ray itself, whereby truth reaches us, that is cognition; and if this were removed, all that would be indicated would be a pure direction or a blank space.[17]

Like Heidegger, Hegel is forcefully asserting that our relation to an object or a world (and its relation to us) must be there in advance of any tool we might imagine as giving us access to it—so Hegel and Heidegger alike produce arguments against method just where Panofsky appeals strongly to it.[18]

Unsurprisingly, this contrast plays out in distinctly different understandings of interpretation and its relation to the objects that are its occasion. In particular, while Panofsky sees objects as available for interpretation, Heidegger sees them as given in interpretation, already caught up in interpretation simply in being the things they are. What one might call "explicit interpretation" is the continuation of a movement the object itself already is; interpretation so conceived is necessarily circular, at least in the sense that there is nothing external to interpretation to which it might be anchored or against which its adequacy might be gauged.

Panofsky's primary intellectual allegiance is to Cassirer, but he is at least briefly sufficiently intrigued by Heidegger to try out some central Heideggerean notions in one of his last German publications:

> In Heidegger's book on Kant, there are some remarkable sentences on the nature of interpretation, sentences that at first glance refer only to the interpretation of philosophical texts but which at bottom characterize the problem of interpretation in general: "If an interpretation," Heidegger writes, "reproduces only what Kant has expressly said, then it is from the outset no longer an interpretation insofar as an interpretation has for its task to render expressly visible that which, beyond its explicit formulation, Kant has brought to light in its very foundation; but that Kant could no more take the measure of than any philosophical knowledge in which what is decisive is not what is said *expressis verbis* but the unexpressed placed before our eyes in what is expressed. . . . Of course, any interpretation, in order to abstract from what the words say that which they mean to say, must employ violence." It's incumbent on us to recognize that these remarks bear on our modest descriptions of paintings and the interpretations we give of their content just insofar as they do not rest at the level of simple statement but are themselves already interpretations.[19]

"Iconography and Iconology" quietly withdraws the claim of a necessary interpretive violence altogether and works actively to discount the continuity between description and interpretation that this passage so explicitly endorses. Instead, interpretation is posed as nearly as possible in terms of a well-grounded and essentially "scientific" proceeding, founded on an act of "natural" or "factual" description which serves as the stable support for the attribution of specific conventional meanings, which in their turn offer the necessary support for the fullest account of the object in terms of its intrinsic human meaning. Panofsky's stolidly rectangular synoptic table with its neatly carpentered rows and columns appears in marked, if implicit,

contrast with Heidegger's embrace of interpretation's necessary circularity.[20] Equally implicitly, and rather less markedly, it refuses Hegel's dialectical image of the spiral shape assumed by knowledge as it begins in inchoate self-certainty, loses itself in otherness, and finally returns to itself in fully articulated self-possession—a scheme that nonetheless remains legible in the diagram's articulation of a passage from the natural through the cultural and conventional and back to the recovered universality of human nature.

"Iconography and Iconology" is an essay we read easily; we have no trouble seeing what Panofsky means. The essay makes sense in our curriculum, and it makes sense of our curriculum. But this is very largely because it in large measure produced that curriculum. As one's focus on it shifts from what it means to what it does, the text itself becomes notably less transparent, and one becomes much more acutely conscious of the often slippery relation between what it means and what it says. The essay opens with an example appealing in its ordinariness and clarity—my tipping my hat in passing an acquaintance on the street. But we are now perhaps somewhat less inclined to let ourselves slide unresistingly into Panofsky's ample first person. We see two men tipping their hats in mutual recognition, mirror images of one another perhaps, sure of the humanity they share and affirm in one another. We may be tempted to give them names—Vasari, perhaps, and Panofsky, or maybe Panofsky and Dürer, or then again perhaps Vasari and Dürer. We may begin to wonder why we seem always to have one more name than the street or the mirror seems to require, and we may wonder what sense the dance of these three particular names makes: shall we say that Vasari is art history's natural fact, Dürer its theoretical specification, Panofsky its universalization? Or would we rather say that as each pair of figures takes its turn in the mirror, the third rotates into place as its support, at once crucial to the recognitions it enables and inevitably concealed behind it?

Might this scene, this moment of mutual recognition, perhaps be worked by some trace or threat of violence? Panofsky notes that "this form of salute is peculiar to the Western world and is a residue of mediaeval chivalry: armed men used to remove their helmets to make clear their peaceful intentions and their confidence in the peaceful intentions of others."[21] Are we inclined to connect this by some path other than that of Panofsky's evident meaning to what may now seem the strange particularity of the essay's extended example of a beheading problematically disconnected both from its maker and its motif? Certainly when we look to Caravaggio, a major fig-

ure in the Baroque tradition to which this example unquestionably belongs, we find the motif of beheading circulating with extraordinary freedom among Judiths and Salomés and Davids but always also in close proximity to both mirrors and self-portraiture. What was Vasari doing when he cut and pasted his paper frame on Cimabue's sheet of sketches—putting it in perspective?

There are ways to go on with such questions, and this book will explore at least some of them. But for the moment it's enough to notice that in them reading becomes something other than seeing what the text—but we might as well say also painting or work of art—means. It's become a more complex kind of attention, uneasily balanced between seeing and interpreting, and balanced there in ways that leave us profoundly uncertain about what we might want to say or not say about the relations between the textual or discursive and the visual.

IN PARTIAL SUMMARY, THEN: In his repeated discovery of "historical distance" as the defining feature of both art history and its preeminent Renaissance objects, Panofsky accomplishes a number of things that have come to be constitutive of contemporary art-historical practice. He breaks history definitively away from criticism and its problematic, judgmental intimacy with its object. He likewise breaks art history's general object away from the present and so implicitly raises a question around "the modern" as an alternative site for art history's self-understanding. He breaks with his own immediate art-historical predecessors, Alois Riegl and Heinrich Wölfflin, who had, in different ways, urged a vision of art history emerging out of their continuing attachments to the Baroque and to a distinctively Northern art. And, perhaps most important, he invents a particular need for "method" as the means by which "historical distance" can be appropriately bridged.

"Iconography and Iconology" is, most directly, the exposition of just such a method, a step-by-step passage from our natural responsiveness to images across the difficult chasm of cultural or historical difference and then back to the shared ground of the fully human. The name of this movement—and so also of the art historian's primary intellectual activity—is "interpretation" and the ground upon which it moves—the primary object of art-historical inquiry—is "meaning." The primary reference of "theory" in such a model will be to method—to the equipment and controlling principles that prevent the art historian from falling into mere intuition or speculation.

"Iconography and Iconology" has, of course, not gone without criticism of various kinds. Formalists have repeatedly criticized its orientation to meaning and the accompanying tendency, as they would claim, to reduce complex visual works to their literary sources. Sir Ernst Gombrich has pointed out various problematic Hegelian residues in Panofsky's thought—both the familiar dialectical passage from the natural through the cultural to the fully human we've already remarked upon and the vision of cultural wholeness (what Gombrich calls "Hegel's Wheel") that is particularly prominent in Panofsky's *Gothic Architecture and Scholasticism*—while continuing and extending his emphasis on historical distance and the corresponding need for method. And outside of art history itself there have been a series of sustained developments and transformations in ideas about interpretation. One major impetus to these developments emerges out of Heidegger's presentation of interpretation not as a stance toward the world but as the actual lived shape of its inhabitation, thus bottomless and not conformable to the strictures of method. Heidegger's picture of interpretation, particularly as extended and transformed by figures like his follower Hans-Georg Gadamer and the French philosopher Jean-Luc Nancy, continues to be a valuable resource for any effort to think anew about art history as a mode of intellectual inquiry, and this general current of thought is certainly one of the central informing grounds for much of the "theory" that began to exert a strong influence on the humanities across the board in the 1970s and 1980s.[22]

While we will certainly encounter elements of these alternate strains in art history in the pages that follow, for the moment we want to emphasize several key points that emerge from this consideration of Panofsky's work:

1. Panofsky is in a certain sense exemplary in his way of constructing a vision of art history—of its objects, ground, and procedures—out of his attachment to a particular set of objects within it. Of course putting his achievement in these terms suggests that other constructions of the discipline—other modes of attachment to its subjects—might also be possible, and in these other constructions objects, grounds, and procedures might be very differently articulated and distributed.

2. "Method" arises as a central term within Panofskian art history just because of the way the field is constructed more generally; the role of method within this field is both to guarantee and, more importantly, to define "objectivity." This too might be otherwise. It might also be noted that the field structured by "historical distance" necessarily includes a place for the skeptical art historian who would accept the relevance of the model of historical distance while remaining un-

persuaded of the possibility of actually bridging that distance—a skeptic, then, evidently committed to both subjectivity and method.

3. The distinctive peculiarity of Panofskian art history is that it expresses its attachment to its objects as detachment from them and takes such detachment as the general shape of art-historical objectivity. Deep alternatives to Panofsky will appear—within Panofsky's frame—as both "subjective" and methodologically unconstrained in ways that will make their more particular sense difficult to see or hear, and it will be strongly tempting to assimilate such alternatives to the kind of skepticism touched on above.

SPANS

In this light it is particularly interesting to turn to the work of Michael Baxandall, most especially his 1985 book, *Patterns of Intention: On the Historical Explanation of Pictures*.[23] Baxandall, like Panofsky, makes his period home in the Renaissance—*Patterns of Intention* was preceded by studies of Northern Renaissance sculpture, explorations of Italian humanist rhetoric in relation to painting, and a study contextualizing Renaissance painting in relation to a notable range of broader Renaissance practices, including matters as various as forms of contract, commercial estimation, and dancing.[24] *Patterns* does its work across a considerably broader range of examples, devoting chapters to Picasso and Chardin as well as to Piero della Francesca, and notably also including an extended opening treatment of Benjamin Baker's 1890 Forth Bridge. Baxandall repeatedly qualifies his interests in the book as "subtheoretical," a term at once dryly ironic and wholly accurate in capturing the book's complex refusal of "method" as well as its marked lack of interest in the kinds of philosophic reference that played so large a role in our exposition of Panofsky. If it would be too much to say that Baxandall in effect substitutes irony for method, it is certainly true that *Patterns* is informed at every level by an extraordinary rhetorical alertness and so demands an answering alertness in its reader—a demand Baxandall makes clear enough in an early remark about the book's title, "in which the multiple puns (I count three or four) are important to me."[25] The pronounced writerly artifice of *Patterns of Intention* makes a marked contrast with Panofsky's much more workmanlike prose, and so may suggest that the reader ought to take particular notice when Baxandall starts referring to the terms of his account, in the closing chapter, of Piero's *Baptism of Christ* as "plain reading."

The first object Baxandall takes up in *Patterns* is the Forth Bridge, and it seems to serve him as a particularly clear example for a discussion of method: a good account of how this object came to be as it was would, Baxandall suggests, depend above all on a usefully full account of the Charge that Baker was given (to bridge the Firth of Forth) and of the implicit Brief he developed to fill that out (a list of features like the physical situation, material and structural possibilities, known difficulties, and so on). This is, particularly coming hard on the heels of our discussion of Panofsky, a striking starting point: the work as made thing rather than vehicle for meaning.

But we do well to note, before turning more fully to Baxandall's proposal here, that the Forth Bridge is not quite the first object Baxandall treats. His first object appears quite casually. The book opens with Baxandall's saying (the book revises lectures given at Berkeley in 1982 and intentionally retains a strongly spoken tone): "We do not explain pictures: we explain remarks about pictures—or rather, we explain pictures only in so far as we have considered them under some verbal description or specification. For instance . . ."[26] And the instance offered is Piero's *Baptism of Christ*, which continues to show up throughout Baxandall's introduction without ever appearing as its object ("Here is an excellent passage from Kenneth Clark's account of Piero della Francesca's *Baptism of Christ* . . ." "This can be illustrated by taking and sorting a few words from Kenneth Clark's pages on Piero's *Baptism* . . ." "I could plausibly say of either Piero della Francesca's *Baptism of Christ* or Picasso's *Portrait of Kahnweiler* . . ." "Suppose I say of the *Baptism of Christ* . . ."). The general issue this particular painting is repeatedly chosen to exemplify is, broadly, descriptive, and is more specifically attached to Baxandall's worrying at what it might mean to speak of "firm design" in relation to this work—a matter, one might say, of "plane reading." The turn in the next chapter to an extended account of the Forth Bridge immediately situates this evidently "formal" focus in the field of practical doing and making—the executing of commissions—rather than that of the appreciative discernment we most commonly associate with "formal analysis."

What then does Baxandall offer by way of method? There is first all the thought that things made can be analyzed in terms of a fairly empty Charge ("Bridge!" is Baxandall's shorthand for Baker's Charge) and the maker's responding Brief, which Baxandall lays out in this instance as an extensive sample from a presumably larger and notably heterogeneous list of considerations bearing on the bridge's physical situation, existing materials and

know-how, design commitments, prior history of construction on that site, and so on. As Baxandall works through the relations between Charge, Brief, and the bridge itself, he is led to redescribe his activity as sort of game played out on a "triangle of re-enactment."

"What we do," he says, "if we want to know about Baker is to play a conceptual game on the triangle, a simplified reconstruction of the maker's reflection and rationality applying an individual selection from collective resources to a task."[27] A brief summary is then followed by a few remarks transitional toward the objects that are presumably the book's primary concern—works not of engineering but of art.

This transition merits particular attention. It begins by asserting that while "it is possible to find objects with which one can follow something that looks a little like the Forth-Bridge type of explanation," he prefers to begin with a work (Picasso's *Portrait of Kahnweiler*) that puts such explanation "under heavy strain." A few pages further along he specifies this strain more closely: "Something quite preliminary that is missing is the problem that Picasso was addressing, both general Charge and specific Brief."[28] What, then, the reader is surely entitled to ask, was the point of the Forth Bridge exercise? And if we are going to say, as Baxandall eventually does, that "Picasso's Charge really resided in the body of previous painting Picasso would have acknowledged as painting worthy of the term,"[29] would it not have been better to have turned first to one of the many moments in the history of art where Charge and Brief are still relatively explicit and independent of the peculiar notion of artistic autonomy that Baxandall's "body of previous painting Picasso would have acknowledged as painting worthy of the term" is evidently aimed at—for example, Piero's *Baptism of Christ*, where there is a clear Charge, a direct commission to make an altarpiece according to terms that are partially embedded in an explicit contract—and then, as it were, to work one's way forward toward Picasso, demonstrating along the way something of how the external Charge so clearly visible in Piero's case becomes progressively more deeply embedded within the history and practice of painting itself? What is the point of a statement of method, if its immediate sequel is the abandonment of that method rather than (as in "Iconography and Iconology") its demonstration or application? Why write a book that seems conceptually and historically backward, at odds with itself?

Not asking these questions will amount to not reading Baxandall's book,

and since readers do frequently manage not to ask these questions, it's probably worth noticing some of what goes into passing over them: There is, for example, a marked willingness to take Baxandall's repeated denigrations of "theory" and "method," his refusal to claim he has things of this kind to present, as so much rhetoric, exercises in a certain kind of false modesty, and so on (we know what theory and method are, and we know what follows from them). There is a strong sense also of knowing what "examples" are—cases that have, certainly, their historical or cultural specificity but that also stand in a constant relation to the theory or method we bring to them, so the order in which they appear is not a deep feature of them except in those instances where the examples specifically build in some further illustrative complexity. This is closely linked to a further expectation that the order of theoretical exposition is in principle independent of the relating of relevant examples within a historical narrative (so we take Baxandall's subtitle, *On the Historical Explanation of Pictures*, to mean that history is the field of explanation but not a dimension of it; "historical" doesn't modify "explanation" that way). This list can no doubt be extended considerably further; failing or refusing to read is at least as complex a business as reading itself.

If one *is* hauled up short by the oddness of this transition, one may discover oneself explicitly caught up in a moment of reading or rereading. One's eye might, for example, be stuck on Baxandall's particular way of stating what the Picasso painting does to his method—it puts it "under heavy strain"—so that one becomes suddenly alert to the connectedness of this particular phrasing with a particular strand of language that has run throughout the Forth Bridge chapter, a strand in which talk of tension, compression, and load-bearing is closely interwound with talk of alloying and assaying and, for that matter, talk of strands and their intertwining. Sometimes these words and phrases will have clearly belonged to talk about the bridge, its actual materials and construction; at other times they will appear, in retrospect if not on first reading, as belonging more or less to Baxandall's reading of that construction; at still other times it will seem difficult to pin down exactly where they fit among the bridge and Baker and Baxandall. A scattering of passages:

These are surely objective circumstances, in the sense of having a real presence apart from Baker's mind. However, what is less stable is their weighting, their relative mass in the thinking that made the design.[30]

Yet is was he who fixed on this or that rather than another and it was he who alloyed them into *a* form.[31]

I cannot distribute the different circumstances of the bridge among its different sections—side winds to the left, Siemens steel to the right, expressive functionalism somewhere else. In the form of the Bridge, Baker alloyed circumstances, he did not aggregate or collocate them, and we cannot follow him conceptually into the alloyed form of the Bridge. By assaying it out, in the sense of overlaying the form with conceptualizations that have at least something in common with the tissue of his own self-critical reflection, we make it treatable to a degree.[32]

What we're noticing now is, of course, Baxandall's writing, not exactly in distinction from something we are tempted to call his theory or his method but perhaps as a crucial element or condition of it. We had no occasion to notice Panofsky's writing this way, and when we did start noticing features of Panofsky's writing it was if we had found a way of undercutting its apparent transparency; noticing Baxandall's writing feels, by contrast, like a step toward getting his proceedings in focus.

We are also noticing a specific rhetorical feature of that writing. "Metaphor" will be a tempting word for what we think we are seeing here, but this term would have to be carefully weighed against the device Baxandall points to in his preface, the pun—which does indeed seem a better way to capture the movement that carries "alloying" from metallurgy to circumstances to the Bridge's form and into Baxandall's own account of these things, thus offering a way to understand how Baxandall's words of this kind less stand for some feature of his object than are as if continuous with it, at once internal to it and extensions of it. The particularly insistent word "alloy" of course also points to something very much like this: the steel Baker made such innovative use of, among whose notable properties are a combination of strength and flexibility, is, of course, an alloy, a mixture of heterogeneous materials that fuse under heat and pressure. Baxandall's chapter evidently means to be made of a similar stuff:

If I use the concept "design" I do not normally use it in all these senses at once. If I used it of a picture in a more unqualified way—as in "I do like the design of this picture"—surely I would be shedding for the moment that part of its sense that lies in the process of making the picture and referring to a quality more intrinsic to the marks on the panel—"pattern" rather than "drawing" or

"purposing" or "planning"? In its finished reference this may be so: I would be entitled to expect you to take it, for the purpose of criticism, in that more limited sense. But in arriving at it, I and you and the word would have been coming from the left of the field, so to speak: there are leftist and centrist uses of "design" in current and frequent use, but if we pick on the centrist denotation we have been active on the left at least to the extent of shelving its meanings.[33]

If, working through this exploration of the senses alloyed as "design," one recognizes "pattern" (surface design, template, etc.) as itself one vehicle of the multiple puns that form the book's title, then one will also begin to see the paragraph itself as a complex, tensile lattice that opens its writing toward something for which "allegory" will probably be the most tempting word—as, for example, in a passage like this:

> For instance, if we are told or if we infer after observation that Benjamin Baker reckoned tubes best for compression lines and lattice girders best for tension lines with secondary shear stress, this surely sharpens our sense of the organization of matter within the cantilevers. But, correspondingly, once one has got to this point, the object itself leads us to see the progressive sharpening of the angle of the cross-tubes as one moves out on to the wings of the cantilevers (Pl. 5) and much else which one does not have to spell out. This is the nature of the critical act.[34]

The parenthetical visual reference in this passage is to a photograph of the Forth Bridge's central pier and southern cantilever (figure 1).

But the nearest visual reference, which strikingly resembles the photograph, is the diagram just above this paragraph on the same page:

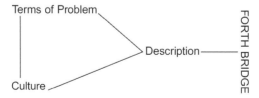

Baxandall's "conceptual game on the triangle" suddenly appears as, overwhelmingly, also a pun played upon or discovered in its object. Nothing emerges as "method" that does not more or less immediately dissolve into

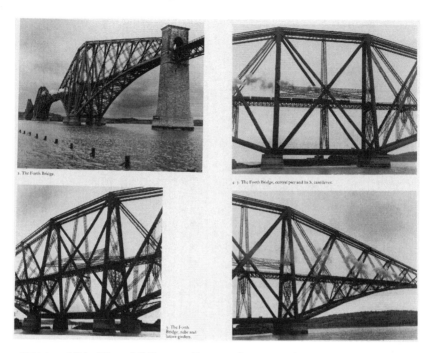

FIGURE 1. Michael Baxandall, *Patterns of Intention*, figures 2–5. Photographs by Eric de Maré.

the writing of the object. This is the nature of the act Baxandall specifies as "critical" and places at the center of historical explanation.

We got into all this by wondering about the transition from the book's first chapter, on Baker, to its second chapter, on Picasso, and particularly about what appeared the arbitrary abandonment of method at just that point. But we may now be strongly tempted to take this transition as answering exactly to the passages within Baker's Bridge from pier to cantilever. And we may be equally strongly tempted to take the book as a whole as having a structure like that of a single span within the bridge—two pier chapters, on Baker and Piero, supported by the architecture of Charge and Brief, between which springs the cantilevered span of Picasso and Chardin, a structure clearly displayed in Baxandall's illustration of "the structural principle of the Forth Bridge demonstrated by members of Benjamin Baker's staff"[35] (figure 2). Seeing the book this way, one might find oneself pausing also over a double-page spread that faces off Picasso's *Demoiselles d'Avignon* and a longitudinal view down the cantilevered span (figure 3). Is this what it looks like to face the past?

FIGURE 2. Michael Baxandall, *Patterns of Intention*, p. 21.
Drawing by Eric de Maré after a contemporary photograph.

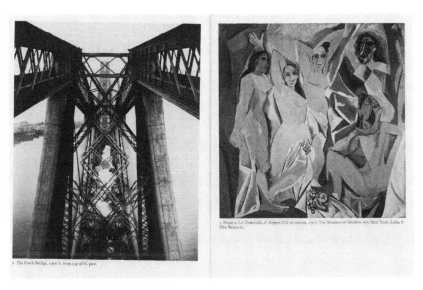

FIGURE 3. Michael Baxandall, *Patterns of Intention*, figures 6 and 7.
L: photograph by Eric de Maré. R: Picasso, *Les Demoiselles d'Avignon*.

Baker's Bridge, as we now have it, is not simply an exemplary object of explanation but an allegory of it. One way the historian standardly takes his or her Charge is as, precisely, *Bridge!*—which is to say, find some way to get from here, this present, to there, that distant past. The Forth Bridge is a realized interpretation of this Charge, succeeding not because it is solidly supported every step of the way but because over crucial spans it supports itself. "Span" shows itself as a particular interpretation of the Charge *Bridge!*, and it is one of particular interest to Baxandall just because it borders on—raises the question of—the relation between what is self-supporting and what is solid because it rests on firm ground. To grasp a span as a span is to grasp a system of relations sustaining itself as a whole, thus something very like an object—and a very different object from the implicit post-and-lintel construction of, for example, Panofsky's synoptic table. One major difference is that this object models not method but art's actual history—the perverse sequence of Picasso, Chardin, Piero just is the spanning in question. From this vantage point, Panofsky's methodological worries look strangely dependent on repeatedly forgetting precisely that history, thus imposing on oneself the repeated and necessary imagination of some void—some uncrossable river or gulf—between the historian's present and the object's past. A cantilevered span is, in principle, built from both sides at once, and its effective principles are more imaginatively accessible if one pictures it, so to speak, from a spot within the river it crosses than by placing oneself on a given shore worrying about how to get to the other side.[36] This suggests that Baxandall is not simply giving us another way to build a bridge; he's suggesting a fundamentally different stance toward the past, one very strong consequence of which is that the works he addresses seem to play a fundamental role in making out the shape of that past rather than more simply standing within it as we might imagine, or represent, an object standing in a space. Baxandall couples something very much like formal analysis to historical explanation in a genuinely surprising way.[37]

If this is right, and if it is right to see Baxandall's diagram of the triangle of reenactment as a radical revision of and alternative to Panofsky's synoptic table, then it may be useful to imagine Panofsky as someone Baxandall has more or less constantly, if also obliquely, in view throughout *Patterns of Intention*. One might reasonably expect any implicit dialogue of this kind to come to some particular point with Baxandall's treatment of Piero's *Baptism of Christ*.

As we've already had occasion to note, Piero della Francesca's *Baptism of Christ* appears on the very first page of *Patterns of Intention* as the occasion for

a question about composition or "firm design." It reappears in the book's closing chapter—and this should be surprising—as the vehicle through which Baxandall proposes to address "two related issues that have been hanging around"—questions about how far we can really "penetrate . . . cultures or periods remote from our own" and about "whether we can. . . . verify or validate our explanations."[38] These are the questions at the heart of Panofsky's vision of art history, and there's a sense in which Baxandall accepts Panofsky's way of formulating them—they are, for both Baxandall and Panofsky, matters of an observer putting things "in perspective" ("what the observer may have," Baxandall writes, "is a perspective").[39] But just here Baxandall puts a particular twist into these formulations by picking up on Piero's *commensurazione*—a word that names something very much like composition and does so in a way that gives perspective a particular importance. As Baxandall summarizes: "*Commensurazione*'s reference can be taken as to a general mathematics-based alertness in the total arrangement of a picture, in which what we call proportion and perspective are keenly felt as interdependent and interlocking."[40] It is this broadness beyond perspective that allows him to speak of what he's after as "the distinctive colour of proportionality in Piero,"[41] a shift away from the Panofskian model that subtly transforms our sense of what it might mean that what we have on Piero is "perspective."[42] Baxandall's remark on the interest of Piero's word is crucial: "Alien concepts like *commensurazione* have an important part not only because we apprehend historical distance in the course of learning them but because, in the texture of our conceptualization about the picture, they stand for a contrast between those people and us."[43] Attending to *commensurazione* just is the apprehension of—the spanning, so also marking—of historical distance. And at the same time, *commensurazione* is a term that crystallizes our interest in the look—the composition—of the picture. It's this imagination of a historical spanning grounded in or supported by the picture itself that Baxandall has, in a sense, been after from the outset and that he has also drawn on throughout the book as each chapter cantilevers out into the next, making the whole a complex pattern of tensions and compressions carried and articulated in the alloying in Baxandall's sentences of their meanings and the pictures to which they point.

Commensurazione is, in modern English, "commensuration" or "commensurateness." Taking it, as Piero evidently does, as a term for "composition," it suggests strongly that a picture is a taking of its own measure, so to speak, setting its scene in proportion, finding its ratio. The interest it takes

in perspective is directly pictorial and not broadly epistemological because it is focused on how something finds within itself its proper measure and not on establishing a common—say, Euclidean—measure that can be imposed on a range of otherwise measureless things. In this sense, Baxandall's focus on Piero's painting and his ways of speaking of it is very precisely balanced against Panofsky's claim for the epistemological privilege of perspective and the rationalized space it offers as history.

The two issues with which the Piero chapter opens—how far we can really penetrate the intentional fabric of other cultures or periods and whether we can adequately validate claims to do so—are deeply familiar late-modern (some would say definitively postmodern) concerns, giving explicit expression to the skeptical possibilities within Panofsky's epistemological turn. The standard skeptical outcome is a claim about the "incommensurability" of cultures and periods, conceptual schemes, discourses, and the like—as if we were to imagine that such divergent formations had in every instance measures internal to them (say, centimeters here and inches there), but somehow had those systems of measure without having any more general notion of measure as such and were thus inconvertible and untranslatable. Maybe bees are in fact like this, communicating in their dances distances and directions that are peculiarly absolute or scaleless (one species' or hive's dance, we might imagine, would not simply be misunderstood by another—it would not be recognized as communicative at all). Baxandall's strong assumption is that neither pictures nor cultures are at all like this—that they are made above all of relation, and are thus necessarily and essentially self-critical, and are therefore also both inherently historical in themselves and essentially exposed to criticism and to transformation. Indeed, openness to criticism and historicity are all but identical in Baxandall's imagination of art history, an activity he refers to most frequently in *Patterns* as "inferential criticism." It's from this position that Baxandall makes such peace as he feels it's necessary to make with such seemingly heavy weight theoretical terms as "scientific" and "hermeneutic," thus also both with Panofsky and Panofsky's sometimes skeptical inheritors.

He takes particular care to work through the ways in which, while "meaning" is certainly among both the conditions and the effects of a picture like the *Baptism of Christ*, our interest in the picture remains answerable to nothing deeper than what he calls "plain reading." "Plain reading" is of course hardly simple; if it can claim a certain freedom from various kinds

of self-mystification and misleading images of how surface and depth, past and present, might or might not belong to one another, it gives rise also to its own complex demands. In particular, just because it has no deeper anchor than the text or picture being read, it is obliged to show itself as, precisely, a reading or showing of that text or picture that remains permanently questionable: "Certainly," Baxandall writes about whether or not he's done well enough by the Angels in the painting, "your feelings about this have quite the same status as mine."[44] One suspects that this sentence gets slightly different readings in the United States and in England, in part because the word "quite" does not work the same way in the two countries and in greater part because Americans are more prepared to see in it a remark about the equality of opinions while English readers recognize in it a comment on the kind of authority such an account can claim.

The remark suggests that "we" are integral to *Patterns of Intention*, its claims not only offered or exposed to us but to be tested in us—a reason, one supposes, for Baxandall to have wanted to keep something of the lectures' oral quality and to pause in closing over how such speaking gets at the heart of "publication," not as the notation and presentation of research results but as the voicing of experience that is, in principle, ours as well as his—sometimes ours over and against his, but (this would be the only measure of his authority) sometimes such that we find our experience corrigible by his.[45] One might claim that our desire for method is defense against the difficulty of this claim.

If to go on from "Iconography and Iconology" means to follow a method, how to go on from *Patterns of Intention* is harder to make out. The tempting thought is that it would be to take one's Charge from Baxandall in something like the way Picasso take his Charge from the body of painting he acknowledges as worthy of that name. But this, of course, would be to say that art history is unguaranteed by method, so always at stake in its doing and its writing. The choice is not between methods but between entire conceptions of the field: how it might be attached to or detached from its objects, how it might be distinct from or continuous with an activity called criticism, what objectivity might accordingly mean or not mean, what relations there might be between art history's history and its claims on knowledge or acknowledgment, what kinds of assent we can imagine for our accounts, and what dissent might matter in what way. These are the kinds of choices this book means to bring into view.

CHAPTER THREE

On the Limits of Interpretation

DÜRER'S *MELENCOLIA I*

We saw in the preceding chapter the way in which Albrecht Dürer figures in Panofsky's art history—embodying a humanist ideal of moderation and distanced reflexivity. This is particularly apparent in his reading of Dürer's engraving of the allegory of Melancholy, *Melencolia I* (1514; figure 4) This little print has been the subject of intense scholarship and speculation by some of the most distinguished art historians apart from Panofsky, including Aby Warburg and the philosophical literary critic Walter Benjamin. In fact, these three scholars' work on the engraving is integrally linked. Warburg was commissioned to write a monograph on the subject, but in 1918 he fell gravely ill and had to be confined to a psychiatric asylum for six years, diagnosed, ironically, with a severe depressive illness leading to schizoid insanity.[1] The task fell to Fritz Saxl, who was managing Warburg's library in his absence. He recruited Panofsky, then a junior professor at the University of Hamburg, to help. Their extensive study was published in 1923.[2] At the same time, Benjamin was completing his postdoctoral *Habilitation* treatise, on the seventeenth-century German *Trauerspiel* or "mourning play" and the form of the allegory, with hopes of gaining entry to an academic career. He had consulted and was deeply influenced by Warburg's paper "Pagan-Antique Prophecy in Words and Images in the Age of Luther" (published in 1920, in an incomplete form), which touched on Dürer's engraving. Benjamin added citations from the Panofsky and Saxl book to the final draft when he became aware of it in 1924. Neither the faculty of German literature nor that of philosophy at the University of Frankfurt knew what to make of the dissertation, nor did Panofsky when he was sent a chapter, so Benjamin's hopes for an academic career were dashed.[3]

A comparative study of the three texts, which also takes in Panofsky's reprise of the topic in his monographic study *The Life and Art of Albrecht Dürer* (1943), is a good way to reopen debates surrounding the limits of

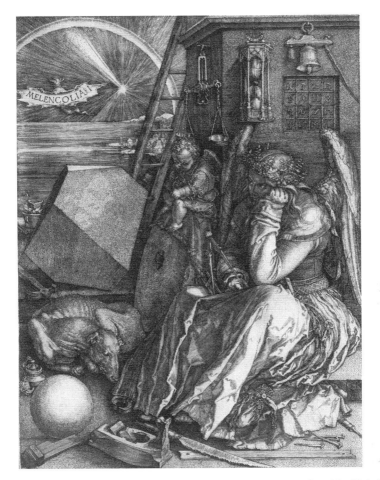

FIGURE 4. Albrecht Dürer, *Melencolia I* (1514). The Metropolitan Museum of Art, New York, NY, U.S.A. © The Metropolitan Museum of Art/Art Resource, NY.

interpretation, particularly with regard to the practice of iconography and iconology. Panofsky often reiterated his view that interpretation involves a synthesis of objective and subjective considerations: an objective, archaeo-logical approach to the meaning of a work of art has to be supplemented by an irrational, subjective, re-creative synthesis to penetrate to the immanent sense of the work as a totality.[4] This ultimate level of interpretation marked the difference between factual, "scientific" iconography and the more specu-lative practice he called iconology. The "immanent meaning" had to take account of formal and expressive features of a work that are not susceptible to determinate proof. His exhaustive reading of Dürer's *Melencolia I* is a

perfect example of his strategy, and it fully justifies the extent to which Pa-
nofsky's erudition is admired and his iconological approach emulated. This
chapter, however, aims to call into question that approach by juxtaposing his
reading of *Melencolia I* to that of Aby Warburg and Walter Benjamin. My
purpose is not to contribute to the enormous amount of scholarship on the
Dürer print but rather to draw out what is at stake in these different readings
of it. I want to show that the debates swirling around the print are animated
by fundamentally different ideas about art and the history of art and are not
just disputes over matters of arcane iconography.

The three scholars under discussion have much in common. Two were
part of the generation of German Jewish intellectuals whose position in
society was brutally disrupted by Hitler's rise to power. Warburg died in
1929, but his large banking family and precious library had to seek refuge
in Britain. All were interested in the history and transformation of motifs
across different historical and cultural contexts and all treasured their mul-
tilayered richness. All made regular reference to popular prints, calendars,
and broadsheets that gave access to a whole world of visual culture beyond
great works of art. They all studied philosophy and psychology, and they
brought those disciplines to their understanding of art. All were interested
in fundamental polarities that structure human thought and experience.
This last point needs further elaboration because, as we shall see, it is the
differences between the sorts of polarities at work in their discussions of
Melencolia I that set them apart from one another.

ABY WARBURG

A great deal of the secondary literature on Warburg takes its cue from Ernst
Gombrich's intellectual biography of him.[5] Gombrich represented Warburg
as a man whose understanding of art was governed by a polarity between
reason and unreason, logic and magic, distance and proximity, frenzy and
philosophy. This is fair enough, but I think that Gombrich was mistaken
in his claim that for Warburg this duality has simple positive and negative
poles: "Though he saw the Renaissance as an area of conflict between reason
and unreason he was entirely on the side of reason. For him the library he
collected and wanted to hand on to his successors was to be an instrument
of enlightenment, a weapon in the struggle against the powers of darkness
which could so easily overwhelm the precious achievement of rationality."[6]

Actually, for Warburg the revival of classical antiquity brought with it the energy of an "emotional gesture" born of Dionysian frenzy as well as serene Olympian detachment—the two being closely intertwined. Nietzsche's *The Birth of Tragedy* was important for Warburg in framing this opposition and in understanding these fundamental principles as interdependent cultural forces, not alternatives. As Nietzsche declared, "Apollo could not live without Dionysius."[7] Warburg described the ambivalent inheritance of classical antiquity in Italy around 1520 as a "Janus-faced herm," a head with two opposing faces, suggesting their inseparability.[8] In the opening pages of his essay on Luther, Warburg criticizes Winckelmann's one-sided reception of an antiquity characterized as the summit of "calm grandeur" (*stille Grösse*). Warburg protests that in order to arrive at his "classically rarefied version of the ancient gods . . . this 'Olympian' aspect has first to be wrenched from its entrenched, traditional, 'demonic' aspect."[9] He also condemned any art or art history that reduced these motifs to "purely formal interest." Combating these tendencies, he celebrated the way the "constrained" world of gesture in Ghirlandio's fresco *Birth of St. John the Baptist* (1486) is broken by the swift "Nympha," a descendant of ecstatic Maenads dancing in the orgiastic cult of Dionysius, ushering into the Tuscan Renaissance the "true voice of antiquity."[10]

Given this background, Gombrich's attempt to characterize Warburg's understanding of the Dürer print as a victory over the dark forces of the demonic side of antiquity in favor of modern enlightenment must be a gross simplification.[11] For Warburg, Dürer's greatness derived precisely from his serious investment in the "true voice of antiquity." His *Death of Orpheus* (1494) is rooted in "the dark mystery play of Dionysian legend."[12] Equally important, however, is his ability to contain those dangerous forces. In this connection, he writes of Dürer's depiction of "robust composure"—a near oxymoron capturing a strenuous maintenance of a tension—which is clearly a more dynamic, fraught alternative to Winckelmann's "calm grandeur."[13] For Warburg, both moments of the dialectic are indispensable, and the Dionysian side should not be understood as unequivocally negative. When a small model of the Laocoön was unearthed in fifteenth-century Italy, Warburg notes that its language of emotive gesture "went straight to the hearts of all those who chafed at medieval expressive constraints."[14] His sense of the way the whole of cultural history can be understood in these terms can be summed up in an example of what is undoubtedly a case of human

advancement: sacrificial blood-spilling was sublimated in the Eucharist. Yet if this ceremony is to remain vivid and significant, it must not lose touch with it roots; otherwise it becomes empty rhetoric and mechanical ritual, devoid of meaning and feeling. The double need for both cool detachment and passionate attachment is beautifully expressed in a passage from a lecture on Rembrandt in which Warburg praises the artist's profound understanding of antiquity: "May these tours through the semi-subterranean regions where the expressive contours of the mind are minted help to overcome a purely formalistic approach to aesthetics. . . . The ascent with Helios towards the sun and the descent with Proserpina into the depths symbolize two stages which belong as inseparably to the cycle of life as do the alternations of breathing."[15]

Warburg's 1920 paper on pagan-antique prophecy during Martin Luther's time demonstrates the continuing potency of astrology in particular. Astrology combined both aspects of Warburg's ruling opposition, for it involves subtle mathematical calculation and measurement as well as fear of demons and belief in magical causation—the "pivots of one vibrant, primordial psychic state." These are "grafted to a single stem" even if they pull in different directions: "Logic sets a mental space between man and object by applying a conceptual label; magic destroys that space by creating a superstitious—theoretical or practical—association between man and object."[16] Warburg held that the cultural ebbs and flows determined by the power of these forces provided an alternative to a history of civilization based on a purely chronological theory of development.[17] Luther's time, the first half of the sixteenth century, offers an example of this polarity in action, for in Germany as well as in Italy two attitudes to antiquity were in play—one that was ancient, practical, religious, the other modern, artistic and aesthetic. The central part of the paper concerns a horoscope made for Luther by the Italian astrologer Gauricus—much to Luther's disgust. Yet his good friend Philipp Melanchthon welcomed it and even seems to have approved of the way it falsified Luther's birth date to 1484 in order to make it coincide with a year of propitious planetary conjunction that, according to astrologists, heralded the advent of a new prophet. Warburg's point is that Luther's age was a hybrid one in which he could be seen as protected by St. Martin under Christian belief and by Saturn and Jupiter under the ancient astrological system. "In the age of the Reformation the fear and awe of Saturn stood at the very center of astrological belief," but the baleful effects of Saturn could

be mitigated by the presence of Jupiter, who could turn a malign astral fate threatening insanity into insight.[18]

Warburg was interested in this material for its own sake, but he also valued it as a context for thinking about the art of the period. Dürer's art, he argues, forms a part of this hybrid culture: "So deeply rooted is one part of his work in archetypal, pagan cosmological belief that without some knowledge of this we have no access, for example, to the engraving *Melencolia I*, that ripest and most mysterious fruit of the cosmological culture of the age of Maximilian I."[19] One exhibit offered by Warburg, Dürer's print of *The Monstrous Sow of Landser*, shows the artist "at home . . . in the world of prophetic freaks"[20] (figure 5). The print is derived from a broadsheet that put a sensational news item, the birth of a monstrous sow with one head, two bodies, and eight legs, to political ends—it was interpreted as a miraculous portent in support of Emperor Maximilian's policies. Warburg notes the

FIGURE 5. Albrecht Dürer, *The Sow of Landser*, 1496. The British Museum, London.
© The Trustees of the British Museum.

similarity between the broadsheet and modern tabloid journalism, calling it a "'Natural Horror Sensation Late Extra' written to serve immediate political ends."[21] The belief in these kinds of signs and wonders survives from the distant past because of a "compulsive human need to establish a mythical causation."[22] Dürer's exacting draftsmanship, however, shows scientific interest in a singular phenomenon of nature. "To some extent," Warburg concludes, "Dürer had already put this Babylonian mentality behind him."[23]

Warburg sets *Melencolia I* in this mixed cultural context, which combines Arabic, pagan, Christian, and scientific outlooks. Dürer's print shows a somewhat disheveled angel sitting heavily on a stone plinth, her head propped on a clenched hand. In her other hand is a compass and on her lap a closed book. Her face is in deep shadow, yet she gazes with bright eyes into the distance. The title of the engraving is inscribed on a banner held aloft by a bat, "Melencolia I," so it is evidently an allegory of the melancholic humor, but the numerous, apparently miscellaneous items ranged around the central figure are not those one would expect to find accompanying a personification of the humor—hence the unusually perplexing character of the print.

From antiquity to early modern times, *melancholia* was a term in medical discourse for one of the four "humors," or bodily fluids, which were supposed to govern a person's temperament. Ideally these fluids would be perfectly balanced, but inevitably one predominates. The sanguine humor, produced when blood is the body's dominant fluid, was regarded as the most favorable: it was associated with air, spring, youth, and cheerfulness. Melancholia, the effect of an excess of black bile, was the worst, associated with earth, autumn and winter, evening, and late middle age. The melancholic person is surly and miserly; he or she shuns company and is inclined to solitary study. In extreme cases, this inward-turning temperament could become pathological, leading to insanity and death. Yet there were already inklings in ancient Greek texts of a positive melancholia that increased one's powers of insight. When the theory of humors was crossed with astrology from the East (particularly Baghdad), the melancholic temperament was linked to the planet Saturn—hence our adjective "saturnine," a near synonym for "melancholic." The ambivalence of melancholy was found in the attributes of this planet, which was thought to be both the slowest and the highest in the firmament.[24]

In the Luther essay, Warburg adduces various documents circulating in

Dürer's time that prescribed remedies for an excess of black bile causing malign melancholia: one prescribed mental concentration "to transmute his sterile gloom into human genius."[25] The face, posture, and head resting on the clenched hand of Melencolia might well suggest this intense concentration. Another remedy was to enlist the help of Jupiter. Warburg draws attention to the magic square above the head of Melencolia and uses a book circulating in intellectual circles called *Picatrix*, an Arab transmission of astrological and magical practices in late antiquity, to interpret the meaning of the device.[26] The square is "magic" because all the rows and diagonals add up to 34. The one in Dürer's engraving also reveals the date of its making, 1514, in the middle of the bottom row. This mathematical wonder was associated with the astrological sign of Jupiter, and so its presence invokes the magical intercession of Jupiter, the "jovial" planetary body, thought capable of counteracting Saturn's malign influence. This is the nub of Warburg's interpretation. He criticizes the Viennese art historian Karl Giehlow for interpreting the square as a symbol of inventive genius rather than primarily as an amulet against Saturn's planetary influence, and more generally for seeing *Melencolia I* as an allegory of rational thought freed from the fear of planetary demons.[27] For Warburg, too, the engraving is ultimately a consoling humanistic message of liberation from the fear of Saturn. Yet it importantly shows the struggle to subdue the "malignant, child devouring planetary god," even if it shows that struggle more or less won.[28] A figure tied to magic and myth has been made spiritual and intellectual. A depressive, possibly suicidal fate can be transmuted by means of occult magic into the gift of profound thought. "Sublimation" is a good word to describe this process, for sublimation transmutes a substance or desire without eliminating it. At the end of his life, Warburg wrote in his journal: "The potentially dangerous enemy bound up in the image of the astral demon Saturn is given a new meaning which serves as a protective screen [*Schutzhülle*]."[29] It is as though Dürer's image of Melancholy absorbs dangerous energies and binds or contains them.

Resistance to myth and superstition in both Dürer and Luther is central to Warburg's argument. He admires their ability to carve out a space for reflective thought in a world apparently dominated by magical causation and astral fate. As we shall see, this is the aspect of Warburg's essay taken forward by Panofsky and Saxl. Yet I think that commentators are mistaken when they collapse Warburg's approach into that of Panofsky and Saxl.[30]

After all, the print expresses this idea in the language of astrology: Melencolia is "a Child of Saturn," and her victory over its malign influences is far from secure.[31] Warburg's parting shot is to note that the allegorical figure wears on her head a garland of the classical herbal remedy for staving off malign melancholia, not the laurel of victory. Dürer anticipates the work of future liberators of "conceptual space" (*Denkraum*), and Warburg regarded this as a wholly positive achievement. Yet this fact should not blind us to Warburg's sense of the dangers of excessive detachment when, for example, he criticizes the constrained gesture in medieval art or the "calligraphic" decoration of the Baroque saying, "Their expressive values were cut loose from the mint of real life in movement." Warburg's writing, his library, and his picture Atlas were all designed to create and preserve *Denkraum*, but also to serve a "mnemic function": "Through renewed contact with the monuments of the past, the sap should be enabled to rise directly from the subsoil of the past and imbue the classicizing form in such a way that a creation charged with energy, should not become a calligraphic dynomogram."[32] He expresses much the same idea in the Luther essay, noting how borrowings from late antique sources, including *Picatrix*, "breathed new life into the mummified *acedia* of the middle ages."[33]

ERWIN PANOFSKY

We saw how Warburg objected to Giehlow's idea that Dürer's image showed Melencolia, having transcended medieval superstition, transformed into a Renaissance humanist genius, after the model of Ficino. Panofsky and Saxl revert to Giehlow's Neoplatonic interpretation, but they add a great deal of other material relating to the history of images of melancholia and acedia (sloth). Marsilio Ficino, a Renaissance physician, humanist philosopher, and translator of Plato, was instrumental in elevating melancholia from a temperament that in the Middle Ages had been allied with the sin of sloth into an equivocal inheritance combining both the blessing of genius and the curse of madness. Yet Ficino's *The Three Books of Life* (*Libri de Vita Triplici*) is full of astrology—the last book is called "On Making Your Life Agree with the Heavens." It offers advice on how to cope with the excess of "heavy" black bile that afflicts those born under the sign of Saturn (such as himself) so as to turn a fate that could lead to madness and death into the source of the most elevated thought. For Ficino, this elevated melancholy

was a version of Plato's conception of the artist's divine frenzy, that is, a gift both sublime and dangerous.[34] Panofsky credited Ficino with the "humanistic glorification of melancholy" and the "ennoblement of the planet Saturn."[35] Ficino figures in Panofsky's thought as an exemplary model, one who dignified man as "a rational soul participating in the intellect of God, but operating in a body."[36] This sentiment is glossed by Panofsky in "The History of Art as a Humanistic Discipline" (1940) as expressing both "the insistence on human values (rationality and freedom) and the acceptance of human limitations (fallibility and frailty)."[37] This polarity, which strikes me a sadly attenuated version of Warburg's sense of the powerful dialectic handed down form antiquity, colors Panofsky's reading of *Melencholia I*.

Panofsky trawls through the history of popular representation of the four humors, where we find Melancholy often depicted as "an elderly, cheerless miser" who grasps a purse hanging from a belt. Sometimes she is shown falling asleep, thus merging melancholy with the iconography of the Christian sin of sloth. Dürer draws on and transforms these lowly motifs. His print depicts neither the base melancholy of morose inactivity nor the lethal melancholy of madness and death, but rather Melancholy as an allegory of profound thought. In addition to the tradition of portrayal of the humors, Dürer evidently drew on traditional personifications of the liberal arts. Panofsky produces a woodcut of the personification of Geometry from 1504 that shows nearly all the devices in Dürer's engraving (figure 6). He persuasively argues that the articles littering the area around the figure refer to geometry, carpentry, and measuring: a plane, a saw, a ruler, a molder's form, a pair of pincers, nails, hammer, and the compass. Two other objects, a sphere of wood and a "rhombo-hedron of stone," appear to be emblems of the practical geometry underlying architecture and carpentry. In Dürer's print, Panofsky concludes, Melancholy is intellectualized by reference to the arts, and Geometry is humanized by reference to the temperaments.[38]

Panofsky's interpretation reaches the higher levels of intuitive, speculative iconology when he argues that the devices and tools surrounding the figure of Melencolia indicate that the engraving represents an intelligence tied to the imagination, struggling but unable to transcend the earthbound, spatial world to attain the realm of pure abstract ideas.[39] Although Dürer's Melencolia is winged, she seems unlikely ever to take flight—hence her frustration. She is paralyzed, not by lack of energy but by an intellectual problem, by reason blocked. "Her fixed stare is one of intent though fruitless

FIGURE 6. Gregorius Reisch, "Typus Geomtriae," from *Margarita Philosophica.*

searching. . . . Her energy is paralyzed not by sleep but by thought."[40] This line of interpretation is informed by the Neoplatonic distinction between two kinds of intellect, one capable of entertaining abstract philosophical ideas and the other constrained to imagining things in concrete mental images. Persons of the latter type, unable to transcend the limits of the imagination, are bound to be melancholic. As Panofsky says, "The consciousness of a sphere beyond their reach makes them suffer from a feeling of spiritual confinement and insufficiency."[41] In Panofsky's view, this is what *Melencolia I* ultimately expresses. "She gives the impression of a creative being reduced to despair by an awareness of insurmountable barriers which separate her from a higher realm of thought."[42]

Panofsky attaches great importance to the fact that Dürer conceived of

Melencolia I and *St. Jerome in His Study* as counterparts: they "express two antithetical ideals."[43] While St. Jerome is comfortably installed at his desk, Melencolia crouches on a low slab of stone in what looks like a building site. While he works in a sun-filled room, she is outdoors at night. He is serenely occupied with his divinely inspired theological work, while she is a state of "gloomy inaction." While St. Jerome is seated in a tidy study, Melencolia is surrounded by a bewildering array of disordered objects. He contemplates transcendent truths; her thoughts are tied to the world of objects and imagination. Dürer opposes "the peaceful bliss of divine wisdom to the tragic unrest of human creation."[44] In other words, Melancholy sees though a glass darkly, not face to face.

Panofsky concludes that Dürer has specifically represented the artist's melancholy and further suggests that Dürer thought of himself as a melancholic genius, especially as he was interested in those arts tied to the imagination—geometry, proportion, and perspective.[45] The engraving is, then, the "spiritual self-portrait" of a man aspiring to the Ideas but confined to Art. In support of this thesis, he quotes Dürer in a melancholic mood: "The lie is in our understanding, and darkness is so firmly entrenched in our mind that even our groping will fail."[46] While one might concede that the print could well be a partial self-portrait, it seems to me less plausible that the consummate artist's melancholic temper had to do with thwarted desire to transcend the visible world. In addition, while Panofsky's proposal that Dürer has amalgamated the allegory of Melancholy with the personifications of the liberal arts is surely correct, it would seem that in his quest to tie the image to Dürer's interest in perspective and proportion, he exaggerated the prominence of Geometry. An implicit alternative interpretation of *Melencolia I* is offered by a depiction of the seven liberal arts made by Georg Pencz in Germany sometime after Dürer's print was made, and clearly under its influence. The attributes we find in Dürer's print are here distributed among the various arts: the scales for Dialectics, the book for Grammatica. The personification of each art is attended by an eager putto student, one of whom, beside Arithmetria, writes vigorously on a tablet. Geometry has a compass, but so does Astrology, who with a sphere by her side indicates bright stars in the sky. We can infer from Pencz's unpacking of *Melencolia I* that he read it as a fusion of the melancholic humor with the liberal arts in general. In other words, melancholia is the humor associated with those engaged in intellectual and artistic endeavors of all kinds.[47]

While Warburg showed us Dürer's *Melencolia I* as the representation of a struggle between reason and demonic forces that managed to compress their energies in a state of "robust composure," Panofsky's Neoplatonic Melencolia is one who feels epistemologically constrained by her entanglement in the world of things and images, rather than, like the philosopher, able to leave that mere husk behind in the attainment of pure rational thought. This, of course, has the worrying implication that Panofsky must think that his hero, Dürer, regarded the work of art as a disposable husk whose purpose was to illustrate or communicate an idea. Georges Didi-Huberman had no hesitation is reaching this conclusion. He claims that Panofsky himself regarded the image as a dangerous lure that must be defended against: "In order to constitute iconology as an 'objective science' it was necessary for Panofsky totally to exorcise something inherent in the very powers of the object."[48] When the task of writing the monograph on *Melencolia I* fell to Saxl and Panofsky, the latter's post-Kantian epistemological concerns took the place of Warburg's urgent investigation into the afterlife of antiquity, which he undertook as if it were "a matter of life and death."[49] Giorgio Agamben argues that Warburg saw his personal demons as also afflicting the culture at large. In a diary entry, he wrote: "Sometimes it looks to me as if, in my role as a psycho-historian, I tried to diagnose the schizophrenia of Western civilization from its images in an autobiographical reflex."[50]

WALTER BENJAMIN

The writing of Walter Benjamin's book *The Origin of German Tragic Drama* (1924–25) was exactly contemporary with Panofsky and Saxl's study, although it was not published until 1928.[51] In order to understand Benjamin's idea of melancholy and the dialectic underlying it, one has first to understand his theory or mythology of language. Benjamin describes a prelapsarian world where the originary language or *Ursprache* was immediate, preconceptual, and true.[52] After the fall, language became a collection of arbitrary signs imposed on the world.[53] A sense of loss and longing is thus built into Benjamin's theory of language. His own style of writing, which seems to grasp for something that cannot be fully articulated, constantly reminds the reader of the difficulty of writing. The dialectical oppositions that drive Benjamin's thought, then, are between loss and recovery, meaninglessness and perfect knowledge, and their corresponding affects of de-

spair and exaltation. The particular historical situation that precipitated the Baroque German mourning play, according to Benjamin, had partly to do with the strictly Protestant Lutheran dispersal of a Catholic God-suffused world, which left behind a realm of petrified relics and inauthentic actions. The deep thinkers of the age withdrew, mourned, and meditated, and some wrote mourning plays.

Benjamin sees Dürer's engraving as an anticipation of this state of affairs. The print depicts a dejected world where things litter the ground, objects no longer of use but of contemplation. Yet the print also demonstrates a mode of thinking in response to this fallen world: allegorical thought. Benjamin's notion of allegory is best approached through his account of the difference between the symbol and the allegory. This distinction recalls the one Warburg drew between neoclassical serene grandeur and a more conflicted, dialectical conception of classical antiquity. For Benjamin, "harmonious inwardness" corresponds to the indivisible unity of form and content summed up in Winckelmann's conception of classical sculpture. "The artistic symbol," writes Benjamin, "is plastic" and its reception is instantaneous.[54] Allegory, on the other hand, is the apotheosis of a violent dialectical movement between extremes that refuse reconciliation. Picking through the ruins of allegory is piecemeal and slow.[55] Needless to say, Benjamin's conception of allegory is quite different from the literary form retrospectively invented by the neoclassical and romantic theorists "so as to provide the dark background against which the bright world of the symbol might stand out."[56] According to that view, allegory is like language; that is, it amounts to no more than a conventional relationship of signification between image and abstract meaning.[57] In order to counter that view of allegory and language, Benjamin recalls the Renaissance understanding of hieroglyphs, thought to contain in their enigmatic shapes traces of divine wisdom. Allegory strives for this rebus-like encrypted knowledge that gestures back to the lost originary language and forward to paradise regained. Allegory is "beyond beauty." It picks up highly significant fragments and arranges them, never concealing the artifice of this activity.[58] Benjamin sums up: "Whereas in the symbol destruction is idealized and the transfigured face of nature is fleetingly revealed in the light of redemption, in allegory the observer is confronted with the *facies hippocratica* [deathly face] of history as a petrified primordial landscape."[59] Allegory is not beautiful because it is true to historical catastrophe and to fallen nature when "the false

appearance of totality is extinguished."[60] In a well-known phrase, Benjamin associates allegory with the fallen world left behind by history: "Allegories are, in the realm of thoughts, what ruins are in the realm of things." [61] The mute, mourning world, abandoned by God, is rescued by the allegorist, who "lends speech to things."[62]

Benjamin's critique of Panofsky and Saxl's study of *Melencolia I* is oblique and centers on the figure of the stone. Benjamin thought that their concentration on Dürer's heroic genius and stress on the influence of Florentine Neoplatonist humanism led them to underplay the significance of this image of sheer earthbound materiality. The heavy heart of the melancholic is projected outward onto the stone, which in turn seems to determine her temperament. Although he does not mention it, the millstone is also explicable in terms of projected psychical heaviness. Melancholy's embrace of dead objects, its "loyalty to the world of objects,"[63] is signaled here, but the stone also serves as a reminder that we are in the end nothing but dead matter. In addition, whereas Panofsky interprets the hourglass above Melencolia's head as a scientific instrument for measuring time, Benjamin sees it as the ubiquitous sign of time and death.[64] For Benjamin, Saturn's status as the ancient god of agriculture means "everything saturnine points down to the depths of the earth." In this connection, he quotes a passage from a German Neoplatonist, Agrippa of Nettesheim: "'The seed of the depths and . . . the treasures of the earth' are the gifts of Saturn."[65] This descending path, which leads to the gravity of thought but also to materiality and death, is Benjamin's counterpoint to the ascending steps of inspired access to the eternal Ideas of Neoplatonic theosophy.[66]

Benjamin's account of *Melencolia I* differs from Panofsky's and Saxl's in another respect. Benjamin was concerned not only with the iconography of the subject but also with the *form* of the allegory and its reception. As we've seen, while the symbol is born and is understood in an inspired flash of genius that coalesces meaning and figure into a unified totality, the allegory is more earthbound and composite; its meaning unfolds in a series of moments.[67] The melancholic is a born allegorist, for, as Benjamin notes, "the lightning flash of intuition is unknown to him."[68] Benjamin's sense of the necessarily piecemeal approach of allegory makes him sensitive to what might be called the "performative" aspect of deciphering Dürer's engraving. Whereas Panofsky and his colleagues undertook a total and unified interpretation of the print, they failed to see that the enigma, the very dif-

ficulty, the ambiguities, the piece-by-piece accumulation of meanings *are intrinsic to the form of the allegory*. In other words, *Melencolia I* is not just a representation of intense, conflicted thought; it is also an occasion for it. Joseph Koerner makes this point emphatically in his book *The Moment of Self-Portraiture in German Renaissance Art*, where he argues that the obscurity of Dürer's engraving "is partly the artist's intention." He continues: "Instead of mediating *a* meaning, *Melencolia* seems designed to generate multiple and contradictory readings, to clue its viewers to an endless exegetical labor until, exhausted in the end, they discover their own portrait in Dürer's sleepless, inactive personification of melancholy. Interpreting the engraving itself becomes a detour to self-reflection."[69] What this means is that the task of interpretation is less a matter of deciphering the meaning of a text and more like an encounter with an enigmatic object that brings us up against the limits of interpretation. If the viewer of Dürer's print does not experience this moment of dejected frustration, it seems fair to say that he or she has failed to encounter it as a work of art: our response should oscillate between the ecstasy of meaning and the abjection of nonmeaning.[70]

This necessary reflexive moment of interpretation raises a further issue. What possible relation is there between the contemporary art historian and the early sixteenth-century object of interpretation? Benjamin would say that a relation is possible because of certain resonances between the past and the present. At these points of conjunction, he says, things "enter into legibility." Certain epochs are confronted by the impermanence of things—epochs that have experienced widespread destruction, such as in Europe during the Thirty Years' War (1618–48) and after the First World War, when Benjamin was writing. That is, the metaphysical desolation, alienation, reification of things, and withdrawal of meaning prefigured in *Melencolia I* have a resonance with our melancholy precipitated by the shock of modernity, its technology, commodification, and wars. For Benjamin, this resonance between the past and the present releases the political potential of history.[71] A metaphor that he uses to express this sort of conjunction is particularly appropriate in this context: "constellation."[72]

A good example of just such a constellation is found in Benjamin's account of the French photographer Eugène Atget. He is mentioned in both of Benjamin's essays on photography, and although it is not made explicit, Benjamin clearly saw him as a modern allegorical artist who found meaning in the ephemeral, neglected, and outmoded.[73] In the 1931 essay "Little History

of Photography," he applauded Atget for refusing to present the world as or-
dered and meaningful, which in our times is a lie or, at best, myth. Instead,
"he looked for what was unremarked, forgotten, cast adrift."[74] Atget passed
by the great sights and beautiful landmarks, but "what he did not pass by
was a long row of boot lasts; or the Paris courtyards, where from night to
morning the handcarts stand in serried ranks; or the tables after people
have finished eating and left, the dishes not yet cleared away."[75] Atget was
drawn to the petrified relics of modern life. His street scenes were described
by Benjamin as looking like the empty scenes of crimes.[76] The withdrawn,
impersonal gaze of the camera makes everything it sees enigmatic. While
allegory has a corrosive effect on myth, it is also a way of going beyond ni-
hilism and despair toward a creative reconfiguration of the fallen world.[77]
Allegorical art must have both the destructive, fragmenting moment that
shatters mythical beauty, leaving behind "a petrified, primordial landscape,"
and a productive moment of finding meaning again in the fragments.[78]

One way of summing up the differences between our scholars' interpreta-
tions of the engraving is to note how the attention of each seems particularly
drawn to one of its many scattered objects. Each singles out a privileged ob-
ject—one that is emblematic of the whole and thus serves as a key to inter-
pretation. For Warburg, it is undoubtedly the magic square that hangs above
the angel's head. This device was associated with the astrological power of
Jupiter and so, for Warburg, indicates that Dürer subscribed to the ancient
occult belief in Jupiter's jovial influence that could ward off the malignly
Saturnine side of melancholy. Warburg seizes on this magic amulet in order
to make the case that Dürer is a transitional artist whose work mixes myth
and enlightenment in equal measure. This is precisely what makes him a
figure of such fascination for Warburg. While Panofsky's exhaustive account
leaves no motif uninterpreted, his view of the engraving is best summed
up by the compass in Melencolia's hand. This is a tool used for measure-
ment, geometrical construction, and mechanical drawing—just the sort of
space-bound activities that Panofsky thinks indicate Dürer's sense of his
limitation with respect to knowledge of a properly philosophical kind. Ben-
jamin's privileged object, the stone, is clearly counterpoised to Panofsky's
compass—like rock to scissors. The sheer weighty physicality of the stone is,
for Benjamin, a reminder of our physical being and inevitable death.

The engraving itself is, of course, a sort of privileged object for all three
art historians. This is what makes the comparison of their interpretations

so telling. We've seen how Panofsky makes of the print a Kantian allegory of the limits of human knowledge. But it represents for him far more than this. One suspects that just as he sees in the figure of Melencolia Dürer's spiritual self-portrait, he also sees himself. His identification with the artist is patent. Panofsky was a German art historian who mastered the Italian Renaissance, and in his early years he styled himself a theoretical art historian who aimed to give the discipline more systematic, philosophical foundations. He, like Dürer, wrote on perspective and proportion. Yet the significance for him of this particular Dürer engraving probably ran deeper than the accounts of it he published, for we know that he was subject to spells of depression. Warburg and Benjamin, one senses, are tapping into a quite different set of concerns that link their work to the themes explored by Nietzsche and Freud, rather than Kant—themes such as myth and enlightenment, memory and amnesia, hope and despair, dereliction and redemption. They, too, identified with the figure of Melencolia; Warburg, we know, suffered from severe depressive mental illness, and Benjamin's sense of his identity was bound up with melancholy: "I was born under the sign of Saturn—the planet of the slowest revolution, the star of hesitation and delay."[79] In these circumstances, it is hard not to see Dürer's engraving functioning for all three thinkers as a sort of magical amulet against depression, self-destructiveness, and madness.[80]

Panofsky provided the dominant model for art history in the twentieth century, yet the ground has been slowly shifting. Certainly the delayed reception of Benjamin was followed closely by an equally delayed reception of Warburg. One art historian has explicitly taken the theme of Melancholia as her privileged object. Michael Ann Holly understands the work of the art historian under that sign or trope. This is so because, she argues, it is our job to retrieve and reawaken what are lost or dead objects.[81] Our objects are "dead" in the sense that they have become separated from a past culture that gave them life—they are "orphans," "relics." They also elude us in the sense that we have difficulty capturing them in the flimsy conceptual net that is language. Although she draws on Benjamin and Warburg among many others, her most important point of reference is not the literature of the humors but the essay "Mourning and Melancholia" in which Freud distinguished between normal mourning and melancholia. Mourning, for Freud, is the painful process of severing emotional attachments to someone loved and lost. Melancholia, by contrast, is a pathological condition in which a person

unconsciously keeps the lost object (often the mother) in a sort of internal crypt and inflicts punishment on that internalized object for betrayal and abandonment. As Freud so poetically put it, "The shadow of the object fell upon the ego."[82] If mourning is severing attachments, then the art historian's job, on Holly's account, would be a kind of melancholic anti-mourning; the writing of art history springs from a sense of loss and a desire to reconnect with the faded objects of the past.

Holly's suggestion that melancholia is the "unconscious" of the history of art is an appealing one and closely related to the one put forward here. Yet it is worth reconsidering the way Holly frames the nature of the art historian's relation to the past. She approvingly cites Panofsky's suggestion that the task of the humanities consists of "enlivening what would otherwise remain dead."[83] There is a striking difference between this notion of the past in need of resuscitation and the Warburgian conception of the "afterlife" or *Nachleben* of images. Warburg traced the migration of images of primitive expressive gestures or *pathos formulae*—gestures of ecstasy, depression, rage, fear, and desire—and attended to the oscillations played out between the ecstatic or manic Nympha and the depressive river god. Warburg's historiography seems to be informed by psychoanalysis.[84] History consigns certain moments to oblivion, but they survive underground, ready to reappear uncannily in a transformed state. Didi-Huberman has argued strenuously that Warburg's historiography is Freudian in this sense, although it is uncertain to what extent Warburg read Freud.[85] Like the return of the repressed, certain forms, certain expressive gestures of exceptional intensity, are destined to recur in unexpected contexts. They constitute a cultural memory bank of images. For example, searching for the means to express Mary Magdalene's utter despair at the crucifixion of Christ, Renaissance artists unexpectedly repeat the gestures and turbulent drapery of pagan ecstatic Maenads. Or in the case of *Melencolia I*, as Warburg writes, "uncannily and spontaneously, the spirit world of antiquity derived new life from the passionate and vibrant age of the Reformation."[86] These anachronisms disrupt the temporal linearity of historicism. If this is so, then the art historian's task is not so much a matter of reviving the dead as of observing the ways in which the past haunts us and attempting to understand its effects. Warburg's compared the art historian to the seismograph, alerting us to shifts deep within the contemporary cultural crust.[87] Works of art were, for him, the "nervous organs of perception of the contemporary internal and external life."[88]

That is why Warburg built up his *Mnemosyne-Atlas* (1924–29), a photographic collection of images from antiquity through the Renaissance to the present-day popular press (figure 7). It is less well known that Benjamin also collected an extensive scrapbook of images (now lost). He too, as we've seen, criticized the linearity of historicism. For him, "the true image of the past flits by" or "flares up briefly."[89] It is a ghostly revenant that might have

FIGURE 7. Aby Warburg, "Plate 55," from *Mnemosyne Atlas*. Warburg Institute, London.

FIGURE 8. Gerhard Richter, *Atlas Sheet 10* (1962). © Gerhard Richter 2009.

salutary or catastrophic effects. For Freud, the individual's past is obscure but potently at work in the present. Benjamin transposed this theory about the individual's relation to infantile experience to the collective or social plane and then used it as the basis for a nonlinear historiography.

Since 1962, the German artist Gerhard Richter has been compiling an atlas of mostly found images from magazines and newspapers and family albums. Like Warburg, he arranges the images on large panels (figure 8). Most of them are banal, and many allude to the "economic miracle" of postwar Germany. Benjamin Buchloh understands these images as agents of "psychic anaesthesia": "What becomes evident in Richter's archive of the imagery of consumption is the underside of this peculiar West German variation on the theme of banality: the collective lack of affect, the psychic armor with which Germans of the post war period protected themselves against historical insight."[90] Yet beside these banal panels are some displaying horrific photographs of the Nazi death camps and some documenting the death of members of the Baader-Meinhof terrorist group in Stammheim Prison. The latter documents formed the basis of a suite of fifteen blurred

gray paintings that must be counted among the twentieth century's greatest history paintings—*October 18, 1977* (1988).

In each of these cases, the aim of the atlas seems to have been to piece together the scattered remnants of historical memory. Trauma, repression, and the uncanny return of the repressed are the psychical equivalents of the trajectories tracked in these image inventories—traumatic imprinting, disappearance, transformation, and reemergence. These collections of images are the pieces of a mosaic that are the raw materials for a reinterpretation of our sense of the past. Benjamin refers to them as fragments, "blasted out of the continuum of history."[91] Freed from that continuum, they can be reused, reinterpreted, in the present. This implies that interpretation should not endeavor to excavate a fixed meaning tied to a particular set of circumstances in the past. Rather, we should look for fragments from the past that have survived their moment in history and with them form a constellation that will give us a new understanding of the past and the present.

What the Formalist Knows

The writings of Heinrich Wölfflin, and most particularly *The Principles of Art History: The Problem of the Development of Style in Later Art,* are an explicit effort to found a discipline oriented to the history of art and to do so on the basis of an intuition that is recurrent in both art history and art criticism. Positions that make this intuition central to their conception of criticism and history are generally referred to as "formalist." Such positions have been the recurrent target of sustained and telling criticism, but no such criticism has been enough to simply and permanently close off formalism, in one form or another, as a fundamental option: whatever formalism's failings, it evidently registers a thought or feeling about art that does not stop claiming our interest. The question, then, is, what does the formalist know?

There are a number of answers to this question, in many cases offered by the champions of some particular formalism—there is, for example, Clive Bell's claim that "lines and colours combined in a particular way, certain forms and relations of forms, stir our aesthetic emotions."[1] This formulation does not travel particularly well even within the general universe of formalisms; it's hard, for example, to imagine Wölfflin subscribing to it, but it does bring out well enough something of what we typically mean by formalism—a distinct interest in, say, the surface of a work of art as opposed to its presumed interpretive depths, as well as the assumption of a distinct (and likely primary) place in our dealings with such works for aesthetic considerations. This last feature suggests that formalist positions will tend to see history and criticism as closely related activities in a way that other visions of art history will not.

In general, formalist positions in art and art history seem to involve an insistence on one or more of the following points: (1) the primacy of the

visual in the experience of art; (2) the irreducibility of some notion of a "work" of art; (3) the necessity of criticism. While the movement from any one of these thoughts to the others looks in many ways obvious enough, it is a far harder matter to say how they might actually hang together, and indeed one way of sorting out the different positions we are inclined to recognize as formalist would be to pick out which of these formulations seems to be the operative core of the view.

Wölfflin's *Principles of Art History*, defining the history of art as the history of vision, appears as formalist particularly in relation to the first of these points. An interest of this kind may be quite direct—it may make a claim about works of art as defined by particular arrangements of line and form and color, and this may or may not include a more particular theory about appropriate or inappropriate arrangements (the passage from Bell, like many late nineteenth- and early twentieth-century central formalisms, appears to make a claim of this kind), or it may offer a more complex account of the scope and nature both of the visual and the interest or pleasure we take in it. The particular interest of Wölfflin's *Principles* arises to a high degree from the apparent centrality and complexity of his view of vision, a view that leads him to assert that it provides the essential object of the discipline:

> Vision itself has its history, and the revelation of these visual strata must be regarded as the primary task of art history.[2]

Making out the sense of this proposition is reason enough to be interested in reviewing Wölfflin's *Principles*, but there is a further, somewhat more oblique reason one might take an interest in reading or rereading Wölfflin now. Wölfflin's definitive disappearance from the foreground of academic art history's self-understanding—his being, as it were, dropped from the survey—appears to loosely coincide with a marked turn in the worlds of art and criticism, especially in the United States, against another "formalism," for the most part quite distinct from Wölfflin's and associated above all with the name of Clement Greenberg. Considering these two formalisms, and their fates, more or less alongside one another may be useful for gaining a deeper or sharper grasp of what it is the formalist claims to know, and it may also enable us to ask what it is that appears to be fading from view at the close of the 1960s—which is to say it may give some ways of thinking

about the relevance of a particular range of claims about modernism and postmodernism to the ways we imagine the shape of art history.

PRINCIPLES

Wölfflin's brand of formalism appears somewhat peculiar because where formalisms typically tend toward an unified account of what we find visually or aesthetically pleasing, Wölfflin seems to offer an account of two wholly independent kinds—styles—of artistic work and achievement and then to yoke them somewhat arbitrarily into historical progression. The two kinds of achievement are distinguished as Classical and Baroque, and Wölfflin offers a set of five closely interlinked contrasts that allow one to pick out the fundamental differences between these two great styles. Long after *The Principles* itself has disappeared from the art history curriculum, the terms of these contrasts continue to circulate in the lectures and talk of art historians. The Classical is conjointly defined by the features Wölfflin picks out as linear, planar, closed, multiply unified, and absolutely clear, while the Baroque is defined by the painterly, recessive, open, unitary, and relatively clear. The historical thesis says that art develops from the Classical to the Baroque. An obvious analogy—Wölfflin doesn't hesitate to take up the invitation—is with language. French and English, like the Classical and the Baroque, are simply different: both are fully adequate to the world (there's nothing you can't say); each can be the medium of great art; and it would be both foolish and empty to imagine that one is "better" than the other, closer to some "essence" of language, and so on. At the same time, it's obviously a good thing to know what language you are speaking and what language is being spoken by those you are talking to or about; get this wrong and the conversation goes nowhere.

This analogy doesn't seem to help much with Wölfflin's apparent historical claims: it doesn't make sense to think that one language is somehow historically mandated to become another, and so it seems natural to downgrade this side of Wölfflin, to take what appear as claims about how art's history works as nothing more than fairly direct transcription of the actual sequence of Renaissance and Baroque and so devoid of any particular carry beyond those two periods. This would mean, of course, that *The Principles*

of Art History is not really that at all; the subtitle— *The Problem of the Development of Style in Later Art*—turns out to be a much more accurate indication of the book's actual scope and relevance.

As Wölfflin's willingness to take up the linguistic analogy suggests, it is not hard to find statements in *The Principles*—and certainly in a number of Wölfflin's other writings—that suggest he is deeply drawn to this understanding of his argument. Nonetheless, it's easy to demonstrate that it must be wrong, as well as that Wölfflin knows this, and knows it even during his moments of greatest attraction to the position we've just sketched.

Early on in *The Principles*, Wölfflin offers us the exemplary contrast of portraits by Dürer and Hals (figures 9 and 10). The specific contrast he is interested in here is that between linear and painterly, but the pair is fairly striking in terms of all Wölfflin's categories and offers a particularly good shape for the overall contrast between Classical and Baroque.

FIGURE 9. *(left)* Albrecht Dürer, *Portrait of Bernard von Reesen* (1521). Gemaeldegalerie Alte Meister, Staatliche Kunstsammlungen, Dresden, Germany. Bildarchiv Preussischer Kulturbesitz/Art Resource, NY.

FIGURE 10. *(right)* Frans Hals, *Portrait of a Young Man* (1646/1648). Andrew W. Mellon Collection. Image courtesy of the Board of Trustees, National Gallery of Art, Washington.

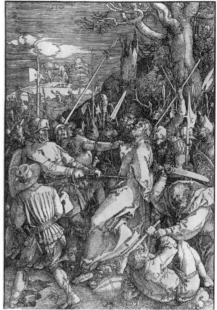

FIGURE 11. *(left)* Martin Schongauer, *The Arrest of Christ* (1470–82). The British Museum, London. © The Trustees of the British Museum.

FIGURE 12. *(right)* Albrecht Dürer, *The Arrest of Jesus Christ* (1510). Bibliothèque nationale, Paris, France/Giraudon/The Bridgeman Art Library.

Much later in the book Wölfflin offers a contrast between Dürer and his very close predecessor Martin Schongauer (figures 11 and 12).

As long we keep these two sets of examples insulated from one another, it will be easy to imagine that Wölfflin is giving us, as it were, a method for sorting images into two discrete piles, one Classical and one Baroque. But the moment we let the two pairs communicate with one another, we see a chain of contrasts—first Schongauaer against Dürer, and then Dürer against Hals. In the second pair, Dürer clearly captures the force of Baroque painterliness against Schongauer's linearity, even as in the first pair all the features just assigned to the Dürer pass over to the Hals. In the one moment Dürer appears as Baroque, and in the other he has become Classical.

What has passed in front of us cannot be reduced to two kinds of images; instead we are witness to a peculiarly dynamic relation, a work of transformation in which it is not possible to say with any certainty who is speaking what language, the division between Classical and Baroque, and all their subjacent contrasts, passing in a sense directly through Dürer's art *itself*. One's hesitation over the word "itself" here reflects the way a given work has suddenly ceased to be a thing one can imagine characterizing adequately apart from any other work and instead appears and is characterizable only in relation to other works.

It's worth underlining several distinct features of this lesson. The first is that the Dürer does not begin as Classical—it only becomes Classical under the impress of the Hals—so our statement that "in the first moment Dürer appears as Baroque, and in the second he has become Classical" is accurate in linking a work's *appearing* to the Baroque and its historical fate to the

Classical. No work appears as (already) Classical; in this sense the Baroque always precedes the Classical and engenders the Classical as an effect.[3]

If we have lost one analogy with language (the idea that Classical and Baroque are simply like two different languages), here we gain a surprising access to a rather different analogy. But for this we need some preparation.

There are a significant number of well-known difficulties in imagining language as a directly human invention: one wants to imagine something like the "first speaker" pointing to the fire in the cave and saying "fire," and then everybody somehow catching on (much as Adam presumably pointed to his first bit of the world and named it). But if this is indeed to be the invention of language, it is hard to see how anyone knows (a) what the first speaker is pointing at (it doesn't have a name to single it out); (b) that the speaker's noise is a word (there haven't been any before); (c) why anyone should imagine there is any relation between the pointing and the noise made; and (d) how anyone has any basis for distinguishing that particular noise from any number of other more or less similar noises the first speaker may or may not make or have made on any number of other occasions that may or may not be or have been similar to this one. In brief, every time we haul up this picture of the first word, we seem condemned to assume that the whole of language is in some sense already in place. We think of such a moment in the same way that we can accurately and directly enough imagine some group of people deciding green lights will mean "go" and red lights will mean "stop." But they can come up with this arbitrary system of conventions because they already have the means of convening themselves. The question about the origin of language is how they came into possession of those means, how they came to inhabit such a universe.

Seeing these difficulties can lead one to prefer thinking of language as something discovered rather than invented.[4] The "first speaker" story becomes very different and rather more complicated, asking us to imagine now two languageless creatures moving across the world when one of them is startled by, let's say, a bolt of lightning striking relatively nearby and emits, in response, a shout of some kind. Several days later, the same two creatures, still languageless and roaming across the world, once again find themselves witness to a lightning bolt, now flashing down less surprisingly or less nearby—leading the one who did not cry out the first time to turn to the other, grinning, maybe gesturing, maybe giving a gentle nudge in the ribs, and repeating quietly that little startled cry. And this, it turns out,

counts as saying "lightning," something the first cry by itself did not do. In the grip of this story, we'll say that the first word—the one "said" on this second occasion, since nothing was "said" on the first—is a metaphor of some kind, repeating what was an expression of fear as an act of nomination, and at the same time it has as its effect the engendering of a literal meaning henceforth available to at least the two of them. It takes a bit of narrative to get this view out, but we in fact invent/discover language in this way all the time—every time the baby's mispronunciation becomes the family's word for the thing, or every time you and I turn a proper name or a phrase found in our shared experience into a general word or phrase for a certain kind of event or person. (For many years in my family, "vovo" was a standard way of designating the television set, and between my wife and me "up on the roof" is a lighthearted way of describing persons or propositions in, so to speak, deep trouble; from time to time we are reminded that we share this euphemism with an indeterminate community of other speakers similarly attached to the relevant joke. Punch lines can be like lightning bolts, just as metaphors can appear closely related to puns.)

The force of this analogy is to suggest that it's less a matter of Classical and Baroque each being like a language than it is a matter of their belonging to each other in something like the way in which meaning—literal and figurative—belongs to language. And much of the force of the analogy may lie in its ability to help one see just how deeply Wölfflin means it when he says that art's history is everywhere transformation, and proposes that such transformation has a specific shape—his preferred image here is a spiral—that makes history less one thing after another and more nearly one thing repeating another (the roots of this figure are, importantly, Hegelian). The analogy also may allow us to notice some features of Wölfflin's argument that he does not himself clearly catch. For example, if we return to our sequence of Schongauer-Dürer-Hals, we may now notice that as we move from the first pair to the second, the Schongauer in fact drops out, becomes invisible, much as the actual expression of sheer feeling that was the condition for its own subsequent transformation into—repetition as—language can be said to drop out in our language story.

Both the dynamic of Classical and Baroque and that of literal and figurative entail the vanishing of a more primitive moment on which they both depend (and which becomes "primitive" only as an effect of their emergence). A certain kind of retroaction is deeply built into both models—and seeing this should help with seeing why for Wölfflin the principles of art history are discoverable above all through a consideration of "later art." To put it at its most extreme: there is for Wölfflin no such thing as "early art" (you don't see what art is by looking at its first instances, which are, in themselves or by themselves, nothing—we may have cried out in shock or surprise on many occasions before one of those occasions become the site of language's discovery).

When you project the Schongauer and the Dürer in the classroom and then click on the remote so the Schongauer goes away and the Hals appears in its stead, where has the Schongauer gone? One tempting answer here is to say that it's gone to another classroom where the conditions of visibility are distinctly different from those of the Wölfflinian art history class. Perhaps it has passed into Panofsky's room next door, and in doing so it has perhaps gained a meaning at the expense of its historical visibility. A more general answer might be that it has gone into the classroom that takes culture rather than art as its object, and if that answer seems worth pursuing, one of its promises may be that it offers a distinct way to imagine the relation between two disciplines distinguishable as "history of art" and "visual culture."

We may feel some discomfort with the thought that the Schongauer, which we know after all to be a work of art, has passed into visual culture. We will probably feel less uncomfortable if we rework our example so that it starts with, say, a medieval altarpiece—which we have some reason to think was cultural before it was art-historical. We may then feel that it is being more nearly returned to its "proper" position, and we may feel that still more strongly when we are asked to think about whether or how an African mask or an Indian temple might be an art-historical object. These are questions we feel, at best, clumsy in front of, not exactly sure what terms or arguments would be relevant to them. The suggestion that we may now be at least abstractly prepared for is that something in our picture of how disciplines have their objects may be responsible for some part of our difficulty.

We are, for example, strongly accustomed to thinking of objects and disciplines as distributed in a kind of intellectual space; the difficult prospect opened here is that disciplines might be distinguished by their temporal relation, by something like their differing tenses. What may be particularly striking in this instance is that terms we typically take to be very intimate with one another—art and culture, where we are likely to think of "art" as being contained in "culture" or perhaps representing its highest instance—now seem suddenly to diverge, to not belong to the same moment or to not share the same conditions of visibility. Where we have tended to think about what space a given object does or does not belong in—say, that of anthropology or that of the history of art—we may now want to find ways to talk sensibly and consequentially about the times of an object's visibility, its historicity.

The suggestion one might take from Wölfflin is that art is structurally "late," coming in one sense always after its own fact even as it also provides

the conditions under which that fact becomes visible. This would be to say that Wölfflin's historical thought is deeply oriented to the modern both as what breaks with or succeeds upon the traditional and as what obliges us to address tradition as such—an obligation we presumably do not feel when we live in the midst of tradition "itself." Of this last we may well be tempted to say that "in a tradition this process of fusion is continually going on, for there old and new are always being combined in something of living value, without either being explicitly foregrounded from the other." What we, moderns, call "tradition" is, by contrast, the consequence of an explicit foregrounding of tradition that our historical consciousness—our modernity—imposes on us: "Historical consciousness," we'll say, "is aware of its own otherness and hence foregrounds the horizon of the past from its own." And having said these things, we may then find ourselves wanting to show that this modern, historical consciousness is "only something superimposed upon continuing tradition, and hence it immediately recombines with what it has foregrounded itself from in order to become one with itself again in the unity of the historical horizon it thus acquires."[5]

The voice we find ourselves speaking in here is Hans-Georg Gadamer's, working through the difference he takes Heidegger to make to the understanding of interpretation, and we've allowed ourselves to drift into it just in order to hear what it does and does not share with Wölfflin's. Among the elements shared we can pick out (1) a general refusal of method in favor of discovering principles for our activity inherent in our grasp or claim on an object; (2) a corresponding recognition that such principled objectivity opens the object to its ongoing historical transformation, with past and present inextricably entangled in our grasp; and (3) a concomitant recognition that our interpretive activity makes sense—is called for—only in relation to a fundamental break with a prior condition. But with this last, the differences also kick in: Gadamer, despite his many differences from Panofsky, holds to the Panofskian notion that successful interpretation amounts to an overcoming of that break, whereas for Wölfflin that break is the inevitable and indefeasible consequence of the conditions under which we have an object at all. For Gadamer what finally and predominantly speaks in us is tradition; for Wölfflin it's more nearly the case that modernity itself becomes general, its difference found wherever we look, the absolute condition of our seeing.[6]

Gadamer is strongly associated with the thought that interpretation is, as is often said, "bottomless"—that is, there is no purely descriptive ground

on which interpretation might securely rest, and everything that might offer itself as such ground will be found to be itself already caught up in interpretation. It's in this light that he appears to offer a certain kind of radical alternative to Panofsky's much more constrained model of interpretation, Gadamer embracing the circularity Panofsky wants to hold at bay. Taking him up here, in the context of Wölfflin's *Principles*, one begins to see that what is actually at issue is not so much the bottomlessness of interpretation as the stability of the line we want to draw between description and interpretation. If we take Gadamer to be telling us simply that "it's all interpretation," we will end up imagining our activity in terms of a particular relation to meaning that will certainly vary somewhat according to how exactly we understand the consequences of Gadamer's argument but that will remain, above all, a relation to meaning. But if we take Gadamer to be saying something not about the impossibility of description but about the impossibility of fixing any line between it and interpretation, then we will realize that he might equally be teaching us something about the bottomlessness or endlessness of description. Seeing this, we may find ourselves compelled to say that the question Gadamer finally opens up is about the relation between the meaning of the object and the fact of its appearing. And this question is evidently the one that fundamentally shapes Wölfflin's *Principles*: "Yet an analysis with quality and expression as its objects by no means exhausts the facts. There is a third factor—and here we arrive at the crux of this inquiry—the mode of representation as such. Every artist finds certain visual possibilities before him, to which he is bound. Not everything is possible at all times. Vision itself has its history, and the revelation of these visual strata must be regarded as the primary task of art history."[7]

The passage we chart as we move in this way from Panofsky through Gadamer to Wölfflin is extraordinarily complex. It's one in which we see the bearing of theory shift from method to principle, the weight of our interest pass from interpretation to description, and the privileged locus of art-historical self-understanding move from the Renaissance to the modern. With this last the shape of art-historical time itself—what, so to speak, counts as "historical," how a term like "Renaissance" or "modern" even begins to mean—shifts as well. If we say that Wölfflin proposes an art history that finds its essential object in art's appearance, then we may also find ourselves both wanting and able to say that he offers a disciplinary model in which the discipline has its own limits as a problem—they too can only ever appear.

A certain interdisciplinarity—a relation to conditions that traverse the field as a whole—might then be one of its essential possibilities: it would be an effect of the terms through which Wölfflin's art history constitutes itself that they engender, at a place that appears both a limit and the heart of that discipline, an object that it is not proper to it, that demands another discipline and another set of principles—we can call this other discipline a version of "visual culture" that would be notably distinct from the "visual culture" that one might imagine as a generalization of Panofsky's iconology. Where a Panofskian turn toward visual culture at least seems to depend on nothing more than an expansion of the field of the given (Panofsky's art history has no constitutive stake in any particular notion of "art'), this Wölfflinian visual culture has everything to do with the specificity of the object that its principles both constitute and derive from, and it offers itself as at once an alternative to, a way on from, and an internal interference with art history "proper."[8] In posing the relation between "visual culture" and "art history" as a matter of conditions of visibility—of the relationship between slides that show and slides that do not show—we are suggesting that Wölfflin's concern for "the mode of representation as such" is not simply one that arises within his art history but one that is constitutive of it and of its relation to its limits.

It should be apparent by this point that Wölfflin places an unusual pressure on the ways we most standardly imagine the general shape of disciplinary knowledge. We've noted, for example, that the picture of fields of knowledge lying more or less alongside one another in some general space doesn't work well here; we've been forced as well to distinguish sharply between "method" and "principle"; and we've been led to phrase the relationship between a field and its limits in unusual and somewhat obscure ways. Some pictures may help us sort through some of this.

This picture is intended to bring out some of the features we ordinarily assume in talking about knowledge. It gives us a subject facing a field of objects that can be divided into kinds, thus giving rise to a series of discrete fields of study. It is, at least at this level, not important how "natural" or "arbitrary" the divisions within the field are, nor is it important how sharply drawn the lines between them are. It is, however, important that there are boundaries, that they are, in principle, distinguishable from the fields they mark off, and that in relation to those fields they mark the particular place where the question of interdisciplinarity arises. Because the subject faces the object, it is possible to raise a question about how the subject is related to that object, about what guarantees there might or might not be that the subject has a good view of it, and so on; these will appear as questions of, above all, method. We've seen, of course, a particular version of this at work in Panofky's constitution of art history and seen how he makes that question of method turn through the particular matter of perspective (a figure whose naturalness is apparent in this picture).

Over and against this, Wölfflin appears to be appealing to an older and much more suspect model of disciplinarity—an Aristotelian model in which "principles" are said to derive from an "object" that those principles also pick out. The suspicion brought crushingly to bear on this model by the emergence of modern science is that it is circular and thus empty.[9] To take a much used and abused example, to explain why opium makes us sleepy by saying that it possesses a "dormitive principle," is to explain nothing at all.[10] A picture for this kind of discipline might look something like this:

This certainly makes explicit the circularity of this kind of "explanation." Particularly coming so hard on the heels of a much more familiar picture, it also invites certain kinds of misreading. We are likely, for example, to take

it that the discipline lies in some sense inside the curving lines that would then demarcate its boundary, but that's clearly wrong (those lines just are the field). We are likely also to take those lines as the means by which object and viewer or subject are attached to one another, but that's also and equally clearly wrong (the viewer or subject is a precipitate of those principles and has no existence apart from them). In fact, there's nothing in this diagram that really answers very well to what we would want to call "the outside" of the field—nothing that answers to our comfort with saying that any one of the fields represented in the earlier diagram lies both outside and along-side another. There's a strong sense in which we would be right to say that outside of the movement there is nothing, and most particularly there is neither subject nor object. But we would be right also to say that it is distinctly a delimited field and that "outsidedness" is not foreign to it. The problem is that we don't find that outsidedness where we usually look for it. We get closer, perhaps, to what we want to say here if we turn ourselves at, so to speak, right angles to the diagram and say that "the outside" just is the white page or ground on or against which object and principle emerge. This at least offers to get at the way in which the limits of a field of this kind are not localized as its edges but are a continuous feature or dimension of it, a condition of its appearance.

If these pictures get the general shape of Wölfflin's activity about right, we will no doubt have further questions about its details; in particular, we will want to know what, if anything, saves it from sleepy triviality. But before launching ourselves back into Wölfflin's text, we might draw at least two preliminary morals.

The first is that arguments that pass back and forth across these two highly general pictures of knowledge will be prone to various forms of misreading and misunderstanding. For example, if we are committed to the first picture, we will tend to see people hewing to the second as offering a peculiar, prob-ably untenable, license to subjectivity (and those people will, in turn, genu-inely not know what we are talking about—subjects in the relevant sense do not exist for them). Conversely, if we are committed to the second picture, we will see people operating in the first as engaged in an activity that will strike us as both senseless and deeply peculiar (we'll feel as if they imagine themselves acting in a place they cannot possibly occupy, a place somehow both outside of the world and nonetheless having it in view, Mars perhaps), and we'll be able to make some kind of peace with them only when we find

ourselves able to understand their detachment in more worldly terms (as, for example, a peculiar mode of attachment). These are two different kinds of pictures. They do not show what they show in the same way.

The second moral is much more briefly stated: at least in Wölfflin's case, it looks hard, if not impossible, to pry what the formalist knows apart from how it is known.

APPEARING

In focusing the first part of this chapter on questions about the disciplinary shape and implication of Wölfflin's *Principles*, we have somewhat skirted the directly visual emphases that undergird the description of his art history as "formalist." In this register Wölfflin offers first of all a vocabulary intended to enable a certain level of description—the well-known pairs linear/painterly, planar/recessive, closed/open, multiplicity/unity, and absolute/relative clarity. In each instance the first term of the contrast offers to open up an aspect of the Classical and the second the corresponding aspect of the Baroque. Wölfflin also offers a general characterization of the underlying sense of these linked contrasts—the Classical terms reflect a tactile or haptic orientation to things as opposed to the Baroque orientation to the optical. As he puts it, in one mood, "They are two conceptions of the world, differently orientated in taste and in their interest in the world, and yet each capable of giving a perfect picture of visible things."[11] Statements of this kind—the kind that suggest Classical and Baroque stand to one another as French and English do—can frequently be countered by other statements elsewhere in the book that either invite other analogies for their relationship (like "literal" versus "rhetorical') or raise a question of "value" that sits uneasily at best with the claim that the two representational modes are equally adequate to the world. Some of these moments of self-contradiction or uneasiness are right on the surface, inviting us to play one formulation off against another. Others are a bit more buried, at work within single sentences or paragraphs, and to a degree dependent on the reader's capacity to catch the force of some particular formulation—as, for example, when he writes in discussing the various aspectual transitions from Classical to Baroque, "The transition from tangible, plastic, to purely visual, painterly perception follows a natural logic, and could not be reversed. Nor could the transition from tectonic to a-tectonic, from the rigid to the free conformity to law."[12] The last phrase

here—"free conformity to law"—is an all but direct quotation from Kant on the beautiful, and when one registers that note in the passage (no doubt reinforced both by the earlier invocation of the "purely visual" and by a more obscure sense that painting and the painterly are tied up in all this), one will likely feel that the tactile and the optical are not simply equally valid alternatives but that the optical has a certain aesthetic privilege for Wölfflin—that a "more visual" visual art is better than a "less visual" visual art. But of course one will also wonder what "a 'more visual' visual art" really is. Are we supposed to think that one painting might be more visible than another? Don't we always see all there is to see?

Some of Wölfflin's sentences and paragraphs can feel as if they are almost wholly driven by these kinds of contradiction or uncertainty. Take for example this paragraph:

> Let us try to sift out these basic forms in the domain of more modern art. We denote the series of periods with the names Early Renaissance, High Renaissance, and Baroque, names which mean little and must lead to misunderstanding in their application to south and north, but are hardly to be ousted now. Unfortunately, the symbolic analogy bud, bloom, decay, plays a secondary and misleading part. If there is in fact a qualitative difference between the fifteenth and sixteenth centuries, in the sense that the fifteenth had gradually to acquire by labor the insight into effects which was at the free disposal of the sixteenth, the (classic) art of the Cinquecento and the (baroque) art of the Seicento are equal in point of value. The word classic here denotes no judgment of value, for baroque has its classicism too. Baroque (or, let us say, modern art) is neither a rise nor a decline from classic, but a totally different art. The occidental development of modern times cannot simply be reduced to a curve with rise, height, and decline: it has two culminating points. We can turn our sympathy to one or to the other, but we must realize that that is an arbitrary judgment, just as it is an arbitrary judgment to say that the rosebush lives its supreme moment in the formation of the flower, the apple-tree in that of the fruit.[13]

Some of this perhaps stands now in sharper relief than it might have on first reading—Wölfflin's deep unhappiness with the very idea of a "period," and maybe also the ease with which he is willing to gloss "Baroque" with "modern." The main thrust of the paragraph is easy enough to pick out and paraphrase: while it is true that the sixteenth century can do some things the fifteenth

couldn't just because the fifteenth century worked through those things, this doesn't make sixteenth-century art better than fifteenth-century art.

But that paraphrase doesn't get at how Classic and Baroque play into the argument or enter into the sentence towing "value" along with them. When we try to add that into our understanding of the sentence, then the bit about the sixteenth century standing, familiarly enough, on the shoulders of the fifteenth seems no longer exactly to the point. It's what doesn't hold together here that then seems to produce the immediately following sentences—the first saying, evidently, that "Classic" implies no particular value, because Baroque can be Classic too (but of course here "Classic" precisely is a value), and the next sentence proceeding to break apart the very things its messy predecessor had tangled together, the Baroque suddenly no longer having in any sense its classicism but being "a totally different art."[14] It's just not clear what Wölfflin means here; the paragraph seems driven by a thought it perhaps enacts or betrays but does not manage to state. Jean-Luc Nancy can seem to be struggling with the same point when he writes, in "The Vestige of Art," "The history of art is a history that withdraws at the outset and always from the history or historicity that is represented as process or as 'progress.' One could say: art is each time radically *another art* (not only another form, another style, but another 'essence' of 'art'), according to its 'response' to another world, to another *polis*; but it is at the same time each time *all* that it is, *all art* such as in itself finally . . ."[15]

Wölfflin's next paragraph returns to the question of periods and eventually works its way back to what must be his core point about such historical shapes as "periods" and must also be central to the previous paragraph's struggle with itself: "Of course, in the strictest sense of the word, there is nothing 'finished': all historical material is subject to continual transformation; but we must make up our minds to establish the distinctions at a fruitful point, and there let them speak as contrasts, if we are not to let the whole development slip through our fingers."[16] This surely is what Wölfflin most fully means, and seeing that is useful in diagnosing the earlier paragraph's difficulties: as if a particular picture of what a period and a style must be interferes with his ability not only to lay out what he means but also to say why it matters, what kind of stake informs history understood this way. But one may also feel that although this helps explain the difficulties the remarks about the fifteenth and sixteenth centuries got into, there's still something to be caught about the particular turns that express that difficulty (we may

have a better view of the difficulty and so a better view of the terms at play in it, but there's something about how just these sentences express that difficulty that continues to elude us).

Here a quick glance in what may at first seem a rather surprising direction—toward the poet Friedrich Hölderlin, and particularly his famous letter to his friend Casimir Ulrich Böhlendorff—may help snap Wölfflin's difficult sentences into focus:

> We learn nothing with more difficulty than to freely use the national. And I believe that it is precisely the clarity of presentation that is so natural to us as is for the Greeks the fire from heaven. . . .
>
> It sounds paradoxical. Yet I argue it once again and leave it for your examination and use: in the progress of education the truly national will become the ever less attractive. Hence the Greeks are less master of the sacred pathos, because to them it was inborn, whereas they excel in their talent for presentation, beginning with Homer, because this exceptional man was sufficiently sensitive to conquer the Western Junonian sobriety for his Apollonian empire and thus to veritably appropriate what is foreign. . . .
>
> Yet what is familiar must be learned as well as what is alien. This is why the Greeks are so indispensable for us. It is only that we will not follow them in our own national [spirit] since, as I have said the free use of what is one's own is the most difficult.[17]

The first question, really answerable only by ear, is whether one can indeed hear this passage at work within Wölfflin's. An affirmative answer will turn to some degree on Hölderlin's repeated "free use" in relation to Wölfflin's "free disposal," on some recognition that Hölderlin's linkage of that phrase to "the national" and Wölfflin's use of it in relation to periodicity are looped through each other (so the Greek and German in Hölderlin are also ancient and modern, just as fifteenth and sixteenth centuries in Wölfflin are also south and north[18]) and a broader recognition of a rhythm or periodicity common to their central sentences.

Hölderlin is a complex case—a pivotal figure at the origins of both German romanticism and German idealism, student friend of Hegel's, incarcerated for mental illness most of his long life, and recovered for German literary history only in the twentieth century. Wölfflin certainly belongs to his early audience, as does Martin Heidegger. Heidegger and his followers have made much of the passage we've quoted. That passage gives voice to one deep motif in Hölderlin—the thought that one discovers home only in mov-

ing away from it, because at home one's home is in some sense concealed from oneself (the Greeks' being outwardly what the Germans are inwardly can discover to the Germans what they, on their own, cannot know but can only be). And this is a motif that can seem to be enacted also in Dürer's movement back and forth over the Alps—as if Italy was what allowed Dürer to return to a place he had never been. Or should we read these journeys as Panofsky does, with Dürer as the means though which southern humanist culture establishes and in a certain sense perfects itself in the north? The question alone is enough to give us a strong sense of what was at stake for Panofsky in recapturing Dürer from Wölfflin (and so also why and how Dürer repeatedly shows up at crucial moments in such key early essays as "Perspective as Symbolic Form" or "The History of the Theory of Human Proportions . . .").[19]

Does this long excursus help us with the questions we've been trying to raise about the visual in Wölfflin and the deep shape of his formalism? Does Wölfflin perhaps think that vision works like this—that seeing is, say, a continuing "return" to a place one has yet to inhabit?

Wölfflin's fullest glosses on tensions that structure his object suggest that he does indeed think something of this sort:

> We must go back to the fundamental difference between draughtsmanly and painterly representation as even antiquity understood it—the former represents things as they are, the latter as they seem to be. This definition sounds rather rough, and to philosophic ears, almost intolerable. For is not everything appearance? And what kind of a sense has it to speak of things as they are? In art, however, these notions have their permanent right of existence. There is a style which, essentially objective in outlook, aims at perceiving things and expressing them in their solid, tangible relations, and conversely, there is a style which, more subjective in attitude, bases the representation on the *picture*, in which the visual appearance of things looks real to the eye, and which has often retained so little resemblance to our conception of the real form of things.[20]

We have a habit of thinking of progress in knowledge as involving a continuing passage beyond mere appearance that moves us ever closer to the real state of things. Wölfflin seems, in marked contrast, to be suggesting that art is motivated by the felt need to get past our knowledge of the world and, as it were, back to mere appearance, which has also not yet happened or which

we have not yet found our way to inhabit: "A more developed art has learned to surrender itself to mere appearance. With that, the whole notion of the pictorial has shifted. The tactile picture has become the visual picture—the most decisive revolution which art history knows."[21]

We may remain—Wölfflin himself evidently remains—a bit undecided whether this "revolution" is a particular event within a larger history of art (a revolution like the one in France or the one that was to deliver us from capitalism) or is in fact the permanent object of art history, what it finds wherever it looks, the revolution of a wheel that does not cease turning. It's worth reading the whole of the paragraph that Wölfflin produces as a gloss on the assertion just quoted:

> Now we need not, of course, immediately think of the ultimate formulations of modern impressionist painting if we wish to form an idea of the change from the linear to the painterly type. The picture of a busy street, say, as Monet painted it, in which nothing whatsoever coincides with the form which we think we know in life, a picture with this bewildering alienation of the sign from the thing is certainly not to be found in the age of Rembrandt, but the principle of impressionism is already there. Everybody knows the example of the turning wheel. In our impression of it, the spokes vanish, and in their place appear indefinite concentric rings, and even the roundness of the felly [rim] has lost its pure geometric form. Now not only Velasquez, but even so discreet an artist as Nicolas Maes has painted this impression. Only when the wheel has been made indistinct does it begin to turn. A triumph of seeming over being.[22]

The English translation both suppresses some notable features of the German text and places in still greater relief the relation between the revolution that constitutes art history's object and the revolving wheel as a paradigmatic painterly object.[23] Between the German and the English one knows exactly neither where to stop reading nor how to continue, as if just here one is at the very heart of a complex figurative knot outside of which Wölfflin's art history is unthinkable, objectless. One can think of this knot as composed of several interlacing circles—one described by the play between things as they are and things as they appear, one described by a quasi-Aristotelian disciplinary movement from object to principles and back, and one linked to the loosely Hegelian thought of history as spiraling repetition. One may also want to think of the interlacing of these circles as what keeps any one

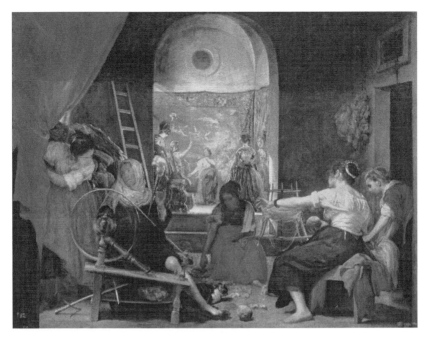

FIGURE 13. Diego Rodríguez Velázquez, *The Spinners, or the Fable of Arachne* (1657?).
Museo del Prado, Madrid, Spain. Scala/Art Resource, NY.

of them from being merely circular and closed on itself, thus defining the essential structure and limits of art-historical showing.[24]

If we return now to the particular linguistic analogy that proved productive earlier, we will be tempted to say that there is a strong sense in which this knot is, in effect, the consequence of what Wölfflin implicitly takes as the deep rhetoricity of vision, a continual passage within it between what in language we distinguish as the literal and the figural. Presumably the background imagination here would be of a purely animal vision that neither knows its objects nor worries about their appearance. The theory that we, both following and pushing the *Principles*, seem committed to is that we get to literal vision—seeing things as they are—only by virtue of a prior figurative moment ungraspable as such in its moment of first appearance. Just as our theory of language says there is not, in the first instance, a literal language that later gains a certain rhetorical capacity, so our Wölfflinian theory of vision says there is not first of all a literal seeing that subsequently gains some further capacity not essentially linked to it. In each case, we will want to say that what we take to be prior is in fact an effect of what seems

to follow: human seeing "begins" with painting, the way "lightning" begins with its poetic announcement. And of course we may suspect that this is no longer simply a matter of analogy—we may now want to say that human seeing is vision under the condition of language, is the seeing proper to a being that speaks, and that art's special knowledge is of that fact. What the formalist—Wölfflin, in any case—knows is that art appears.

EXPERIENCE

In an often-cited essay from 1960, the critic Clement Greenberg offered a general account of his position on modern art, and more particularly modernist painting. The position is widely and appropriately understood as "formalist," both in the sense that is strongly oriented to the visual dimensions of the work of art and in the sense that it places critical judgment squarely in the foreground. Greenberg's formalism has, on the face of it, little to do with Wölfflin's. Wölfflin is mentioned once relatively early in Greenberg's writings (the reference does little more than mark the occasion of the art historian's death in 1946), and there's some reason to think Greenberg may have looked again at Wölfflin in the early 1960s, but beyond the shared opposition between the optical and the tactile, there's little evidence of any crucial influence from, sustained engagement with, or even any continuing interest in Wölfflin. "Modernist Painting" does make an argument about the difference between Modernist and "Old Master" painting that can seem in some ways reminiscent of what we've seen in the *Principles*—"Whereas one tends to what is in an Old Master before one sees the picture itself, one sees a Modernist picture as a picture first"[25]—but the relation is loose at best, and the formulation here particularly flat-footed. This flat-footedness troubles the essay throughout in a variety of ways—for example, this particular sentence is immediately followed by a considerable qualification: "This is, of course, the best way of seeing any kind of picture, Old Master or Modernist, but Modernism imposes it as the only and necessary way, and Modernism's success in doing so is a success of self-criticism."[26] "Self-criticism" as it figures here is the presiding term for the essay as a whole. As Greenberg famously puts it in the opening paragraph: "I identify Modernism with the intensification, almost the exacerbation, of this self-critical tendency that began with the philosopher Kant. Because he was the first to criticize the means itself of criticism, I conceive of Kant as the first real Modernist."[27]

The essay draws a sharp distinction between external criticism and self-criticism, and takes it that the essential drive of self-criticism is toward a "purification" of whatever practice engages in it. In the case of painting, this, Greenberg believes, leads it to orient itself above all to the flatness that defines it over and against every other art. By 1960, Greenberg's influential account was already beginning to be the object of what eventually became sustained criticism on a variety of grounds, most notably its presumed "reductionism." More importantly for us, it was also beginning to undergo its own internal crisis, largely set off by Frank Stella's Black Paintings of the previous year, which were to prove massively significant both for the course of American art in the 1960s and for Greenberg's criticism.

The reference to Kant is worth pausing over, because it is one of a number of such remarks that play into the common characterization of Greenberg's position as a specifically "Kantian" formalism. But where Wölfflin's "free conformity to law" is in fact a direct, if concealed, citation of Kant on the beautiful, Greenberg's reference is not to the *Critique of Judgment* but to the *First Critique* with its assertion that ours is peculiarly an age of criticism in which all modes of thought—and most notably reason itself—are called to self-examination in order to secure their claims. This means, among other things, that "criticism" as Greenberg uses it here does not connect so much with the *Third Critique*'s claim that of taste there can only be criticism and not a theory[28] as with the very different sense of criticism as precisely the submission of one or another claim to explicit standards of argument or proof (this is presumably why Greenberg later in the essay links "self-criticism" to "scientific method"). It's clear that Greenberg means us to take "self-criticism" as something other than criticism in this sense—it is said to be "immanent," to work from "the inside," and to do so "through the procedures themselves of that which is being criticized"—but his control over this contrast seems at best intermittent. And this means that his control over crucial terms grammatically linked to "criticism" and "self-criticism" in the essay suffers from the same intermittence. A particularly important instance is the word "standards," which moves back and forth between naming something like a set of rules or criteria, and meaning (as, it is tempting to say, it both must mean and does not quite manage to unequivocally mean in the essay's closing sentence[29]) just those exemplary and theoretically unmasterable works that are art's history and its only standards. What's at stake here is something Greenberg most usually refers to as "the experience of art."

This is most often and directly in Greenberg what we have before a work of art—what something claiming to be a work of art either offers or fails to offer to its viewer. But it might also be taken as—and Greenberg sometimes strongly advances it as—something the work itself might be said to have (or not have); this is evidently how it means it in the important early essay "Avant-Garde and Kitsch," when he writes that "kitsch is vicarious experience and faked sensations,"[30] as if the work itself claimed to have lived something it has in fact not lived or claimed to make its own something it has in fact never had. These two formulations offer significantly different ways of defining experience, and the second is the more difficult insofar as it evidently takes it that what befalls one might not be experience apart from one's owning of it. These are the fundamental stakes beneath the crisis of Greenbergian formalism; they are visible in Greenberg's writings from the outset, and those writings mean to alert us to the possibility of such a crisis (that we no longer know what to make of our experience, do not know well what counts as experience) even as they also play their own part in precipitating it (that is, they have from the beginning a way of forgetting or misphrasing the fundamental intuitions they draw on).

Reprinting "Modernist Painting" in 1978, by which time Greenberg was firmly situated in the contemporary art world as the old demon still not fully suppressed and so still fighting back, he felt compelled to add a postscript, which reads in part:

> I want to take this chance to correct an error, one of interpretation and not of fact. Many readers, though by no means all, seem to have taken the "ratio-nale" of Modernist art outlined here as representing a position adopted by the writer himself: that is, that what he describes he also advocates. This may be the fault of the writing or the rhetoric. Nevertheless, a close reading of what he writes will find nothing at all to indicate that he subscribes to, believes in, the things that he adumbrates. (The quotation marks around *pure* and *purity* should have been enough to show that).[31]

As self-justification this is, at best, disingenuous. It is simply true that Greenberg was both as a critic and, by all evidence, as a person fiercely prescriptive. It is nonetheless also true that for much of his career Greenberg tried to draw a sharp distinction between his judgments and the various forms of larger historical or theoretical sense he thought they could bear; the former were presumably things he would stand by and the latter defen-

sible only insofar as they remained responsive to the judgments that blazed a trail they were obliged only to follow. As a practical matter, it's hardly surprising that the barrier between these two eventually broke down; one might even find the ambition to make judgments without inheriting the sense one makes of them humanly peculiar.

What makes this postscript worth attending to is the way Greenberg moves to lay the blame for his misunderstanding on something he calls "the writing or the rhetoric," as if it were a matter of something he had done wrong or could at least have done better. But he then immediately (and not terribly surprisingly) about-faces and lays the blame, with increasing vehemence, on the reader's failure to attend to his text. These are maneuvers sufficiently familiar to anyone who has ever been caught up in his or her own moments of self-justification or denial as not to need any particular explanation—instances of what Freud calls "the logic of the kettle"[32]—but that should not wholly blind us to the things Greenberg is right about. He's right, for example, that *pure* and *purity* are regularly written within quotation marks. He's right also when he says, somewhat later in his postscript, that he never exactly meant "flatness" as an aesthetic criterion; the qualifications are right there in "Modernist Painting."[33]

Is there then no problem with "the writing or the rhetoric," just a lot of lazy readers? And what about those quotation marks on *pure*? Is it enough to say that readers have not adequately attended to them, or do we have to ask what equipment, if any, Greenberg has provided his readers that would permit them to attend to them in an appropriate and consequential way? Do we have to ask how far Greenberg himself has attended to them and in what way? These are the kinds of quotation marks that are generally referred to as "scare quotes,"[34] and at least some part of what that means is that we do not know exactly what they mark. Greenberg might be citing a sort of generalized modernist discourse, and then we'd probably want to know why such citation is not a deeper and more sustained feature of his writing. He might be ironizing the term, and then we'd probably want to know where he stands when this term is subject to such treatment. He might be using these marks to keep the reader from asking questions about the word they contain (they mean to scare you off), or he might be using them because he does not know whether or how he means the word inside them (and so he's the one who is scared).

When we look over this range of choices, it is deeply tempting to see these

quotation marks as marking—being precipitated out of—a more general rhetoricity that Greenberg's writing finds itself able to neither adequately acknowledge nor simply evade. Surrounding *purity*, they would be at once essential to what Greenberg means to say (that is, he does not mean *purity*) and the alibi for his failure to say what he does mean.

What we've been loosely tracking as tensions internal to Greenberg's writing open out in the late 1960s into a particularly complex knot in the writings of a figure often seen as Greenberg's closest follower but who is in many ways also his sharpest critic. Michael Fried's 1967 essay "Art and Objecthood" is widely (and rightly) read as an assault on a particular strand of art emergent in the United States in the 1960s and now most often referred to as "Minimalism." But in being that, it is also a particular internal argument with Greenberg. The connection between the two arguments is difficult and crucial.

At the outset, Fried picks out the general body of work he means to address by listing a number of then-current designations—Minimal Art, ABC Art, Primary Structures, and Specific Objects—and then moves to offer his own designation, "literalist art." He offers no particular justification for this phrase, and most readers are tempted to connect it to the argumentative fabric of the essay in a number of presumably overlapping ways. It is, for example, introduced hard on the heels of an opening characterization of the work in question as "largely ideological," seeking "to declare and occupy a position—one that can be formulated in words and has in fact been so formulated by a number of its practitioners";[35] "literal" taken in this light would be very close to "literary," a standard Greenbergian way of describing a certain kind of artistic failure endemic to modernism in the visual arts (Surrealism would be the prime instance of a body of artistic work undone by an essential literariness). But this declaring and occupying of a position turns out, as the essay unfolds, to describe what Fried takes to be a major feature of the work utterly apart from the formulations with which the artists may also have surrounded it: Minimalist work is, Fried and the artists agree, characterized to a high degree by the simple fact of its taking—claiming—a place in the gallery such that the work presents itself as the center of a situation, and here "literal" would seem to capture the blunt, obdurate, more or less opaque presence of an object that apparently means to be nothing more or other than an object. Readers may come to feel that Fried's usage is also motivated, or at least justified, by what he sees as a cer-

tain literal-mindedness in its practitioners; this is somewhat harder to pin down, but one might note, for example, the way they seem to feel that "anthropomorphism" in sculpture can be avoided simply by making things that don't look like (don't physically remind us of) people; Fried clearly takes this as a sort of literal-minded failure to understand what anthropomorphism is and why it might or might not represent a risk or threat for sculpture. This very particular charge can be linked up to a larger worry that runs all through the essay. Early on, he puts it this way: "From its inception, literalist art has amounted to something more than an episode in the history of taste. It belongs rather to the history—almost the natural history—of sensibility, and it is not an isolated episode but the expression of a general and pervasive condition. Its seriousness is vouched for by the fact that it is in relation to both modernist painting and modernist sculpture that literalist art defines or locates the position it aspires to occupy."[36]

Fried doesn't do anything further in the essay with this passage's pause between "history" and "natural history," but we may be tempted to take a natural history to be one in which experience is somehow natural, thus given and not in need of any particular having. This notion of literalism as a kind of sensibility returns later in the essay in a particularly interesting form: "Literalist sensibility is, therefore, a response to the *same* developments that have largely compelled modernist painting to undo its objecthood—more precisely, by the same developments *seen differently* . . ."[37] The clear invitation here is to imagine two artists walking through the same museum (we can probably be even more concrete here: walking through New York's Museum of Modern Art in particular), taking in the same works, and yet one of them is taking them in somehow wrongly. That wrongness will result in, or be continued as, her making the work that "Art and Objecthood" attacks. "Literalism" would be a name for that wrongness, both in the work and in the encounter with the work in the museum.

If we adjust the picture just a bit—imagine our two artists now not in the museum but reading Clement Greenberg's criticism—we'll be tempted to say that they make a certain kind of reading mistake: they take Greenberg literally. And with this our focus in the essay shifts and sharpens, and we begin to see how the attack on a particular strain of art is necessarily an attack also on Greenberg—as if literalist art forced into visibility a fault line running through Greenberg's writings, sometimes appearing as a problem with Greenberg's "theory" and sometimes as a problem in its expression.

The way in which "Art and Objecthood" has both Minimalism and Greenberg in joint critical view is perhaps nowhere more clearly signaled than in the text's generally approving citation of Greenberg, to which is then appended an extended footnote that voices "certain qualifications" that are, in fact, absolutely fundamental and amount to the assertion of a deep break with Greenberg.

When we get the argumentative scope of the essay right in this way, a number of its most prominent features come much more clearly into view. One might instance in particular its fundamental reliance on nothing more than Fried's own experience of the work and his implicit playing that off against something Tony Smith offers as an account of an experience formative for his art; here the argument is evidently about what in fact counts as an experience—what it is or means to have an experience, what it might be or mean to fail to have one's own experience. But these are also exactly the terms Greenberg had put in play in his early writings, and they are terms one can imagine as deeply at stake in the activity we call "reading Greenberg," particularly as it is given flesh in the unusually complex act of criticism "Art and Objecthood" is.

It's not to our purpose here to pursue this reading in any further detail. It's enough for us to take away a couple of points that seem to knit up fairly closely with what we've also seen in Wölfflin: first, that there is a rhetoricity deeply at work within our encounters with works of art, and second, that this imposes a certain complexity on our imaginations of art's history such that it is always possible to find ourselves standing wrong way round within it, closed to art's appearing and so also closed against the ongoing work of transformation that is art's historical being. We can be insured against such risk only at the cost of our actual object, and we are accordingly obliged to the full difficulty of our modernity. We've seen Jean-Luc Nancy providing a sort of gloss on these issues in Wölfflin; here it may be useful to hear a bit of Stanley Cavell, Fried's closest intellectual interlocutor in the 1960s: "When there was a tradition, everything which seemed to count did count. (And that is perhaps analytic of the notion of 'tradition.') . . . The [modernist] problem is that I no longer know what a sculpture is, why I call *any* object, the most central or traditional, a piece of sculpture."[38]

A second remarks puts in the starkest possible terms what it is to take fully seriously the further thought that our access to art's appearing does

not go apart from the hazarding of our words and experience. The critic, Cavell writes, is

> part detective, part layer, part judge, in a country in which crimes and deeds of glory look alike, and in which the public not only, therefore, confuses one with the other, but does not know that one or the other has been committed: not because the news has not got out, but because what counts as one or the other cannot be defined until it happens; and when it has happened there is no sure way he can get the news out; and no way at all without risking something like a crime or glory of his own.[39]

ENVOI

This exploration of formalism has turned out to be also an investigation into a distinctively modernist objectivity that is significantly vexed and difficult. The difficulties here are neither merely academic nor methodological; on the accounts we've explored they are difficulties in experience—in our capacity or willingness for it, our expressive or writerly patience with it—and they are deeply bound up with the conditions of art's appearance. One outcome of this may then be a further question about whether our current imagination of the circumstances of art and theory alike as "postmodern" works more nearly toward a fuller acknowledgment of such objectivity or as a mode of its dissolution.

The Spectator

RIEGL, STEINBERG, AND MORRIS

Although recent decades have witnessed a steady decline of interest in formalist art history, there has been a corresponding and ever-increasing interest in a cluster of themes including vision, the gaze, perspective, and the spectator's relation to the work of art—all of which were the very stuff of the early formalist art history of Riegl and Wölfflin. It is the aim of this chapter and the next to bring out the continuities between the work of the founders of the discipline and more recent debates without, of course, ironing out their differences. One strand of writing on this topic focuses on the invention of perspective and its effects on the viewing subject, and that tradition is the subject of the next chapter. In this chapter we open for reconsideration another tradition, which takes its lead from Hegel's phenomenology of the spectator's relation to the work of art. At one point in his *Aesthetics: Lectures on Fine Art*, Hegel figures the spectator's experience of the work of art in terms of the different perceptual and affective relations one has to sculpture and painting. According to him, sculpture attained its peak of perfection long ago in classical antiquity. Its subsequent demise as the leading edge of artistic development had to do with the particular conception of objectivity it embodied: "The statue is predominantly independent on its own account, unconcerned about the spectator who can place himself wherever he likes."[1] Hegel clearly had in mind something like the *Venus de Milo*, which might well be described as "self-reposing, self-complete, objective."[2] Elsewhere this summit of beauty is described as "reserved, unreceptive." Even more bluntly he declares, "It leaves us moderns somewhat cold." [3] Painting, for Hegel, implies a quite different sense of the mind's relation to its objects. Its representations are pure appearances that have no independent existence. Yet precisely because of this seeming insufficiency, the spectator is bound up with it all the more closely. "The spectator is as it were in it from the beginning, is counted in with it."[4] Here we might think of the implied spec-

tator of perspective or of Rembrandt's trembling colors, his fleeting effects of light and shade, and also the way his depicted figures often return the spectator's gaze.

If the statue is regarded as predominantly independent, complete in itself and unconcerned about the spectator, then painting, having a far less substantial, merely virtual existence, appeals to spectators by assuming or demanding their presence and sometimes even their imaginative participation. In short, painting involves, for Hegel, the recognition of the mind-constituted nature of our objectivity, and it offers an occasion for reflecting on it. As Michael Podro makes clear, this recognition carries with it a new sense of freedom, because "for Hegel it was an essential part of that freedom for the mind to break out of its isolation, the isolation of pure thought confronting the alien world of matter." It is in the nature of mind to feel constrained or oppressed "unless it can reach out into the world, unless it can unite thought with the material world."[5] This view contrasts sharply with the traditional idea that only in the exercise of reason can we be free from natural determination and sensuous attachments. Hegel's philosophy of art gives it an important role in the project of human liberation.

ALOIS RIEGL

No one has done more to develop Hegel's striking formulation of this distinction, between works of art that contrive to appear complete "in themselves" and those that are "for others," than the Viennese art historian Alois Riegl.[6] He pioneered a way of thinking about the axis of the spectator's relation to the work of art and the historical evolution of that relation based largely on Hegel's aesthetics. As we shall see, writers who have more recently reflected on these themes, such as Leo Steinberg in his essays on Picasso's *Demoiselles d'Avignon* and *Las Meninas*, refer to Riegl's example, especially his book *The Group Portraiture of Holland* (1902). Yet Reigl's earlier work also turned on this crucial distinction.

The emphasis on the relation between the work or art and the spectator in Riegl's work is bound up with his theory of the *Kunstwollen*, or artistic will, which describes different fundamental assumptions people make about the mind's relationship to its objects. In some cases, as with ancient Egyptian art, for example, the art object is conceived as wholly self-contained and independent, an ideally autonomous object. Other art forms, however,

such as Impressionist painting, display only shifting semblance, sheer visual appearance. The *Kunstwollen* defines what kind of configuration people find satisfying, and this changes from culture to culture and over the course of history. Riegl's celebrated detailed descriptions of particular works are always made in relation to his sense of a "formal strategy" that includes both the visual appearance of the work and, where relevant, the depicted subject. Riegl's formalism, then, does not yield a neutral, empirical description of what is depicted but rather a verbal picture of the work that reveals it as manifesting a particular way of viewing the world or a certain aesthetic sensibility.[7]

SURPRISINGLY, THE IDEA OF an artistic will was first formulated in the context of the "decorative" arts. In his first book, *Problems of Style* (1893), Riegl engaged in debates concerning the genesis of ornamental motifs. He argued strenuously against the view that the origin of the zigzag pattern on ancient pottery is to be traced back to a happy accident that occurred when different colored grasses were woven together. On the contrary, the characteristic geometric pattern tells us a great deal about the aesthetic feeling of the people who made it and, more generally, about how they framed their relationship to the world. On the same grounds, Riegl also contested the view that the imitation of nature had much to do with the appearance of new motifs; he showed how the ubiquitous acanthus leaf pattern was originally a simple lotus motif that was elaborated over generations. Ornament was thus deemed to have an autonomous history driven by certain principles of design.

The implications of this debate can be clearly seen in the case of architecture: if, as was claimed by some contemporary theorists of architecture, it is true that form is dictated by technology and function, then architecture lacks meaning and a history other than the history of technology. Materialist approaches to style give it a casual explanation, rather than an interpretation that would link it to peoples' most fundamental concerns and attitudes.[8] Quite obviously different conceptions of objectivity are at stake here.

THE IDEA OF THE *Kunstwollen* was fully elaborated in Riegl's *Late Roman Art Industry* (1901), where the concept has another resonance. The art of the Hellenistic, late Roman, and early Christian periods was generally regarded as symptomatic of the cultural decadence of the Roman Empire brought

about by barbarian invasions. Yet if, as Riegl maintained, the art of each period of art's history has a distinctive *Kunstwollen*, the notion of decadence loses its purchase. Instead of contrasting late Roman art unfavorably with art of classical antiquity, Riegl searched for a positive aesthetic governing its style. Since he thought that architecture, sculpture, painting, and crafts were all subject to the same aesthetic intention, the *Kunstwollen* had to be defined in highly abstract terms: "the appearance of objects as form and color in the plane or in space."[9] Riegl held that transformations of these highly formal characteristics of art could be attributed to shifts in a people's sensibility or their worldview, driven by an immanent dialectical movement.

Riegl's formalism was partly dictated by the fact that iconographic motifs have only a marginal place in architecture and craft and so cannot be considered fundamental or essential to the visual arts in general. What is essential has to do with the way art figures the mind's varying relation to the world, and this is best indicated by the way in which motifs are taken up and treated. He invented terms for describing these basic relations, summed up in the distinction between the *haptic* (or tactile) and *optical* modes of representation. In the early stages of art's history, he proposed, people had a defensive relationship to a hostile nature, and so their ideal, aesthetically satisfying, perceptual relation to the world was realized in art that kept objects tightly controlled within definite boundaries. Riegl regards the *Kunstwollen* determining ancient Egyptian pyramids, and art of the period generally, to be the creation of self-contained objects surrounded by space conceived as a void.[10] To put it another way, this artistic will aimed to represent something approaching Kant's unknowable "thing-in-itself," that is, a thing as it might be thought to exist prior to any perception or cognition of it. This was, of course, an impossible ideal. Nevertheless, there are certain configurations that contrive to look absolutely self-contained. This was accomplished partly by dispensing with the third dimension, for depth tends to blur the boundary between objects and their surrounds by immersing things in space and atmosphere. Accordingly, the Egyptian *Kunstwollen* reduced depth to an absolute minimum. This ideal object is likened to the conception we gain of objects via the sense of touch and is termed the "haptic" ideal so as to avoid connotations of literal touching. However, the perception of a flat, circumscribed thing still requires some subjective synthesis to bring the separate, haptic points of perception together to form a plane. In this way, thought processes inevitably find their way into the object

of perception, and this compromises its aesthetic ideal of absolute integrity and perfect objectivity. Gradually, greater acknowledgment is given to the way our objects are necessarily bound up with our modes of perception and thought, or to put it another way, people begin to become aware of the extent to which our objects are mind-formulated. According to Riegl's history, Classical Greek art, epitomized by relief sculpture and the columned portico of the temple, acknowledged more fully the mind-constituted nature of the world. Late Roman art relief sculpture, with its deep undercuttings and dark shadows, broke up the tactile plane to such an extent that Riegl was moved to compare it with contemporary Impressionist painting, with the qualification that in contemporary art objects lose their boundaries and self-contained exteriority, thereby becoming pure phenomena. Think of Monet's poppy fields or water lilies, or of Clement Greenberg's description of David Smith's burnished steel sculpture, in which, he said, "matter is incorporeal, weightless, and exists only optically like a mirage."[11]

In *The Group Portraiture of Holland* (1902) Riegl carried forward many of the ideas elaborated in his book on late Roman art, but he did so in a context focused on a particular genre and restricted to a narrower geographical and historical purview.[12] He also abandoned the strict formalism of the earlier book and replaced the distinction between haptic and optic styles with the pair of terms "objective" and "subjective." It was in this book that Riegl really developed his theory of the different ways that pictorial compositions position the spectator. Drawing on Hegel's contrast between sculpture and painting, he made a distinction between a type of composition that is complete in itself and one whose coherence is dependent on the presence of the beholding subject. Riegl gave the name "external coherence" to the typically Dutch type of composition that makes the world of the painting imaginatively continuous with our own and contrasts it with the Italian paradigm of "internal coherence," which is built around a unifying event or an act of will, such as someone giving others an order—resulting in a pyramidal composition held together by relations of domination and subordination. While narrative history painting is the paradigmatic genre of the Italian aesthetic ideal, group portraiture is characteristic of the Dutch *Kunstwollen*. The unifying strategy of external coherence is particularly pertinent in the case of group portraiture because the artist must somehow combine a number of figures in a group without involving them in any distracting or distorting action, while at the same time depicting something more in-

teresting than a row of portrait heads. Looking at the development of the genre during the sixteenth and seventeenth centuries, Riegl shows that in a successful group portrait, acts of will must be suppressed in favor of attentive attitudes, with figures gesturing toward, listening to, or looking at one another. This reduced internal coherence is, however, compensated for by the figures' looking outward and by heightened attentiveness on the part of the beholder. The viewer is solicited, often by the outward gaze or gesture of depicted figures, to join and close their circle.

In *The Syndics of the Amsterdam Drapers' Guild* (1662) Rembrandt contrived to ramp up the internal coherence of the group without sacrificing external coherence (figure 14). The figures are immersed in a shallow circumambient space registered by the blurring effects of loose, painterly handling, while their psychological relation to one another is carried by the slight suggestion of aural attention paid to the central figure, who gestures toward an open book. Most important is the figures' steady gaze in our direction. The spectator is called on to attend and also to complete the scene by imagining a person or persons just to his or her left who is addressed by the chief syndic.[13] "Attention" is the term Riegl used to describe both the

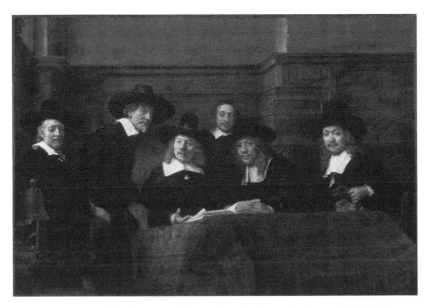

FIGURE 14. Rembrandt van Rijn, *The Syndics of the Amsterdam Drapers' Guild* (*"The Staalmeesters"*) (1662). Rijksmuseum, Amsterdam, The Netherlands. Bildarchiv Preussischer Kulturbesitz/Art Resource, NY.

viewer's and depicted figures' attitude, and it is the solution to the problem of coherence in group portraiture. Riegl summed up the meaning of the term as follows: "Attentiveness is passive, since it allows external objects to affect it without attempting to overcome them; at the same time, it is active, since it searches things out, though without attempting to make them subservient to selfish pleasure."[14] An ethics of beholding is implied here that values a kind of perception free of willful designs or emotional charge. Arthur Schopenhauer's hymn of praise to Dutch still-life painters seems to me a likely inspiration for Riegl's formulation of this attitude: they depict simple objects with great care, and "the aesthetic beholder does not contemplate this without emotion, for it graphically describes to him the calm, tranquil, will-free frame of mind of the artist which was necessary for contemplating such insignificant things so objectively, considering them so attentively, and repeating this perception with such thought."[15] Schopenhauer's description of this attentive attitude is, in turn, clearly descended from Kant's "disinterested" aesthetic judgment.

Although Riegl sought to justify each historical style in terms of its particular *Kunstwollen*, it is clear his own sympathies tended toward a kind of aesthetic ideal that breaks down the self-contained separateness of objects and persons. This is achieved in early Christian art by formal means: the shallow circumambient space binds figures together. For Riegl, "it is significant that this physical bridge between figures was built at the same time as that between persons, which we call attentiveness in the Christian sense."[16] Seventeenth-century Dutch art perfects the depiction of psychological bonds and, at the same time, elicits a performative attentiveness from the spectator. While the attentive person does not abandon all sense of autonomous identity, his or her attitude does imply the partial dissolution of the self-contained ego necessary for sympathy and community without coercion.[17]

LEO STEINBERG

Given this important ethical dimension, it is rather hard to see how Leo Steinberg could hope to enlist the help of Riegl's book to illuminate Picasso's shocking and formally violent *Demoiselles d'Avignon* (1907; figure 15). Confronted by the prostitutes' "overwhelming proximity," the viewer can be anything but attentively disinterested.[18] Yet it does have the formal organi-

FIGURE 15. Pablo Picasso, *Les Demoiselles d'Avignon* (1907). © 2009 Estate of Pablo Picasso/Artists Rights Society (ARS), New York. Digital Image © The Museum of Modern Art/Licensed by SCALA/Art Resource, NY.

zation of a group portrait, although it started out with a more conventional narrative composition.[19] As Steinberg painstakingly shows in his essay "The Philosophical Brothel" (1972), Picasso's many preparatory drawings chart a development and radical shift in the conception of the painting. It was at first conceived as a conventional "Italianate Baroque" composition with a narrative, complete in itself, bound together by interactions between the prostitutes, the sailor seated in their midst, and the medical student hesitating on the left-hand threshold. The scientific profession and nonparticipatory attitude of the student mark him out as the representative of a certain kind of epistemological detachment, as opposed to the sailor's involvement. Steinberg shows that when the male figures are removed, the composition undergoes a radical reorientation: it finishes as a dramatic confrontation between the women and the spectator. At the same time, the space between

the figures is fractured into cell-like compartments. Or, to put it in Riegl's terms, the painting's internal coherence is broken up and replaced by external coherence. But there is of course a major difference between this painting and Rembrandt's *Syndics*. While Riegl described the implied exchange among the Syndics and with the spectator as "attentive," Steinberg refers to our "traumatic encounter" with the *Demoiselles*. To speak of "the spectator" in the context of Picasso's painting is something of an understatement, for one is imagined as fully a participant in the scene, risking all.

Lisa Florman's excellent reading of "The Philosophical Brothel" brings to the fore Steinberg's intuition of the important role that a Nietzschean conception of Dionysian ecstatic engagement might have played in Picasso's radical reinvention of the composition.[20] This dialectic of engagement and detachment links the present chapter and chapter 3, where we explored the theme of detachment versus engagement in the work of Panofsky and Warburg. Florman argues that "engagement" should not be understood as an increase in the self-assertion of the viewer in relation to a work of art. Invoking Nietzsche's understanding of Greek tragedy, she suggests that truly entering into a work of art is not a matter of self-aggrandizement but, on the contrary, of self-abnegation. It is something like the encounter with the sublime, which defeats our efforts to comprehend or conceptualize it adequately. There is thus some continuity with Riegl's conception of attention, as he stressed the way it dissolves one's sense of being an autonomous subject observing a self-contained object and there is some evidence that he read Nietzsche.[21] Florman also suggests that the kind of iconological reading that the painting has attracted conforms to the model of detachment typical of the Panofskian tradition, as opposed to Steinberg's description of the effect of the work as the result of a certain formal strategy.

Picasso himself was, like Riegl, Warburg, and Steinberg, very probably inspired by *The Birth of Tragedy*, but what pictorial precedents might have been important for Picasso? He probably wouldn't have had much appreciation of the Dutch group portraits Riegl discussed, but, as Steinberg notes, "he did know the supreme realization of this Northern intuition—that Spanish masterwork . . . Velázquez's *Las Meninas*."[22] *The Syndics*, *Las Meninas*, and *Demoiselles d'Avignon* involve the spectator with comparable intensity, although Picasso ratchets up that intensity to the utmost. Ten years after the Picasso paper, Steinberg published another essay indebted to Riegl, this time focusing directly on the topic of "Velázquez's *Las Meninas*" (1981;

figure 16).[23] There he expands his analysis of this famous group portrait as a work that, as he puts it in "The Philosophical Brothel," "presents itself not as internally organized, but as a summons to the integrative consciousness of the spectator."[24] Steinberg first of all notes all the failed connections in the painting: the princess is offered a drink in which she takes no interest; a boy harasses a dog that fails to react. Clearly, its internal coherence is weak. Yet this deliberate dispersal is precisely what makes the unity of the scene dependent on the viewer. All but three of the figures look out in our direction.

Steinberg's account of why this painting maintains "such a grip on one's consciousness" is worth quoting at some length: "It must be a force, an energy issuing from the picture that arrests and invites and ends up drafting us into its orbit. Looking at *Las Meninas*, one is not excluded; one hardly feels oneself to be looking *at* it, as one would at a thing over there—a painted

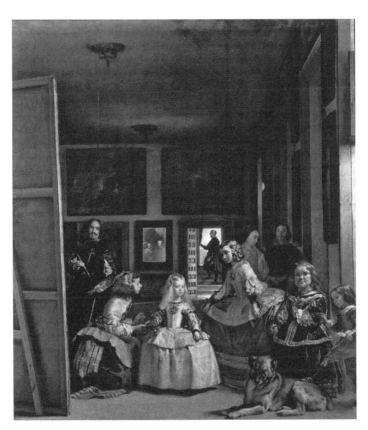

FIGURE 16. Diego Rodríguez Velázquez, *Las Meninas* (1656). Museo del Prado, Madrid, Spain. Scala/Art Resource, NY.

surface, a stage set, or gathering of other people. Rather we enter upon *Las Meninas* as if we were part of the family, party to the event."[25] The spectator is the painting's "complementary hemisphere," for it shows "but one half of its own system."[26]

Steinberg first published this essay in 1981, in the wake of Michel Foucault's dazzling analysis of *Las Meninas* in the first chapter to *The Order of Things* (1966) and its considerable critical reception.[27] However, in a note he says that it was written as a lecture prior to Foucault's essay. He also evinces some impatience with Foucault's view of the painting as an "epistemological riddle." He doesn't need to add that his interpretation is completely at odds with Foucault's. For Steinberg, Picasso's painting looks back to Velázquez's, but equally *Las Meninas* might be said to anticipate *Demoiselles d'Avignon*. For him, the subsequent history of the formal strategy of *Las Meninas* in Picasso and others has made it a precursor of modern painting, and this helps to explain why it maintains such a steadfast grip on us. For Foucault, however, the painting is an allegory of the Classical episteme. It demonstrates pictorially how representation was conceived before the advent of modernity in the eighteenth and nineteenth centuries, when man, the subject, became the center of all representations. According to Foucault, the Classical episteme's idea of knowledge excluded acknowledgment of the human subject of knowledge, and this finds its painterly correlate in the way the viewer (and painter) of *Las Meninas* is displaced. The mirror hanging on the far wall of the room reflects the figures of the king and queen sitting for a double portrait on which the painter in the picture is at work. The painting thus comes full circle without opening a place for the viewer, who is effectively eclipsed by the royal couple. A gap, "an essential void," opens up where the viewer/painter should stand. It follows from Foucault's analysis, then, that it is an internally coherent composition, even though it co-opts a space that extends in front of the depicted scene. [28]

The same year that Foucault published *Les mots et les choses* (the French title of *The Order of Things*) also saw the publication of Émile Benveniste's collection of essays *Problèmes de linguistique générale* (1966). It is tempting therefore to draw a parallel between the dual typology of discourse characterized by Benveniste in "The Correlation of Tense in the French Verb" and Foucault's distinction between the Classical and Modern epistemes.[29] In French there exists a particular writing style for the narration of historical events. This style, *histoire*, is marked by special literary tenses, particularly

aorist (*passé simple*), and it uses the third person only, excluding the first and second persons, "I" and "you," as markers of the narrator and the reader. Indexical markers of time and place, that is, locutions such as "here" and "now," are also excluded. Benveniste remarks, "As a matter of fact, there is then no longer a narrator. The events are set forth chronologically, as they occurred. No one speaks here; the events seem to narrate themselves."[30] The plane of history is distinguished from *discourse*, a mode of writing that is not sealed off in this way from the context of its enunciation and that mimes the immediacy of spoken speech. Any utterance that assumes a speaker and a hearer would fall into this category. It seems clear that Foucault aimed to defamiliarize our perception of *Las Meninas* by suggesting that, contrary to all superficial appearances, it conforms to the painterly equivalent of *histoire*—a literary mode that might itself be thought to epitomize the Classical period's episteme.

Is *Las Meninas* an allegory of a kind of knowledge that failed to take into account the human subject of knowledge? Or is it, as Steinberg so persuasively argued, "a mirror of consciousness"?[31] While Foucault situates the painting in its seventeenth-century intellectual context, he is unable to explain why it is still so powerful; Steinberg's invocation of Nietzsche and the implicit bridge from Picasso's *Demoiselles* to Riegl on Rembrandt to Velázquez can and does. Another way of expressing this thought is to say, in the manner of Baxandall, that Picasso's reference to Velázquez invents a history of art that brings *Las Meninas* into sharp focus for us. The seventeenth-century painting lives for us because of the intervening art history. Svetlana Alpers makes a rather similar claim in her book *The Vexations of Art*, when she observes "the remarkable resemblance of Velázquez to Manet." She continues: "It is Manet's feel for him, I think, that makes him part of the tradition. But conversely, it must be added that Velázquez brings out the tradition in Manet."[32] Steinberg does not directly confront Foucault, but, closing his essay, he observes that every interpretation is partial, inadequate, and open ended. As he so pithily puts it, "Writing about a work such as *Las Meninas* is not, after all, like queuing up at the A&P. Rather, it is somewhat comparable to the performing of a great musical composition of which there are no definitive renderings."[33] This is unfair to Foucault, who, after all, did try to think about style in a way that went beyond mere artistic convention or personal idiosyncrasy. The archaeology of the human sciences that he proposed, however, stresses historical discontinuity and so implies and

demands detachment on the part of the historian. This model applied to painting erects a barrier against any kind of reception of noncontemporary works of art that aims to transcend merely historical interest.

This discussion of the role of the spectator will recall for many Michael Fried's influential book *Absorption and Theatricality: Painting and Beholder in the Age of Diderot* (1980).[34] There are no references to Riegl in it, but Fried's broad philosophical culture means that his distinction between absorptive and theatrical painting draws on the same material and concerns as Riegl's theory. At first sight, it looks as though Fried's characterization of the absorptive painting of eighteenth-century France has nothing in common with Riegl's conception of external coherence as typified by the Dutch school, and this poses a problem since painters such as Jean-Baptiste Siméon Chardin looked back to Dutch genre scenes. Yet Fried stressed the necessity for the anti-Rococo school to maintain "the supreme fiction that the beholder does not exist."[35] Following Diderot, Fried claimed that this "supreme fiction" operated as the precondition for paintings that were intended to attract, arrest, and enthrall the viewer without resorting to the exaggerated, eye-catching style of Rococo art. This demand implies a composition that stays within the virtual space of the frame; the depicted figures, in a Chardin, for example, must not look out at the spectator. Rather, they must be totally absorbed in thought or in their work or play and so oblivious to the beholder. For Fried, absorptive painting is "self-sufficient, a closed system which in effect seals off the space or work of the painting from that of the beholder."[36]

This is apparently the very antithesis of a painting like *The Syndics*. Yet the genre paintings Fried discusses cannot be adequately described as internally coherent either, for the figures depicted are engaged in activities that require no action, will, or subordination typical of the "Italian" *Kunstwollen*. This puzzling disjunction can be resolved if we recall that Riegl's analysis focused on the genre of group portraiture, which necessitates the look out of the picture. The proper question to ask of Riegl is whether Dutch genre or history painting also contrived externally coherent compositions. Riegl's most illuminating comments on this topic come at the very end of his book. There he reproduces an anonymous Dutch pen-and-ink drawing from around 1650, showing a man from behind looking through a door (figure 17). The picture, Riegl says, is apparently internally coherent, for the object of the man's attention is within the picture space. However, this object

FIGURE 17. School of Rembrandt van Rijn, *Man, from Behind,*
Looking through a Half Open Door. Albertina, Vienna.

is not depicted, so the viewer is forced to imagine it. "Likewise, the man's
eyes are not depicted, only his back. But this is rendered in such a suggestive
way that the viewer is inspired to search his or her personal experience and
come up with an idea of what the figure is 'attentive' to."[37] Riegl's account
of Dutch genre painting expands the sense of external coherence to include
pictures that might at first appear closed in on themselves but that demand
to a high degree the spectator's imaginative supplementation.

In this context Riegl mentions other subjects, such as the seamstress so
attentive to her task that we imagine we can make out the tiny stitches. This
is exactly the sort of subject that for Fried is typical of absorptive painting.
Fried thought the spectator's rapt attention and imaginative participation

required a composition that turned its back, so to speak, on the beholder. Riegl shows this is not the case. The essential feature of both Dutch group portraiture and absorptive genre painting is that they prompt the imaginative engagement of the viewer by gesturing toward what is invisible. As Hegel said, we moderns are not interested in works of art that are complete in themselves. Rather, we are drawn to those that leave a space open for the viewer.

ROBERT MORRIS

So far in this chapter we have mainly been concerned with the spectator's relation to painting. This is because Hegel and Riegl saw painting as *the* modern art form precisely because of its patent acknowledgment and involvement of the spectator. For them, the post-Renaissance art audience is no longer satisfied with the self-contained perfection of the sculpture of Classical antiquity. What Hegel called Romantic art, on the other hand, contrives a kind of existential insufficiency, a lack, which makes it depend on and so draw in the spectator. It is no wonder, then, that most of the discussion about the spectator has concerned painting. But what about sculpture? The dominance of the paradigm of painting has occasionally been challenged, for instance, in eighteenth- and nineteenth-century Neoclassicism.[38] But the validity of Hegel's distinction has rarely been challenged. In art-historical writing, a fundamental and value-laden division is consistently maintained between the related sets of terms, vision and touch, the optical and the tactile, distance and nearness. Can we envisage reversing the hierarchy of value implied by these pairs of terms? What if value were placed on works that demanded a form of haptic seeing that probes in the dark? What if the extended duration of time that this "blind" exploration requires were also prized? What, in short, would happen if "the visible were allied to the reachable"? The phrase comes from Maurice Merleau-Ponty—a French philosopher whose work is devoted to rethinking vision as embodied and imagining the body as a visible thing immersed in space. As we will see in the next chapter, he launched a critique of theories of vision that could imagine it in terms of geometric perspective—an immobile and disembodied eye that views the world as through a window. This way of picturing vision implies a mind-body dualism, whereas Merleau-Ponty argues that we can see only because we are visible beings, just as we can touch only because we ourselves are tangible.[39]

This brief excursus on Merleau-Ponty will serve as an introduction to one of the most seriously considered challenges to the model of the spectator's relation to a work of art that privileges painting—the art and writing of Robert Morris. It is important to note at the outset that the context of his work is one of opposition to Abstract Expressionism and Clement Greenberg's celebration of its painterly opticality. This opposition is no doubt behind his experimentation with blind drawing. Working blindfolded, he wrote, "I summon up the memory of the first Cézanne I ever saw—*Mont Sainte-Victoire seen from Les Lauves*—I touch the page as though I were touching the Cézanne."[40] Particularly pertinent for the purpose of drawing out Morris's haptic aesthetic is an essay from 1978, "The Present Tense of Space."[41] In that essay, Morris draws a distinction between the kind of experience one has of a temporally inflected spatial and physical configuration, on the one hand, and an image or object, on the other. He connects the first with the "I" of immediate, present-tense, real-time interactive experience and the second with the "me" of memory—the already constituted self.[42] Morris based these different aspects of the self on ideas drawn from his reading of a book by George H. Mead, *Mind, Self, and Society: From the Standpoint of a Social Behaviorist* (1934).[43] According to Mead, the "me" is constituted by an internalization of others' attitudes toward me and so is a conventional, conformist self. How one acts in any particular situation, however, is unpredictable. This "I" aspect of self, says Mead, is "a movement into the future" that gives us a sense of freedom and creativity.[44]

Morris makes use of this distinction to describe the way that works of art affect the viewer. Some works of art are composed in such a way that they quickly resolve themselves into images; photography is for Morris the epitome of a cultural perception that favors the instantaneous and static image—"the past tense of reality."[45] A complex configuration that exists in real time and space, however, does not settle easily into a mental image. Rather, it defeats any readymade images and ideas we may bring to it, and so makes possible a renewed perception of the world. Experience of this kind constantly eludes my perceptual grasp. Morris's discussion of Rodin's statue of Balzac illustrates well what he means. It is a massive figure whose contours are obscured by the folds of a loose robe, making it necessary to feel one's way around the figure: "One automatically moves around the figure in the attempt to glean more clues about the hidden body. . . . Having no characteristic view, no singular profile to give it a definite gestalt, mem-

ory can't clearly imprint it."[46] As a result *Balzac* exists only for the duration of our viewing—"temporarily in its perceptually changing aspects."[47] It has "presentness" because it does not coalesce into the "rememberable image of the autonomous object."[48]

At the outset, Morris declares that his essay is intended to provide a historical context for thinking about art in the late 1960s and 70s, especially earthworks and installation art. "I want to stitch a thread of connection through some of these and go back to far earlier work with it. Make a narrative. Claim a development in retrospect. Invent history."[49] Morris's history includes Rodin, but it also makes a suggestive link between contemporary art and seventeenth-century Baroque spaces such as Michelangelo's vestibule of the Laurentian Library in Florence and Bernini's colonnade of St. Peter's in Rome: "The concerns of the new work in question—the coexistence of the work and viewer's space, the multiple views, the beginnings of an attack on the structure provided by the gestalt, the uses of distances and continuous deep spaces, the explorations of new relationships to nature, the importance of time and the assumptions of the subjective aspects of perception—also describe the concerns of the Baroque."[50] The post-Minimalist sculpture Morris made and admired has, he suggests, a "Baroque sensibility." Works of several contemporary artists are illustrated to make the case, including installations by Vito Acconci, Robert Erwin, Richard Serra, and Alice Aycock. The work he actually discusses, however, is Robert Smithson's *Mirror Displacements* (see figure 18).

Smithson arranged mirrors in the landscape, photographed the result, and then dismantled it. The mirror pieces, says Morris, "defined a space through which one moved and acknowledged a double, ever-changing space available only to vision."[51] However, there is a "perversity" in photographing the work, Morris continues, because "the thrust of the work was to underline the non-rememberable 'I' experience . . . and photography is a denial of this experience."[52] Yet that compression of the unbounded and the bounded, the site and the nonsite, is at the very heart of Smithson's project. Photography, for him, is not merely a pragmatic acknowledgment of the necessity of public dissemination but one way of framing immediate experience and so turning it into art. Morris is well aware of this, just as he is aware that his creation of an art-historical narrative is an attempt at pattern-making, at "bring[ing] the domain of the 'I' untransformed into the purview of the 'me.'"[53]

FIGURE 18. Robert Smithson, *Sixth Mirror Displacement* from *Incidents of Mirror Travel in the Yucatan* (1969). Collection: Solomon R. Guggenheim Museum, New York. Courtesy James Cohan Gallery, New York. © Estate of Robert Smithson/Licensed by VAGA, New York.

Morris wanted to challenge the terms of the debate concerning the spectator. He criticizes the self-contained image that allows visual experience to be quickly rationalized and easily stored as a memory image, and praises work that encourages the tentative, present-tense, "groping" experience of space and time. He privileges architectural spaces and sculptural installations over the depicted or photographic image. But his distinction has its roots in German phenomenology and the French development of that tradition by Merleau-Ponty. As a result, his idea of participatory installation spaces is ultimately informed by Hegel's sense of painting. Hegel's account of the way works of art assume different modes of perception is couched in terms of different mediums, but his point was fundamentally the same as Morris's. Morris's installation art, just as much as Hegel's painting, is about encouraging the engagement of the spectator, eliciting our imaginative projection and elaboration. What Morris did, in effect, was simply to displace

the Hegelian opposition between sculpture and painting onto that between image and sculptural installation. For Hegel, we recall, the statue suggested a habitual misrecognition of our relation to things as distance and detachment. Morris regards the image in just this way, while sculpture now takes on the value of a kind of bodily appropriation of the flesh of the world. In the *Phenomenology of Perception*, Merleau-Ponty declared that "the thing is inseparable from a person perceiving it, and can never be actually *in itself* because its articulations are those of our very existence, and because it stands at the other end of our gaze or at the terminus of a sensory exploration which invests it with humanity."[54] Hegel's "statue" and Morris's "image" are finally just different ways of figuring our perennial drift into forgetfulness about our continuity with the world. This applies just as much to the art historian. The work of art can never appear "in itself," for it is inevitably part of a complex "installation" we call the history of art, which encompasses both viewer and viewed.

The Gaze in Perspective

MERLEAU-PONTY, LACAN, DAMISCH

Debates within art history about the themes of vision and the spectator's re-
lation to the work of art have frequently centered on the significance of per-
spective. Theoretical interest in perspective was given initial impetus, partic-
ularly in Europe, by the young Erwin Panofsky's remarkably ambitious paper
of 1927 "Perspective as Symbolic Form." Maurice Merleau-Ponty's midcen-
tury critique of single-point perspective construction, which was part of his
effort to rethink the nature of visual perception, was also of key importance.
Jacques Lacan, the French psychoanalyst, drew on Merleau-Ponty in his
speculations about the gaze and perspective in his Seminars from the 1960s.
These landmarks formed the basis for the accelerated discussion of the im-
plications of the perspectival apparatus of lens-based media, particularly
film, that dominated discussion in the 1970s and 80s. This history of writing
has precipitated something of an orthodox notion of the gaze in perspective.
According to an oft-repeated argument, perspective consolidates a gaze that
secures the position of the viewer and stabilizes existing power relations. It
represents vision as disembodied, monocular, distanced, cut off from more
tactile relations to the world. This has the consequence of encouraging the
illusion of visual mastery and perhaps also contributes to the shoring up of
power relations in an unequal social regime where some have the power of
looking and others are relegated to being objects of the gaze.

A print by Dürer showing an artist drawing a female model using Al-
berti's veil—a squared-up transparent cloth attached to a frame—is often
used to illustrate the visual mastery and rationalization of sight that are
thought to characterize the perspectival gaze of modernity (figure 19). Per-
spective and its associated technologies, such as photography and film, are
thought to channel vision in certain ways but also to encourage mistaken as-
sumptions about a unified, centered, and transcendent subject. We shall see
in more detail how film theorists in the 1970s, notably Jean-Louis Baudry

FIGURE 19. Albrecht Dürer, *Draughtsman Drawing a Recumbent Woman* (1525). Kupferstichkabinett, Staatliche Museen zu Berlin, Berlin, Germany. Bildarchiv Preussischer Kulturbesitz/Art Resource, NY.

and Christian Metz, compared the conventional cinematic apparatus with perspective construction. More recently, Jonathan Crary's *Techniques of the Observer* (1990) offered an extended analysis of the ways that modernity determines vision for its own ends, while perspectival codes of representation preserve a sense of mastery of the visual field.[1]

In fact, Dürer's print should have alerted us to certain problems inherent in this now familiar account of perspective, for it shows the artist constrained to line up his eye with the dangerous point of a small obelisk and peer through the graph of the veil in order to see the model. The apparatus impinges itself forcefully on the artist. Would not the spectator of the completed painting also feel constrained by it? Or would his or her experience of the picture be transparent, apparatus-free, and satisfying? Because attention has been so focused on the correlation of active male and passive (nude) female, the constraint imposed on the artist by the apparatus was overlooked.

One of the most eloquent and influential documents of antiperspectivism, Merleau-Ponty's essay "Cézanne's Doubt" (1945), celebrates the artist for his effort to think and describe in paint a relation to the world that is "prescientific" or, as he often puts it, "pre-reflexive." According to Merleau-Ponty, Cézanne accomplished the task of painting from nature without resorting to the tools of perspective, thereby depicting not artificial but "lived perspective." Most of the recent critiques of perspective initiated within film theory, however, appeal not to Merleau-Ponty but to the structuralist psychoanalyst Jacques Lacan, especially his celebrated article on the mirror stage of infantile development. The mirror stage attests to the human

being's love of the image of his or her own body as whole and coordinated. Cinema, which aligns the point of view of the spectator in the cinema with the view of the camera/projector, was understood as a kind of machinic perspectival apparatus that, mirrorlike, gave one the illusion of a controlling gaze. Perspective and orthodox film form were thus understood in terms of the Lacanian imaginary and credited with helping to secure docile subjects of bourgeois ideology who misrecognize themselves as free agents. Laura Mulvey's groundbreaking article "Visual Pleasure and Narrative Cinema" added to this critique the dimension of gender difference. On her account, the cinematic apparatus is said to install not just a "bourgeois" subject but a specifically masculine one whose pleasure in cinema depends on the way it satisfies his desire for both erotic stimulation and visual mastery.

Although this strand of film theory emphasized that the imaginary re-lation to the image involves a *misrecognition*, this did not seem to pose a problem for the efficiency of its ideological effects. It was somehow forgot-ten that for Lacan the imaginary is the site of highly ambivalent affects—both jubilant recognition and aggressive rivalry, both ego-confirming and paranoia-inducing. The mirror stage provokes paranoia and anxiety about "the body in bits and pieces." The "quadrature" of the body-image creates a troubling remainder that Lacan later called the "real." While it is true that Lacan used perspective to figure a Cartesian conception of subjectivity that imagines itself as all consciousness, it is also the case that he used an exag-gerated use of perspective, anamorphosis, to figure what orthodox perspec-tive elides. The important implication of Lacan's model is that the squaring up of normative perspective construction, like the creation of the imaginary ego, creates an inherently unstable system. If perspective and anamorphosis are part of the same system, then clearly Lacan's position is more complex than is sometimes imagined.

One art historian has tried to challenge the orthodox understanding of perspective. In *The Origin of Perspective*, Hubert Damisch understands per-spective not on the model of the Lacanian imaginary but rather in relation to his conception of the symbolic order. Damisch argues persuasively that perspective is like a visual grammar that positions the viewer of a work as an "I" over against a "you." Perspective, like language, breaks the hold of any imaginary, apparently immediate relation to the world and interposes a binding structure. On this view, the illusion of visual plenitude and mastery is not enforced but rather shattered by perspective.

We have, then, two radically different understandings of the gaze as it is embodied in perspective construction. On one side, perspective's organization of the visible in relation to the eye of the viewer supports a gaze that feels itself endowed with mastery and personal autonomy. On the other, perspective is the preexisting and impersonal system that forces us to acknowledge that we are subjects of desire whose sense of visual plenitude will necessarily be punctuated by blind spots and whose visual pleasure will always be mixed with pain. On this view, perspective articulates the visible and obliges us to submit to its law and acknowledge the limits of our vision. In other words, according to the first view, perspective constructs a coherent image that encourages the ego's fond illusions of autonomy, while on the second view, the ego is deflated as it is caught in a determining structure. In order better to understand what is at stake in these disparate views of perspective, let us focus more closely on the work of Merleau-Ponty, Lacan, and Damisch.

MAURICE MERLEAU-PONTY

Merleau-Ponty opened his essay "Cézanne's Doubt" by noting the painter's painful lack of confidence, which was exacerbated by a hostile critical reception. The essay aimed to explain this anxiety, this incomprehension, by extolling Cézanne as a truly original artist and thinker who launches his work "just as a man once launched the first word, not knowing if it will be anything more than a shout."[2] The viewer, confronted by these demanding works, is called on to make certain mental adjustments to meet them. "It summons one away from the already constituted reason in which 'cultured men' are content to shut themselves, toward a reason that would embrace its own origins."[3] That embrace would involve the recovery of a sense of one's bodily presence in, or continuity with, the world. This sense of physical immersion in visibility is normally obstructed by our habitual, workaday, instrumental relation to things and also by philosophical, scientific, and cultural divisions between thought and sense perception, mind and body, thinking and seeing. These artificial divisions are imposed on us, just as geometric perspective has imposed itself on our relation to the visible, barring a more immediate or authentic relation to the world. The camera and other technologies of representation with their fixed monocular view are similarly distorting. Merleau-Ponty explains the peculiarities of Cézanne's warped

perspective as effects of his effort to give "the impression of an emerging order."[4]

Cézanne put himself in an impossible position by rejecting both the idea of art as expression (after a youthful phase of painting baroque fantasy scenes) and the Impressionist idea of art as a record of instantaneous perceptual sensation. In their different ways, Expressionism and Impressionism are both subjectivist approaches to the task of painting. Cézanne, says Merleau-Ponty, wanted "to find the object again behind the atmosphere,"[5] so he used color to give shape to things without drawing artificial contours and arranged his pictures without using traditional compositional devices or perspective construction.[6] Cézanne's stress on color was a way of fusing self and world, for, as he said, color is both a piece of nature and a sensation with certain emotional reverberations. For Merleau-Ponty, color is an emphatic case of the general intertwining of seeing and seen. Galen Johnson sums up the position by saying that Merleau-Ponty gives us "a theory of artistic creation as the fusion of self and world, not imitation of the world as object by painter as subject, nor a subjective projection of the world by the artist's imagination."[7] His practice involved a careful study of appearances in order to discover objective structure, and this well describes the phenomenologist's aim as well as Cézanne's. For Merleau-Ponty, Cézanne's painting demonstrates an ideal of thought that emerges out of sensory perception rather than in opposition to it. It discloses our continuity with the world.

Merleau-Ponty stressed that Cézanne's project was not a matter of primitivism but rather of recovering the base on which thought is founded: "he wanted to put intelligence, ideas, sciences, perspective and tradition back in touch with the world of nature which they were intended to comprehend."[8] In the case of perspective, argued Merleau-Ponty, this meant painting "the lived perspective," rather than relying on a ready-made geometric or photographic construction. For example, when we see the top of a cup obliquely, we do not in fact see an ellipse "but a form that oscillates around an ellipse."[9] Cézanne's effort to be true to the object as it is given in perception created warped and wobbly distortions, and this calls attention to the active process of perception in a way that is denied by the strictly systematic distortions of geometric perspective. Merleau-Ponty's complaint, then, is not that perspective involves "distortion" but rather that a structure has imposed itself on vision so persuasively that it has become natural. Its "naturalness" deepens what is already a tendency inherent in vision, as opposed to touch, to incline

us to think of our relation to objects as separate, outside, discontinuous. In addition, perspective installs the mathematical, measurable, or calculable in the heart of the work of art, which should be the prolongation of a gaze that explores the world without these supports. To construct a painting according to the rules of perspective is to determine a priori the look of the visible, therefore obviating the need to really see or to interact bodily with the world. In "Eye and Mind," a late essay, Merleau-Ponty wrote of Renaissance perspective, "These techniques were false only in that they presumed to bring an end to painting's quest and history, to found once and for all and exact and infallible art of painting."[10]

Merleau-Ponty relied heavily on both Émile Bernard's and Joachim Gasquet's correspondence and recollections of their conversations with Cézanne, but he also cited the work of the post-Rieglian Viennese art historian Fritz Novotny, who wrote a book called *Cézanne and the End of Scientific Perspective* (1938).[11] The book is long, mostly untranslated into English, and, with its detailed analyses of landscape paintings, heavy going. It has nevertheless been influential in indirect ways. It was Novotny who first associated Cézanne's treatment of space with landscapes' uninviting, alienating character. While the Impressionists, he argued, used perspective to open up a *Lebenselement*, a living space, Cézanne characteristically deemphasized perspective by avoiding contrasts in depth and blunting or warping the convergence of orthogonals.[12] These peculiarities result in pictures robbed of illusion, emptied of expression, and standing aloof from the beholder.[13] Cézanne subverts perspective from within and is thus credited by Novotny with the radical rejection of perspective in later modern art.[14]

We have seen that while Merleau-Ponty understood the uncertain spatial organization of Cézanne's paintings as "lived perspective," that is, as closer to the complex process of natural perception, Novotny saw in the work a foreclosing of a *Lebenselement*. Nevertheless, the philosopher agreed with Novotny about the "inhuman" coldness of the canvases; he just accounted for it in other ways. He suggested that Cézanne's art dispels all sentimental connotations that would soften certain motifs, along with all superimposed scientific or technical preconceptions. "We live in the midst of man-made objects, among tools, in houses, streets, cities, and most of the time we see them only through the human actions which put them to use. We become used to thinking that all this exists necessarily and unshakably. Cézanne's painting suspends these habits of thought and reveals the base of inhuman

nature upon which man has installed himself. . . . It is an unfamiliar world in which one is uncomfortable and which forbids all human effusiveness."[15]

The landscape painting Cézanne made in 1896 of le Lac d'Annecy in the foothills of the Swiss Alps is "frozen"; it is not thematized or animated by metaphor (figure 20). Merleau-Ponty's struggle to describe the effect of this painting leads him to describe it as the world evacuated of metaphor. And this suggests the paradoxical complexity of Cézanne's task, which is not a negation of artistic means but a use of the resources of painterly expression to depict a world stripped of all human accretions. Cézanne returned "to the source of silent and solitary experience on which culture and the exchange of ideas have been built in order to take cognizance of it."[16] For Merleau-Ponty, the strangeness of Cézanne's canvases has to do with their extreme depersonalization, their "objectivity." Both academic form and sentimental themes are familiar terrain; with Cézanne's work we are pitched into a rough and unfamiliar world. Merleau-Ponty viewed perspective as a reification of vision and emblematic of our general forgetfulness of our continuity with what he would later called the *flesh* of the world. Cézanne

FIGURE 20. Paul Cézanne, *Lac d'Annecy* (1896). Courtauld Institute Galleries, London, Great Britain. Erich Lessing/Art Resource, NY.

counters this tendency and makes "*visible* how the world *touches* us."[17] Merleau-Ponty later referred to this crisscrossing of sight and touch, of sense and world, as the "chiasm" of vision.[18]

JACQUES LACAN

Merleau-Ponty and Lacan referred to each other's work and knew one another personally. Although their views were in many ways at odds, as you would expect given their respective phenomenological and structuralist orientations, there are nonetheless interesting moments of cross-fertilization. Lacan's celebrated essay "The Mirror Phase as Formative of the Function of the *I*" was delivered in 1949, four years after the publication of Merleau-Ponty's *Phenomenology of Perception* and "Cézanne's Doubt."[19] Lacan's essay is also about the human being's relation to the visible world, but, unlike Merleau-Ponty's, it stresses the impossibility of any direct or prereflexive, primordial relation to our surroundings. The fundamental feature of the human being, for Lacan, is self-alienation, and the mirror phase is its dress rehearsal. The infant of about six to eighteen months recognizing its mirror image presents, for Lacan, a "striking spectacle."[20] The child is captivated by the image of an Ideal-I, that is, a better coordinated and more coherent self-image. The image is illusory or deceptive because it does not reflect back the child's real helplessness and dependence owing to the prematurity of human birth. In other words, its beautiful totality belies real bodily fragmentation. This primary identification acts as a template for a whole series of future identifications that will further shape and maintain the deluded ego. It situates the ego, as Lacan says, in a "fictional direction."[21] It also structures one's relation to the world in general as illusory. Finally, the value the infant sets on the image involves a sacrifice of its own being—a sort of suicide in the manner of Narcissus, for in order to sustain this ideal ego the child has to expel or abject all those impulses and objects that cannot be assimilated to the beautiful, coherent image.

There is quite obviously a ready-made theory of the subject's satisfaction in visual art nestling in Lacan's account of the mirror stage—both the image and the mirror, it might be argued, reflect back a more organized coherent world, framed and safely contained. Lacan himself did not think of art in these terms, yet his idea of a specular "misrecognition" inaugurated by the mirror stage gave a psychoanalytic underpinning to the critique of the im-

age, especially the image in popular culture and Hollywood cinema. Two French film theorists were primarily responsible for this transposition. Apparatus theory, as it is called, proposed an analogy between the setup of the cinema (spectator, projector, screen) and that of perspective, crediting both with powerful ideological and psychic effects.

The key text is Jean-Louis Baudry's "Ideological Effects of the Basic Cinematic Apparatus," published in 1970. Baudry explicitly founds his critique of the cinematic apparatus on its inheritance of Quattrocento perspective construction, which, he says, constitutes a viewing subject as center and origin of meaning.[22] Cinematic camera movement serves only to augment this feeling of power and control.[23] Just like the helpless infant in thrall to the mirror image, the viewer of cinema is in fact bodily immobilized and fascinated. However, for Baudry, the spectator identifies less with what is represented on the screen than with the apparatus that stages the spectacle—the camera/projector's point of view.[24] The crucial illusion that cinema fosters, then, is not so much the illusory world represented as the fantasy it engenders of a "transcendental subject." Just as the mirror assembled the fragmented and uncoordinated body into an imaginary unity, the imaginary transcendental self of cinema unites the discontinuous fragments of film into a unified meaning.[25]

Film theorist Christian Metz is the other key figure in the cultural transmission of a theory of the gaze inspired by Lacanian psychoanalysis. "The Imaginary Signifier," published in French in 1975 and translated in the British journal *Screen* the same year, saw the mirror stage as the model for later cinematic identifications. The mirror, he wrote, "alienates man in his own reflection and makes him the double of his double."[26] Although Metz pays some attention to the spectator's identification with figures on the screen, he also claims that the most powerful identification is with the look of the camera—the "all-perceiving" other. In this way, the cinematic apparatus gives the spectator a pleasurable illusion of perceptual mastery.[27] The cinematic apparatus thus helps to form a subject confident in his freedom and autonomy while all the while being subject to the capitalist ideological apparatus.

The idea of perceptual mastery is also fundamental to Laura Mulvey's "Visual Pleasure and Narrative Cinema" (1975). It is one of the most frequently cited, influential articles in the whole literature on visual culture and deservedly so, for it not only introduced this theorization of the gaze to an English-speaking audience but also developed it in crucial ways. One

way Mulvey altered the theory was to introduce the dimension of gender. The other way was to hint at the inherent instability of scopic mastery. For Mulvey, the cinematic illusion of specular mastery is part of a masculine regime of looking dominant in our culture. That illusion is dependent on, but equally troubled by, the image of woman. For Mulvey, "cinema builds the way [the woman] is to be looked at into the spectacle itself."[28] In other words, "cinematic codes create a gaze."[29] Woman in cinema may be styled in such a way that she connotes the "to-be-looked-at-ness" of a passive spectacle, but her femininity, her difference, threatens to incite latent castration anxiety in the male spectator. As a result, scopophilic voyeurism, one form of visual pleasure, is haunted by anxiety. The other form of visual pleasure is narcissistic. The spectator identifies with his omnipotent screen surrogate—"the more perfect, more complete, more powerful ego ideal."[30] The figure on the screen, like the mirror image, offers an idealized, narcissistic sense of self—an ego ideal. While the first type of pleasure discussed by Mulvey, voyeurism, has to do with making the other an object of sight and sexual stimulation, the second type, narcissism, has to do with recognizing one's own idealized likeness. Although Mulvey does not explicitly pursue this argument, it is also the case that narcissism, like voyeurism, is laced with the anxiety of paranoia.

Mulvey and the other film theorists argued that the subject is constructed by the determining machinations of an apparatus. They stressed the way the cinematic apparatus and certain editing techniques control the dimension of time and space and construct a gaze. And they link these effects with perspective construction. Mulvey remarks, for example, "The camera becomes the mechanism for producing the illusion of Renaissance space." In this respect, then, film theory was not so far removed from the apparently distant world of Merleau-Ponty and the paintings of Cézanne. Both decried the fact that in the culture of modernity seeing, thinking and imagining are restricted by a cultural apparatus, and both put their faith in the liberating power of avant-garde art practice. At the close of her essay, Mulvey calls for a radical film's form—"a new language of desire"—and she made films herself that attempted to answer that call. Her stress on language indicated an intention, quite unlike Merleau-Ponty's, to make more explicit and palpable film symbolic articulation and thereby disrupt the subject's imaginary capture.

Objections to the particular interpretation of Lacan that underpinned this strand of film theory were voiced early on. As early as 1975, Jacqueline Rose tried to resituate the concept of the imaginary as adopted by film theory back in its psychoanalytic context and to call into question "the use of the concept to delineate or explain some assumed position of plenitude on the part of the spectator in the cinema."[31] In "The Orthopsychic Subject" (orig. 1989), Joan Copjec stressed the underside of the mirror stage, that is, the way the alienated image may confront the subject as a rival and unleash aggressivity. In other words, narcissistic self-regard is inherently unstable. Identification with a superior other (such as a sibling or parent) is both jubilant and fraught with rivalry and aggression.[32] Narcissism, then, cannot possibly be mobilized to bring about the subject's harmonious relation with the social order.[33]

As we have seen, the idea of the gaze in film theory in the 1970 and 80s was informed by a certain reading of Lacan's "Mirror Stage." Although that essay is about the effects of a visual image on the formation of the subject, it is not where Lacan himself engaged with the French philosophical discussions of *le regard*, the gaze. This was initiated by Jean-Paul Sartre's *Being and Nothingness*, published in 1943. Along with Merleau-Ponty's posthumously published *The Visible and the Invisible*, it was the key text for Lacan's thinking about the gaze in 1964, the year of his Seminar XI, *The Four Fundamental Concepts of Psychoanalysis*. What is not well understood is Lacan's position vis-à-vis Sartre's theorization of the gaze. Sartre's model of vision involved two people, only one of whom is endowed with the power to look. Its prototype is the man at the keyhole whose gaze objectifies the other, robbing his or her freedom. The gazer, for Sartre, assumes absolute freedom and denies it to others. He is all consciousness and the other all body.[34] This radical asymmetry was taken up by some theorists of the gaze, notably by Foucault and feminist accounts of the "male gaze," sometimes in the name of Lacan. Yet as we shall see, what Lacan stressed is the way the gaze from outside unsettles the look of the one who assumes mastery in the visual field. Drawing on Merleau-Ponty's idea of the chiasm (crisscrossing) of vision, Lacan demonstrated how the position of the subject in visuality has to be mapped using two intersecting triangles. He shows the perspectival lines of sight that privilege the position of the beholder can be reversed by nothing more than a point of light:

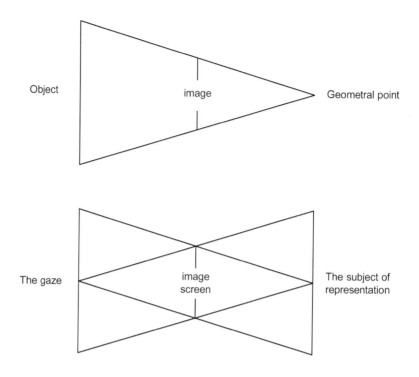

One of Lacan's anecdotes is evidently a riposte to the Sartrean "keyhole" model of vision: One summer a young Lacan is slumming with some fishermen on a boat. A fisherman points to a sardine can floating on the water, catching a glint of the sun's rays; this winking can suddenly turns the self-satisfied Lacan into the discomfited object of the gaze. Of course, something quite similar to this also happens in Sartre's anecdote when the man at the keyhole hears footsteps in the hall and becomes himself a petrified thing. But in Lacan's tale it is not another consciousness so much as a cultural artifact that "looks back." Stephen Melville has suggested that the look back in Lacan's story is representative of the symbolic order, of language, which preexists the subject and always mediates what can be seen.[35] As Copjec puts it, "There is and can be no brute vision, no vision totally independent of language."[36] Further, the young Lacan is not turned into an object but, on the contrary, is forced to acknowledge his position in the spectacle of the world and his relation to others. Drawing on Merleau-Ponty's concept of the chiasm of vision, Lacan points out that I am not just a being that looks at objects, I am also an object in the spectacle of the world. Lacan's theory

of the gaze may seem a far cry from Merleau-Ponty's sense of the chiasm of vision as an embrace of flesh and world in light, but both he and Lacan offer a nuanced sense of the limits of human consciousness. They stress the preexistence of the gaze for the subject.

So far we have encountered a gaze in the imaginary and symbolic registers. Is there a gaze associated with the real? Lacan's *The Four Fundamental Concepts of Psychoanalysis* includes four seminars collected under the heading "The Gaze as *objet petit a*." The real in the scopic field is formed when the eye splits itself off and the gaze as *objet petit a* is expelled. The eye could imagine itself master of all it surveyed were it not for the spot or void left behind by what had to be excluded. This spot seems to "gaze back at me," because it is an intimate part of myself, a part object, projected outside. It becomes the object of the scopic drive, what I search for in the picture, and the encounter with it is wounding. Roland Barthes's account of the effect of the photographic punctum owes a great deal to Lacan's theory of the gaze.[37]

One of the key figures in Lacan's discussion of the gaze is the anamorphic skull in Hans Holbein the Younger's painting *The Ambassadors* (1533; figure 21). Lacan used the painting as an allegory of the way that the "real" of the subject's body and drives looks back from the picture. Since death is one of the realities expelled by the ego, Lacan figured the blind spot of conscious perception as an anamorphic skull. Although Lacan singled out this anamorphic figure as an illustration of the way a picture captures the spectator by presenting something that eludes one's grasp, Joan Copjec is right to caution that we're mistaken if we take that effect as "an occasional rather than as a structurally necessary phenomenon."[38] And since the vanishing point of perspective is both structural and in some ways elusive, it can perhaps better serve the purpose than anamorphosis. And in fact it does so in Lacan's unpublished Seminar XIII of 1966, on which Copjec draws.[39]

HUBERT DAMISCH

In *The Origin of Perspective*, Damisch argues that the invention of perspective introduced a paradigm or model of thought that had far-reaching implications. He takes as his model Panofsky's "Perspective as Symbolic Form" (1927), which, Damisch declares, remains "more than a half a century after its initial appearance, the inescapable horizon line and reference point for all inquiry concerning this object of study."[40] For Panofsky, perspective an-

FIGURE 21. Hans Holbein the Younger, *Jean de Dinteville and Georges de Selve* (*"The Ambassadors"*) (1533). National Gallery, London, Great Britain. © National Gallery, London/ Art Resource, NY.

ticipated Descartes' conception of space as infinite extension; it rationalized space so that it no longer adhered to substantial things. Instead "bodies and gaps between them were only differentiations or modifications of a continuum of a higher order."[41] Perspective also anticipated Kant's Copernican revolution in epistemology. This implies, as Michael Podro has argued, that Panofsky regarded perspective as the advent of reflexive self-awareness about the relation of mind to things and the birth of a kind of art that was essentially about that relation, rather than, say, the imitation of some supposedly preexisting reality: "Perspective, like the critical philosophy of Kant, holds both the viewer and the viewed within its conception."[42] This reflexivity about the nature of art signals the achievement of the sort of critical distance that, in turn, enables a properly historical study of art. So the moment of systematic perspective construction is also the moment that art history

as a discipline becomes possible. There is a curious overlapping, then, of a particular moment in the history of art, the Renaissance, and the very possibility of the serious study of art's history. Object and viewpoint are locked together, or as Joseph Koerner nicely put it, Panofsky's essay "finally works to place *itself* at perspective's historical focal point."[43]

Damisch is clearly attracted to some of the implications of thinking of perspective as a symbolic form, as he stresses its epistemological status. For Damisch, perspective is a materially embodied theory or epistemological model—a way of reflecting on our relation to representation. Yet he substantially modifies Panofsky's theory by suggesting that perspective has many of the same properties as a sentence: it systematically organizes material and positions an "I" over against a correlative "you." Like any system, it imposes constraints, selecting what is relevant; in the case of perspective, things that have definite contours are selected. In fact, Alberti's veil, described in his treatise *On Painting* and depicted by Dürer, was designed precisely to deal with irregular bodies, such as the human figure, which do not easily lend themselves to perspective construction.[44] Damisch's earlier book *A Theory of /Cloud/* is about the way those wispy phenomena nevertheless find their way into Renaissance painting despite being marginalized by perspective's "structure of exclusions."[45]

Panofsky's characterization of perspective also appeals to Damisch as a modernist, because Panofsky emphasized the point that perspective involves the recognition that no representation can be adequate to its object. The system of relations that perspective imposes is a coherent system; it has an internal logic that allows us to consider it in its own terms and not only as a model of the visible world. At the heart of Damisch's book is a critique of art historians burdened with what he calls the "representational hypothesis" or, less politely, the "referential prejudice."[46] His long and staggeringly detailed analysis of three panels of architectural views or *Ideal Cities*, now dispersed to Urbino, Berlin, and Baltimore (figure 22), proceeds by first prizing them free from explanations of their style or iconography in terms of some referent, whether it be the architecture of Florence, scenography, or marquetry. Against these explanations, Damisch insists, "representation is not the only function of painting."[47] Rather than relating the panels, sometimes attributed to Piero della Francesca, to some extrapictorial reality, he aims to show that they constitute a "transformational group." The term is borrowed from mathematics, but Damisch's analysis is informed by Claude Lévi-Strauss's

analysis of masks or myths.[48] The panels form a set of three works that respond to one another in a play of formal oppositions and relations. More than anything else they represent a "play of thought."[49] While for Panofsky the perspectival work of art represents a reflexive, critical awareness of relation of mind to the world, for Damisch the reflexive thought these panels demonstrate is much more self-contained: they represent a purely visual kind of thinking in which the relation of artwork to artwork is paramount. When dealing with abstract art we're accustomed to the modernist idea of painting about painting, but we're apparently less able to think about figurative art in these terms. The tour de force that is Damisch's analysis of the panels is evidence enough of the critical productivity of this idea.

Damisch also makes claims about the effect these panels have on the viewing subject and for this part of his argument he has recourse not to Lacan's imaginary register but to his conception of the symbolic order. Although Damisch uses a Lacanian model to think about perspective, he is sharply critical of Lacanian film theory. Damisch thinks that it denigrates perspective as a mere tool for interpellating subjects for the ends of capitalism or patriarchy, rather than seeing it positively as an extraordinary idea— a cognitive achievement, similar to the invention or discovery of geometry.[50] Perspective is, for him, a spectacular instance of thought in art, and for Damisch this implies the impossibility of maintaining any sharp distinction between writing art history and its objects. The "impatience" he registers in his preface was prompted, then, not only by old-fashioned empiricist art history but also by what we now call visual culture.

But can Damisch easily shift between, first, understanding perspective, with Panofsky, as a model of reflective thought and, then, understanding it as equivalent to Lacan's symbolic order? It is clear what motivated Damisch

FIGURE 22. Piero della Francesca, *The Ideal City, Named the City of God.* Galleria Nazionale delle Marche, Urbino, Italy. Erich Lessing/Art Resource, NY.

to introduce both Lévi-Strauss and Lacan—effectively substituting them for Panofsky's reliance on Ernst Cassirer. Early on in the book, he claims that perspective is "anti-Humanist," and this goes entirely against the grain of Panofsky's view.[51] He cites Lacan's observation that perspective reduces the human being to an eye and the eye to a point, and this reduction is then correlated with the later theorization of the Cartesian subject—itself a sort of geometrical point.[52] Panofsky made it clear that perspective conceived as a symbolic form abstracts radically from perceived reality and effectively denies the possibility of any unmediated knowledge of the world, yet for him it offers ample compensations. The structure of perspective does not decenter the human subject; on the contrary, it offers for the first time, like Kant's a priori categories of thought, an epistemologically legitimate position. Panofsky's great Kantian claim is that our understanding of the world, whether scientific or pictorial, can be both subjectively constituted and objectively valid. This explains why Panofsky revived the formerly obscure term for single-point perspective construction, *costruzione legittima*. For Damisch, however, the subject of perspective has no such confidence. Rather, it constitutes a subject that was to become the subject of modern science "in the form of a point."[53] It marks a crisis of subjectivity and knowledge that became apparent in Descartes' *Discourse on Method* where the subject is reduced to the Cogito ("I think"), and separated by an abyss from extended substance.

Damisch sometimes understands the effects of the picture in purely Lacanian terms: we are subjected, seduced, caught up in the picture;[54] we are programmed, informed by the model.[55] And yet he also wants to maintain a reflexive moment: "perspective . . . provides a means of staging this capture and of playing it out in a reflective mode."[56] On the one hand, Damisch underwrites Panofsky's sense of perspective as a (Kantian) model of thought: he describes it as a "regulating configuration intended not so much to inform the representation as to orient and control its regime."[57] On the other, it is a trap laid for the scopic drive.[58] But are these models compatible? We've seen that the Panofskian epistemological model of perspective carries with it implications or connotations of rationality, critical distance, reflexivity, and freedom. The psychoanalytic, Lacanian model carries with it a quite different set of connotations: seduction, alienation, lack, death, and desire. In fact, Damisch beautifully summed up these latter implications in his /Cloud/ book, where he wrote that "painting . . has the power to make man sensible of his own nothingness, his dependence, his void."[59]

Damisch interprets the perspective paradigm as having precisely the determining, decentering, extrapersonal quality of Lacan's symbolic order. He makes this case by arguing that the vanishing point is equivalent to the point of view—they "coincide on the plane of projection," and consequently the vanishing point has the value of a gaze of the Other. This, he thinks, is demonstrated by Brunelleschi's first experiment in perspective, as described by Antonio Manetti, in which he drilled a peep-hole through a small wooden panel precisely at the vanishing point of a depiction of the Florence Baptistery so that one could peer through it from behind and see an astoundingly illusionistic depiction reflected in a mirror.[60] Damisch proposes that the vanishing point, which is frequently marked in Renaissance painting by a depicted aperture such as a door or a window, will from thenceforth have the significance of a look back, or better, of a look that constitutes me as viewer. The subject of perspective is consequently decentered in relation to this prior point of sight or gaze implied by the depiction.[61] As Damsich notes, "The perspective paradigm effectively posits the other, in the face of the 'subject,' as always already there."[62] Émile Benveniste's theorization of the way the subject is implicated in language is Damisch's model for this account. For Benveniste, "language puts forth 'empty forms' which a speaker in the exercise of discourse, appropriates to himself and which he relates to his 'person,' at the same time defining himself as I and a partner as you."[63] Similarly, perspectival representation, with its visual "sentence structure" (*dispositif d'énunciation*), addresses me with an implicit look.[64] For Damisch, perspective as a paradigm operates like the imposition of language on the individual and has, in the visual register, the same effect of traumatic subjectification. This persuasively argued case would seem to put paid to the common view that perspective installs the viewer in a position of apparent mastery. On the contrary, *"this subject holds only by a thread."*[65] That thread leads from the eye of the observer to the vanishing point and is capable of snatching the spectator, like a fish on a line, into the picture. The spectator finds him or herself looked at by the painting, lured, transfixed, summoned to take up his position. The windows and half-open doors of the *Ideal City* writes Damisch, "are looking at you with all its eyes."[66]

This is the closest Damisch ever comes to conceiving of the vanishing point in the register of the real, although he notes a physical hole in the surface of one of the panels exactly at the vanishing point and observes that the effect of this is "to introduce into a configuration intended to create an

illusion, the point of the real."[67] Toward the end of the book, discussing Velázquez's *Las Meninas*, Damisch finally relents and suggests that perspective may indeed have an imaginary function (see figure 13). Although the technical vanishing point of this painting is on the arm of the man at the door, the imaginary center of the painting is the mirror at the back of the room. At the first center, says Damsich, "the subject is, so to speak, produced by the system in which it has its designated place," while in the second center the narcissistic ego "vainly seeks its own reflection."[68] The light pouring in from the right of the picture suggests another, lateral viewpoint, called the distance point in perspective construction, from which position the depth of the room would open up. The mirror as marker of the imaginary register in *Las Meninas* opens up the possibility that, for Damisch, the film theorists were not entirely mistaken after all. Imaginary perspective would be one in which the apparatus disappears and we are given an image having that "belongs to me aspect," as Lacan put it.[69] Damisch makes an intriguing point about the complex composition of *Las Meninas* that deserves further elaboration: the painting, in splitting these viewpoints and functions and making them palpable, "reflects on its own operations."[70] Here Damisch gestures toward a way of going beyond Panofsky's stress on Kantian reflexivity which applies universally to the subject of perspective and toward a more limited but credible way of thinking the subject's room for reflection in relation to art and the image more generally.

MY ARGUMENT SUGGESTS that the debates and disagreements about the gaze are attributable to the fact that the gaze has at least three different modalities. Just as we have seen in the case of perspective, the gaze can also be run through Lacan's psychic registers of the imaginary, symbolic, and real. These terms offer themselves as ways of thinking about the gaze in relation to the work of art. Confronted with a work of art, we may reflect on the modalities of its hold on us. Does its alluring spectacle offer me an apparently privileged point of view, appeal to my inflated ego, and confirm me in my sense of visual mastery? Or does its palpable artifice suggest that my gaze is caught up in structures, both psychic and technological, and mediated by language? Or, finally, does a picture's opacity or strangeness reflect my blind spot and remind me of my own finitude? The familiar critique of perspective fails to take account of these multiple modalities of the gaze in perspective.

We saw that one of the implications for art history implicit in Panofsky's essay was the deduction of quasi-transcendental terms that create a legitimate point of view for the field of study.[71] The subject of knowledge, the art historian, is thus sprung out of any embeddedness in his or her own cultural/intellectual milieu. As Stephen Melville put it in "The Temptation of New Perspectives," "Panofsky's valorization of perspective forges an apparently non-problematic access to the rationalized space of the past."[72] This is one implication from which Damisch, I'm sure, would wish to distance himself. *The Origin of Perspective* is itself an eloquent testimony to the way history is constantly recast. Damisch acknowledges, for example, the productive effects of Freud and Lacan on subsequent theorizations of perspective, including his own, and he brushes aside charges of "anachronism" brought by scholars of Renaissance art. He writes: "If there is any such thing as history, it must be conceded that it too takes the same route: one that leads through this echo chamber, this singular field of interference in which Freud's text resonates with those of Alberti, Manetti, and Leonardo."[73] Here "critical distance" is not conceived of as empty or abstract space, as it is in Panofsky. Rather, it is thick with the intervening artistic and theoretical developments that make possible an understanding of the past.

CHAPTER SEVEN

Seeing and Reading

LYOTARD, BARTHES, SCHAPIRO

Art-historical writing oscillates between two fundamentally different approaches to its objects. Some art historians and critics aim to "read," interpret, or decipher the artistic "text." At the extremity of this approach, they adopt a rigorous semiological method and a stringent iconoclasm. Others, however, are critical of any approach to the work of art that diminishes our sensory-aesthetic experience of it. An alternative form of art writing, then, aims to embrace the subsignifying materiality and formless substance of the work. At the extremity of this position, even the idea of the "content" or "meaning" of the work is called into question. In her polemical manifesto "Against Interpretation," Susan Sontag deplored the way we confront a singular material visual artifact and immediately reduce it to an idea, thought, or proposition. She called for a more highly articulated descriptive vocabulary that would call attention to "the pure, untranslatable, sensuous immediacy" of the work, rather than looking through it to discover a hidden meaning.[1] The oscillation in art-historical and critical writing between these views suggests that we should inquire into the assumptions underpinning them. On the one hand, the work of art is more or less reducible to language, while on the other, it has nothing in common with it. As soon as one spells it out like this, it becomes obvious that either formulation is a travesty. Art and thought, seeing and reading, cannot be divided up in this way.

This chapter tracks one recent episode in the long history of our ambivalent attitude to the visual image and attempts to find another way of thinking outside these debilitating dualities. The rise of structuralism and semiology across the humanities and social sciences in the 1960s and 70s gave legitimacy to the practice of shattering the phenomenal appearance of a work so that it could then be understood, like language, as a combination of differential signs. Of course, some types of art, like Cubism, collage, or photomontage, seem to have already anticipated this critical procedure, so

it is not surprising to find that some scholars, including both Yve-Alain Bois and Rosalind Krauss, have offered semiotic readings of Cubism.[2] Curiously, it was also these two art historians who collaborated on the exhibition and catalog *Formless*, which drew on Georges Bataille's concept of the *informe* in order to undo the distinction between form and content in favor of a destabilizing "base materialism."[3] This suggests that the ambivalence we're concerned with here doesn't just divide groups of people; it inhabits each of us.[4] It is a division, I suggest, that runs deep and periodically erupts in different forms: the popularity of Gilles Deleuze's book on Francis Bacon and the logic sensation is one indicator of a recent antisemiotic impulse.[5]

We take as our starting point Jean-François Lyotard's early critique of structural linguistics and his understanding of language, dreams, and art. The French philosopher's book *Discours, figure* is not well known in the Anglophone world, as it has not been translated into English, but it has had many attentive and influential readers, including Deleuze and Roland Barthes. Barthes veered from being the cultural semiologist par excellence to becoming one of semiology's most forceful critics. Barthes has had an enormous impact on art historians and critics (including Bois and Krauss), but other art historians found their own way around the defile formed by the split between seeing and reading. Among these was the eminent American art historian Meyer Schapiro, who took up semiotics as a way of approaching Romanesque and medieval art, where archival documents are scarce or nonexistent. Yet his appreciation of the postwar Abstract Expressionist art of the New York School suggests that he was also drawn to art at the very limit of the readable—to color, gesture, texture.

JEAN-FRANÇOIS LYOTARD

In 1971, several years prior to his well-known essay on postmodernism, Jean-François Lyotard published *Discours, figure*.[6] Originally his PhD dissertation, it is a long and spirited attack on the tendency within French poststructuralist theory to privilege language or discourse to such an extent that the visual or figural aspects of cultural forms and the sensuous nature of our experience of them are completely marginalized. The date of the publication, shortly after the 1968 political turmoil in Paris, is significant. Post-1968, the question of what rebels against established structures had to be addressed. Could desire, the body, pre-Oedipal drives, or prereflexive ex-

perience be considered extradiscursive and so provide means to subvert the established order? Lyotard, who had supported the Algerian resistance to French colonial rule and the student demonstrations of May '68, was among the first to question art theories based on the work of the Swiss founder of structural linguistics, Ferdinand de Saussure, and his posthumously published *Course in General Linguistics* (1916).

Structural linguistics had by the early 1970s served as a model for Claude Lévi-Strauss's structural anthropology, Barthes's early studies of literature and popular culture, and Jacques Lacan's psychoanalysis, to name but a few instances of its enormous impact. This was all in accordance with what Saussure had prescribed: "language, the most complex and universal of all systems of expression," could become, he claimed, the "master-pattern for all branches of semiology."[7] The particular way in which Sausurre conceived of language was decisive, for he insisted on the arbitrary, unmotivated character of signification. That is to say, he held that the bond between the sign and its meaning is purely arbitrary and conventional. Furthermore, he thought of language as a self-contained system where meaning depends on the position of a sign in relation to other signs, rather than on some link to an extralinguistic reality. Why was this apparently rather dry and abstract vision of language and other sign-systems so influential? One important feature of the model was that it made a sharp distinction made between the domains of culture and nature. Semiology emphasized the artificial or constructed character of all forms of representation, including those like the realist novel or the photograph, which could so easily be taken as neutral transcripts of reality. The semiological approach estranges the image and allows it to be read as a sign conveying meaning rather than as a realistic representation.[8] Armed with a semiological tool kit, a critic could show an apparently innocent photograph in a magazine to purvey a pernicious ideology. Barthes's *Mythologies* repeatedly demonstrated how mass cultural images, which appear so natural and self-evident, are actually saturated with ideology or myth. The celebrated Algerian soldier who salutes the French flag on the cover of *Paris Match* has had the life sucked out of him and has become a zombie alibi for French colonialism.[9] This is offered as a particularly emphatic case of the general structuralist rule that all representation and indeed "reality" is culturally, discursively constructed.

But there were other factors that made Saussure's model attractive. The analysis of any object of culture as a system of signs seemed to offer a fresh

and rigorous method. One can well understand the appeal of a method that offered a bracing alternative to *belle lettrist*, impressionistic criticism. The method also explodes interpretations centered on "the man and his work." "The Death of the Author," Barthes's important article of 1968, opened up a space between nature (the author as origin of the work) and artifice (the text as a collage of citations).[10] In other words, the almost clinical, quasi-scientific mode of analysis undertaken by the structuralists was precisely what made it attractive. Yet as early as 1977, Barthes reflected on the limitations of the method and distanced himself from it in his "Inaugural Lecture," claiming that his semiology avoided the lure of science by becoming the site for the deconstruction of linguistics. If linguistics tended toward claims to universality, his "semiology would consequently be that labor which collects the impurity of language, the waste of linguistics, the immediate corruption of the message."[11] As the mention of deconstruction suggests, Jacques Derrida was a key figure in the demise of structuralism, for while the structuralists provided a method for deciphering a text, poststructuralist generally stressed the impossibility of this sort of retrieval of a determinate meaning and emphasized rather the way in which critics necessarily rewrite what they are supposedly interpreting.

Lyotard's approach was rather different. Although structuralism grew out of phenomenology, many poststructuralists repudiated it on the grounds that it preserved a unified subject of perception who could have access to an unmediated reality. Lyotard, although not uncritical, remained more faithful to the phenomenology of Merleau-Ponty and became interested in Freudian, rather than Lacanian, psychoanalysis. In doing so, he pioneered the turn, in theory and criticism, to considerations of the body, the visual, affect, desire, and what he called the "figural." In the opening chapter of *Discours, figure*, "Taking the Side of the Figural," Lyotard stated his aim clearly: "This book is a defense of the eye. . . . It has a shadow for a prey. It is interested in that penumbra which, following Plato, speech has cast like a grey veil over the sensible."[12] Despite this emphatic declaration, the subtlety of Lyotard's approach is evident even in the book's title: note that there is a comma between "Discourse" and "figure," rather than a slash indicating opposition. This punctuation suggests that although they are heterogeneous domains, the figural is not opposed to or outside of the discursive; rather, the visual, sensual, material features of language are internal to language and so color its supposed transparency and impede any immediate intelli-

gibility. Language, after all, has rhythm and rhyme, and letters have shapes. Furthermore, in order for language to function, it must designate things that are external to it. The "partisans of language believe themselves capable of imprisoning all meaning, but the truth is that 'all discourse exhausts itself before exhausting' the visible."[13] In short, seeing can never be completely absorbed into saying.

Lyotard begins his book by describing the very different experiences of reading and seeing. He observes that a text occupies a flat space and the marks on the page, "transparent signifiers of meaning," are not especially attended to. In the sphere of discourse, we resemble spiders on a web: "it is as if humans had become two-dimensional beings, with nothing to feel, but instead, moving along gaps in the network."[14] The phenomenology of the visual world, in contrast, is complex and multidimensional and includes my body in a surrounding space. It is this space that is marginalized in our discourse-dominated culture. Lyotard realizes, however, that one cannot simply descend into silence and embrace the figural, for this would lead only to an inversion of the hierarchy of value. Rather, one must begin by indicating the insufficiency of discourse—its dependence on the figure and on a world outside the system of language.

As the argument progresses, we see Lyotard gradually undoing the initial opposition between discourse and figure, particularly by criticizing the structuralist view of discourse. Two elements, he claims, are excluded from this conception. Bill Readings summarizes them as "the referential distance at the margin of discourse" and "the opacity or visibility of discourse at its center."[15] First, Lyotard shows that language is not only signification (signifier calling up a signified) but also *designation*. Here Lyotard calls on the American philosopher Charles Sanders Peirce and his classification of signs, which includes the category of the indexical sign. In language there are pointing words, such as "here," "now," "I," "you," "this." These terms don't only gain their meaning from their position in a closed system; rather, they designate something outside the system in the sensible world. Language gestures outside itself "to the sensory field in which speaker and listener co-exist."[16] Through reference, then, language encounters "the depth of the visible."[17] This phrase recalls Merleau-Ponty's late writing where he argued that the visible is never fully present to us since as it has "depth" or "opacity." Lyotard also challenges the view of language as a transparent bearer of meaning designed for the communication of information by indicating

its *plasticity*—the thickness of the line that forms letters and the sound of words. Unlike the structuralists, who mobilized language to estrange the image, Lyotard claimed that it is the figural that works to disrupt the transparency and security of meaning and so preserves our sense of the limits of representation. Poetry foregrounds linguistic figurality, and for this reason it cannot be translated into prose without loss. While semiology disregards the materiality and singularity of things, the poet treats words as things. Yet poetry is only a heightened case of what is true of language in general, for, as Lyotard says, "cold prose almost does not exist, except at the lowest point of communication. Discourse is thick. It doesn't simply signify; it expresses. And if it expresses, it is because there is also movement and force deposited in it, which cause the table of significations to erupt through a quake which produced meaning." In short, "discourse is not only signification and rationality, but also expression and affect."[18]

Lyotard pursues this argument about the way the figural haunts language, but he increasingly notes the way discourse infiltrates the visual field. Following Merleau-Ponty, he remarks that Renaissance perspective reduces the visible to a sort of "plastic writing." Perspective represents for him a repression of figure by discourse. Western painting, tied to narrative and so "born from Writing," is "badly held in check, always coming back to submit to it and yet escaping it."[19] And, again with Merleau-Ponty, he invokes Cézanne as an artist bent on undoing this reduction of the figural to the discursive. Cézanne's paintings deconstruct perspective and give us a glimpse of the invisible—that is, seeing itself. As a result, his *Mont Sainte-Victoire* ceases to be an object of sight and becomes "an event in the visual field."[20]

In the first half of the book, Lyotard is content to mount an argument against the semiologists who hold that a painting is readable. He's more inclined to agree with Paul Klee (again, with Merleau-Ponty) that looking at a painting is more like following a path the painter has laid down which "the eye sets in motion and enlivens once again."[21] The viewer is set in motion by the figurality of the work of art. In the second half, Lyotard changes tack as phenomenology gives way to psychoanalysis. Bill Readings sums up the shift succinctly: Lyotard becomes interested in the figural as lost object of desire rather than as present object of perception.[22] In keeping with his attack on structuralism, Lyotard disputes Lacan's contention that the unconscious is structured like a language. Rather, he counters, the unconscious is a force that "crumples and creases the text and makes a work from it."

Interestingly, Lyotard links figurality to the death drive, referring to Anton Ehrenzweig's *Hidden Order of Art* (1967), which in turn was indebted to Freud's *Beyond the Pleasure Principle* and to Melanie Klein.[23]

In the key chapter of the second part of *Discours, figure*, "The Dream-Work Does Not Think," Lyotard stages his argument contra Lacan on the ground of Freud's *Interpretation of Dreams*. Lyotard contends that dreams are language that has undergone a strange transformation. It has been subject to unconscious primary processes working hand in glove with the figural. He points out, rightly, that for Freud the dream thoughts that incite the dream are no different from waking discourse, so the essence of the dream cannot lie there. Rather, it is the transformation carried out on the thoughts that is crucial. Condensation and displacement, the two main operations of dream-work, treat discourse as if it had a spatial dimension open to manipulation and so render it illegible.[24] Dreams are made of visual images and crumpled language, "word-things." Peter Dews has pointed out that "Lyotard sees stasis in the fixed intervals of the linguistic system, and links the unconscious with the fluidity and mobility of the perceived world."[25] The figurality that forms dreams is also at work in poetry. Lyotard declares: "It is futile to attempt to bring everything back to articulated language as a model for all semiology, when it is patently clear that language, at least in its poetic usage, is possessed, haunted by the figure."[26] This implies something about how one should regard a dream or poem or work of art. If all these forms involve the copresence of the discursive and the figural, the visible and the textual, then they cannot be reduced to meaning.[27] Cézanne gives us a glimpse of what lies beneath representation, what energizes art. Similarly, Klee's line is not just about tracing a contour; it is "the tract of an energy that condenses, displaces, figures forth, elaborates, without regard for the recognizable."[28] In short, he shows us that "seeing is a dance." One can detect here early signs of Lyotard's interest in the aesthetics of the sublime and the unrepresentable, which so inflected his sense of postmodernism in the 1980s.[29]

ROLAND BARTHES

I have already indicated the important role that Barthes played in this history. Although it is possible to detect his ambivalence about semiological method even in his early work, it is also clear enough that there is a shift in his interest between, say, "Rhetoric of the Image" (1964) and "The Third

Meaning" (1970).[30] Accordingly, when one is writing an overview of his thought, it has become customary to divide his career down the middle and posit an early and a late Barthes. The various shifts in his position are certainly more subtle and complex than this great divide suggests, but it is nonetheless fair to say that Barthes's impact on the study of visual and other arts has been twofold. First, he was a semiologist of culture, intent on laying bare the encoded messages latent in all representations and artifacts. Second, he was a countersemiologist who urged us to overcome our alienation in and servitude to the codes of language and culture through the figurality of art. For early Barthes, the visual image is one of the many repositories of these cultural codes; for late Barthes, as for Lyotard, visual art is an activity that dissolves and breaks free from all preestablished forms. As a result, art-historical writing that has been influenced by Barthes either launches a demythologizing critique of visual culture or takes an aesthetic, almost erotic, interest in the subsignifying materiality of the individual work of art.

In fact, the shift in Barthes's position over the course of his career could have been predicted, because he reflected on his deep ambivalence even in his early work. At the end of "Myth Today" (1957) he spelt out very clearly the nature of his dilemma. He proposed that there are basically just two ways of conceptualizing the relationship of language to the world: on the one hand, we can "posit a reality which is entirely permeable to history, and ideologize," or, on the other hand, we can "posit a reality which is *ultimately* impenetrable, irreducible, and, in this case, poetize," in order to seek out the "inalienable meaning of things."[31] The first assumption governs the practice of Barthes the mythologist, analyst of bourgeois ideology, structuralist, semiologist—in short, the scientist; the second animates Barthes the writer. Even in his last book, *Camera Lucida* (1980), he was still struggling with "the uneasiness of being a subject torn between two languages, one expressive, the other critical."[32] Yet because of this internal split, he was able to weigh fairly the gains and losses associated with both sides of the opposition: "if we penetrate the object, we liberate it but we destroy it; and if we acknowledge its full weight, we respect it, but we restore it to a state which is still mystified."[33]

Barthes was such an eclectic and original thinker that tracking his sources and influences is a futile exercise. However, it is helpful for the purposes of exposition to see the division in his career as a change in the philosophical underpinning of his critical activity. Broadly, the early Barthes works within

a structuralist paradigm, particularly that of Claude Lévi-Strauss, while the later Barthes's thinking is guided by the phenomenology of Merleau-Ponty. Early in his career, Barthes undertook the political task of cutting through surface appearances to lay bare the ultimately determining structures of discourse. The individual was assumed to be subject to those structures and to experience a phenomenal world determined by them. This apparently ruled out any intuitive grasp of an extradiscursive reality. Barthes's early work laid the groundwork for what is now called the study of visual culture. In *The Pleasure of the Text* (1973) the transition from structuralism to phenomenology is announced when he speaks, for example, of his constant battle against meanings that "set" too quickly and "make all thought of becoming" impossible.[34]

The first systematic adoption of the principles of Saussurean linguistics as a model for the analysis of other cultural phenomena was carried out by the French anthropologist Lévi-Strauss. In particular, his essay "The Structural Study of Myth" (1955) started reverberations in literary studies that led to the publication in 1966 of a special issue of the French journal *Communications* that was entirely devoted to structuralist narrative theory. It was introduced by Barthes's essay "Introduction to the Structural Analysis of Narrative."[35] In that essay, Barthes declared that structuralism's constant aim is "to master the infinity of utterances [*paroles*] by describing the linguistic system [*langue*] of which they are the products and from which they are generated."[36] This form of inquiry, which radically abstracts from any particular utterance or instance, would seem valueless for the study of literature or art in general, where texture, nuance, and tone are so important. And Lévi-Strauss himself seemed to confirm that impression when he noted that myth is a type of discourse at the opposite pole from poetry: while a poem is strictly untranslatable, the mythical value of myth is preserved even in the worst translations.[37] Yet as already noted, it was precisely the way in which the structuralist analysis of art cuts through all literary or aesthetic considerations that made it so attractive. Like myth, the products of visual culture could be construed as "objectified thought." Barthes's essay on the Eiffel Tower from 1964, which was originally published to accompany a book of photographs of the tower by André Martin, not only treats the tower as objectified thought but argues that the thought it embodies is itself structuralist. The Eiffel Tower, Barthes argues, is an emblem of "a new sensibility of vision."[38] It announces the advent of "an intellectualist mode of

vision" and does so both in its bare cast-iron structure and in the panoramic view of the city that it makes possible. From both perspectives, one has the sensation of penetrating the phenomenal surface of things to witness "an essence laid bare."[39] It is for Barthes a machine that "permits us to transcend sensation and to see things in their structure." It thus makes possible a new kind of travel in which one is no longer "thrust into the midst of sensation" but rather, from a great height, "given the world to *read* and not simply to perceive."[40] The term "high structuralism" is here given a new and entirely pertinent resonance.

The divergence between the appearance and structure of the Eiffel Tower offers the observer an object lesson in the discontinuity between the two. From a distance, the tower is consumed as a purely vertical line. Close to, however, one observes the obliquity of the supporting pillars and lift shafts; at a more micro level one becomes aware of its crisscrossed network of plates and beams, "a lacework of broken substances." This shift effects a salutary "demystification" and affords the viewer the "delectable contraction of an appearance and of its contrary reality."[41] The effect is comparable to Lévi-Strauss's insistence on the primacy of the logical over the chronological in his study of myth: the myth may be consumed as a diachronic tale, but its underlying logic of binary oppositions is purely synchronic or "paradigmatic." Barthes suggests that this shift in perspective is comparable to the difference between unconsciously consuming the myth whole and understanding its mechanism or deep structure. In the Eiffel Tower essay, however, one finds some indications of another kind of appreciation of it. For instance, one consequence of the tower's spare form is that its meaning is extremely labile. It is, writes Barthes, the "zero degree" of the monument, a virtually empty sign. As such, it is comparable to what Lévi-Strauss called a "zero phoneme" or a "floating signifier," that is, a surplus signifier in a system which is able to carry any value.[42] This gives it, according to Barthes, an oneiric quality loaded with multiple, indeterminate meanings such as modernity, rocket, Paris, insect, and either surveillant Mother or Phallus.

Writing his quasi-autobiography a decade after the Eiffel Tower essay, Barthes reflected on his earlier critical practice. By 1975, he had a quite different impression of the view from the tower. He notes that even at the height of his structuralist phase, when his focus was on the intelligibility of things, he was at least not immune to the pleasure of intellectual activity: "The panorama, for example,—what one sees from the Eiffel Tower—is an

object at once intellective and rapturous: it liberates the body even as it gives the illusion of 'comprehending' the field of vision."[43] In other words, the panoramic vision is pleasurable, but unfortunately this pleasure is bound up with an illusory sense of mastery. Semiological science encourages the same delusion. Barthes now proposes to counter this with "the texture of desire, the claims of the body."[44] Merleau-Ponty's *Phenomenology of Perception* is particularly helpful for focusing the issues at stake in the latter half of Barthes's career. He often acknowledged his indebtedness to Merleau-Ponty, noting as early as 1964, in *Elements of Semiology*, that Merleau-Ponty was a very early mediator of the thought of Saussure. Despite its evident unorthodoxy, Merleau-Ponty's contribution was for Barthes the best development of the crucial distinction between language as instituted system (*langue*) and language as active speech (*parole*). "He took up again the Saussurean distinction as an opposition between *speaking speech* (a signifying intention in its nascent state) and *spoken speech* (an 'acquired wealth' which does recall Saussure's 'treasure')."[45]

Barthes refers particularly to the chapter of *The Phenomenology* called "The Body as Expression, and Speech" in which Merleau-Ponty tried to capture the way language works that gives priority to neither language or thought. Rather, "we move toward an articulate thought by expressing it."[46] This original articulation of thought, in language or in any other medium, is for the most part the work of the artist. For most of us, most of the time, language is an institution that we inhabit. No particular effort of expression or comprehension is required: "The linguistic and inter-subjective world no longer surprises us, we no longer distinguish it from the world itself, and it is within a world already spoken and speaking that we think."[47] In short, we live in a cliché-ridden world. Insofar as we remain on this level, we inhabit a world that is thoroughly penetrated by language and ideology. Merleau-Ponty urges us therefore to seek out the "primordial silence" beneath the chatter of words and "describe the action which breaks the silence."[48] It is particularly important for our purposes that he understood this action as a gesture, as a movement closely bound to the body, and further maintained that the gestural content of words is not wholly arbitrary because they contain an "emotional essence" that makes speaking like "singing the world."[49]

It is clear even from this brief account that Merleau-Ponty put a very particular gloss on the *langue/parole* distinction, (one, parenthetically, that

absorbed a great deal from Heidegger's terms *Rede* and *Gerede*, authentic speech and idle talk).[50] When Barthes adopted the distinction, he gave an equally negative connotation to *langue* or spoken speech. It became not so much an acquired treasure as a set of mental manacles—*doxa* or received opinion, in his terminology. Barthes's antipathy to *doxa* remained constant throughout his life, but his strategy for combating it changed radically. The impact of Merleau-Ponty's and Lyotard's views of the relation of language to the world can be seen in some examples of Barthes's criticism of the visual arts, particularly in his essays on André Masson and the American painter Cy Twombly.

In 1973, two years after the publication of *Discours, figure*, Barthes wrote a brief essay on the French Surrealist painter André Masson, paying particular attention to his use of Chinese ideograms. These paintings embodied for Barthes a theory of the text and of writing. Such beautiful calligraphic marks, he noted, cannot be reduced to mere communication, for they are at the same time gestures, that is, drawn lines that point back to the "*the body which throbs.*"[51] Similarly, color cannot be understood here as a mere ground allowing characters to "stand out" but as pulsional energy. Chained in the Occident to reckoning, writing is here revealed as desire. Furthermore, the ideogram itself represents a quite different order from our alphabet. Chinese characters offend our logocentric sensibility, which insists that writing is only a transcription of speech, an instrument, "a chain along whose length it is the body which disappears." Barthes concludes, in his emphatic way, that what we learn from Masson's work is that "*for writing to be manifest in its truth* (and not in its instrumentality), *it must be illegible.*"[52]

It is but a short step from here to Barthes's two appreciative essays on Cy Twombly, both from 1979 (see figure 23). Barthes observes that Twombly's art is tied to writing and that, like Masson's, it reveals writing as gestural. Barthes was most likely aware of Harold Rosenberg's celebrated essay of 1952, "The American Action Painters," so it is tempting to read Barthes's characterization of Twombly's gestural art as a sly riposte. Rosenberg's essay crackles with the rhetoric of subexistentialist machismo: the canvas is "an arena in which to act," and painting is a lonely, heroic endeavor liberated from all cultural value. We are told that "the American vanguard painter took to the white expanse of the canvas as Melville's Ishmael took to the sea."[53] In striking contrast, Barthes describes Twombly's gesture as negligent, indolent, erotic. He observes that while an action seeks a result or an end,

FIGURE 23. Cy Twombly, *Untitled* (1970). The Museum of Modern Art, New York, NY, USA.
© The Museum of Modern Art/Licensed by Scala/Art Resource, NY.

the gesture is the surplus of an action, its surrounding atmosphere. The gesture is made, as it were, "for nothing." "Is it not at this extreme limit," inquires Barthes, "that 'art' really begins?"[54] The references in these passages to excess and useless expenditure revive terms used in "The Third Meaning," in which Barthes sought "obtuse" or unobvious meanings in stills from Eisenstein's films.[55] In both essays, the work of the dissident Surrealist Georges Bataille and the *informe* is invoked.

In "The Third Meaning" and the essays on Masson and Twombly, it is immediate intelligibility that is considered an impediment to seeing marks as figures. Confronted with a technical drawing made to convey information, one ignores both the performance of the gesture and the materiality of the signs. Twombly's marks, by contrast, play with the very stuff of the sign in a way that evokes the body of the artist; he makes the gesture visible with an apparently indolent cursive script that leaves a trace of its passage through time. There is something rather paradoxical, but perhaps intentionally pointed, about Barthes's taking up works of art that mime writing, since language is to such a large extent social and codified. His attention to writerly artists is a clever strategy for recovering the figurality of all writing.

Barthes wants us to rediscover language from the point of view of emergent, "speaking" speech, rather than as "spoken," instituted language. He reformulates Merleau-Ponty's distinction for his own purposes, introducing the terms "producing" and "product."[56] The product, he continues, "is betrayed as *imaginary*: what is real . . . is producing."[57] The viewer of Twombly's work must, says Barthes, "retrospectively see a movement, what was the hand's becoming."[58]

MEYER SCHAPIRO

There are any number of art historians whose work would be relevant in this context, and most were directly influenced by Lyotard or, more likely, Barthes. Norman Bryson's *Word and Image: French Painting of the Ancien Régime* (1981) is a case in point.[59] Although it is a historical study of seventeenth- and eighteenth-century French painting, its implicit project is to loosen the grip of discourse on the image. In homage to Lyotard, the first chapter is called "Discourse, Figure," and its argument is familiar. Bryson writes of seventeenth-century French academic painting as a kind of imagery that is so "colonized by the word" that every element serves the narrative. Dutch still life, on the other hand, is said to preserve the weight and opacity of the painterly signifier; "language cannot penetrate it." This narrative leads inevitably to Abstract Expressionism and the complete liberation of the painterly material signifier.[60] Bryson is in danger here of forgetting the deconstructive character of *Discours, figure* and slipping into a simple inversion of the hierarchy of value. Instead of an art reduced to discourse, we are offered an art reduced to pure material trace. While it is true that Lyotard does sometimes lend himself to this reading, he is also able to declare at one stage that "dreams are nothing more than a particular form of thinking"[61]—that is, a form of thinking through the figural. How is this fusion of discourse and figure to be conceived in the case of visual art?

Many art theorists who were interested in escaping the model of structuralist linguistics gravitated toward the work Roman Jakobson, a Russian linguist who emigrated in the 1920s to Prague and from there to the United States. There are many references to him throughout *Discours, figure*, many of them critical of Jakobson's structuralist assumptions. Yet Jakobson had an abiding interest in avant-garde art and poetry beginning with his youthful involvement with Russian Formalist criticism and Russian Futurist poetry,

so he brought to linguistics a large measure of poetics. Although he was associated with structural linguistics, he discovered the semiotics of Charles Sanders Peirce in the early 1950s and wrote articles advancing Peirce's view that all types of signs involve a combination of three major types: icon, index, and symbol.[62] Indeed, as film theorist Peter Wollen pointed out many years ago, according to Peirce the "perfect sign" is not pure but a perfectly balanced hybrid of all three types.[63] Peirce's notion of the symbol was closely related to the Saussurean conception of the arbitrary, conventional linguistic sign. Yet as Jakobson observed, Peirce also identified the indexical and iconic components of verbal symbols.[64] Jakobson developed Peirce's ideas, expressed them in simplified, more readable terms, and mediated them to a wider audience.

All of the writers under consideration in this chapter found inspiration in the work of Jakobson, and with good reason, for he drew attention to certain properties of language that are neglected within the Saussurean model. In "Quest for the Essence of Language" (1966), for example, Jakobson poses the question of the nonarbitrary or motivated aspects of language and discovers numerous examples of iconicity in language. Of interest in this context is a particular sub-specie of the icon, the diagram, which displays logical relations in an iconic, pictorial fashion. For instance, sentences can be seen as minidiagrams: Caesar's famous utterance "Veni, vidi, vici" (I came, I saw, I conquered) pictures the temporal order of his deeds. As a general rule, then, "the temporal order of speech events tends to mirror the order of narrative events in time and rank."[65] "The President and the Secretary of State attended the meeting" is an example of a sentence where the initial position in the clause reflects priority in official standing.[66] If in these diagrammatic utterances temporal and logical relations are displayed through their spatial disposition, then pictures must also display these relations diagrammatically. We shall see how Meyer Schapiro took up this suggestion. Perhaps even more significant for art criticism are the implications of Peirce's category of the indexical sign. While in his scheme the icon signifies by virtue of resemblance, the index is classified on the basis of its mode of inscription, that is, the close connection, often causal link, between the sign vehicle and the object it signifies. Examples of this type of sign include sundials and footprints. Jakobson wrote an essay on the indexical properties of language noting, with Peirce, that although the pronoun "I" is a symbol, it cannot represent its object without being in some existential relation to this object. [67]

ROSALIND KRAUSS'S TWO-PART essay "Notes on the Index: Seventies Art in America" (1977) is one of the earliest and best-known art-critical explorations of indexicality. Much of part 1 is taken up with a discussion of Marcel Duchamp's *Tu m'* (1918), a virtual "panorama of the index," but there is also an interesting account of Man Ray's exploration of what he called the Rayograph as an exemplary case of a type of photography that takes advantage of the indexical, more than the iconic, aspect of the medium. Krauss observed that the Rayograph "forces the issue of the photograph's existence as an index."[68] She described the images resulting from putting objects directly onto light-sensitive paper as the "ghostly traces of departed objects."[69] In "Notes on the Index," part 2, also from 1977, Krauss wrote about the indexicality of contemporary installation work. This work is said to invoke "sheer physical presence" as a way of short-circuiting "the more highly articulated languages of aesthetic conventions."[70] The indexical sign, including the photograph, she wrote, "heralds a disruption in the autonomy of the sign. A meaninglessness surrounds it which can only be filled in by the addition of a text."[71] Its regressive aspect, its "reduction of the conventional sign to the trace,"[72] is compensated for by the inclusion in many of the works she considered of a supplemental text, making the work straddle figural and discursive modes.

Krauss's criticism benefited from her reading of Peirce, Jakobson, and Barthes. Yet an earlier generation of art historians had had similar concerns, and at least one of them found his way to this material. The distinguished art historian Meyer Schapiro (1904–96) was a specialist in Romanesque and medieval art, but he wrote many articles on Modern art and the contemporary art of his time and place—the Abstract Expressionism of New York in the 1940s and 50s. He was close to many artists, both American and European. His writing was inflected by a broad intellectual culture that included Marxism, semiotics, and psychoanalysis. Of special interest in this context is the following remark made during an interview shortly before his death: "I spent more time in Paris talking with Merleau-Ponty, whose *Phenomenologie de la perception*, I found to be impressive. Merleau-Ponty's thought was closest to my own. His work on Cézanne and on the nature of perception shared a lot of my concerns. No other philosopher seemed to know as much about the material process, the concrete technique for making art or about the complexity of perception."[73] Given this declaration made at the end of his life, it is curious that there is not a single explicit reference to Merleau-Ponty in Schapiro's published work, although there

are many "Merleau-Pontian" passages.[74] His scholarly work on the Romanesque was marked by his attention to the formal play of the sculpture. In his "On the Aesthetic Attitude in Romanesque Art," for example, he countered the dominant, exclusively iconographic treatment of the work. However, he was also sharply critical of the purely formal treatment of Modern art. In a very early paper, he attacked Alfred Barr, first director of the Museum of Modern Art in New York, for the formalist approach to abstraction in the catalog for the landmark exhibition Cubism and Abstract Art. Against Barr, Schapiro argued that abstract art is meaningful and that it is bound up with its historical context. For example, the hard-edged, technological style of the Russian avant-garde testifies to a faith in the liberating power of the machine. Yet by 1930 this optimism had subsided, and consequently art in Europe and the United States grew increasingly biomorphic. Or, to take a final example, in "The Apples of Cézanne" (1968) Schapiro wrote against the grain of an overwhelmingly formalist reception of the painter, advancing a quasi-psychoanalytic explanation for the special place that apples have in his work.[75] Generally, Schapiro wanted to find a path between iconography and formalism. Or, to put it differently, he wanted to go beyond a conception of the visual image that confined it to either conventional meaning or meaningless abstraction.

Schapiro's brief essay "On Some Problems in the Semiotics of Visual Art: Field and Vehicle in Image Signs" (1969) and his little book *Words and Pictures* (1973) are attempts to problematize iconography by reorienting attention toward the nonmimetic aspects of the image. In "On Some Problems in the Semiotics of Visual Art," he took up the theme of "the non-mimetic elements of the image-sign and their role in constituting the sign."[76] These include the prepared surface, the boundaries and frame, the positions and directions in the field and its shape, and qualities of the image substance. In other words, he attended to those "formal" aspects of the image which do not easily lend themselves to interpretation. Schapiro's project was to expand the field of the meaningful beyond mimetic figuration to include neglected, figural, aspects of the image. As such, it both benefited from and contributed to our understanding of abstraction. He was particularly concerned to determine "to what extent these elements are arbitrary and to what extent they inhere in the organic conditions of imaging and perception."[77] For instance, Schapiro inquired into the role of the frame in constituting the meaning of the sign. Drawing on Wölfflin's *Principles of Art History*, he noted how com-

position is often adjusted to the strong horizontal and verticals of the frame, although beginning in the sixteenth and seventeenth centuries, composition can use the frame to cut foreground objects and so suggest a continuous space behind the frame. "By intercepting these objects the frame seems to cross a represented field that extends behind it at the sides. Degas and Toulouse-Lautrec were ingenious masters of this kind of imagery."[78] Schapiro also observed the way the space around figures affects our sense of them. This is even more evident where several figures are presented, for "then the intervals between them produce a rhythm of body and void and determine effects of intimacy, encroachment, and isolation, like the intervals of space in an actual human group."[79] Schapiro mentioned Edvard Munch in this context, especially his portraits of introverted characters positioned a little to one side in an empty space. Yet this positioning cannot be construed as a purely arbitrary artistic convention, for as he noted, emotionally disturbed children favor an off-center position in their drawings.[80] Throughout the essay, Schapiro adduced cases where nonmimetic, noniconographical (or, in Lyotard's terms, figural) aspects of the image put pressure on how we understand it. Also, what might be construed as purely formal or conventional turns out to be at least partially motivated.

In *Words and Pictures*, Schapiro was again interested in expanding the field of the pictorially significant to include nonmimetic aspects. Specifically, he was concerned to demonstrate that the depiction of a biblical story does not simply double the text; rather, figuration inflects the story and can actually form the basis for later textual elaborations. Although some illustrations may reduce a complex narrative to a simple pictogram, others enlarge the text, adding detail, figures, and settings that are not given in the written source.[81] As Hubert Damisch has observed, Schapiro showed that the relationship of text to image is reciprocal. In support of this principle, Damisch refers to Freud's idea of the translation of thoughts into dreams that involve the work of figuration, and this has certain consequences.[82] Like Freud, Schapiro inquired into how this transposition is carried out.[83]

The closing chapter of *Words and Pictures*, "Frontal and Profile as Symbolic Form," centers on an opposition that in some way operates like the linguistic system of differences. This is clear in the following passage:

> In other arts besides the medieval Christian, profile and frontal are often coupled in the same work as carriers of opposed qualities. One of the pair is

the vehicle of the higher value and the other, by contrast, marks the lesser. The opposition is reinforced in turn by differences in size, posture, costume, place, and physiognomy as attributes of the polarized individuals. The duality of the frontal and profile can signify then the distinction between good and evil, the sacred and the less sacred or profane, the heavenly and the earthly, the ruler and the ruled, the noble and the plebeian, the active and the passive, the engaged and the unengaged, the living and the dead, the real person and the image. The matching of these qualities and states with the frontal and profile varies in different cultures, but common is the notion of a polarity expressed through the contrasted positions.[84]

Here Schapiro demonstrates the usefulness of thinking of meaning in the visual arts as the function of a system of opposed elements, but he also observes that there are limits to the appropriateness of the linguistic analogy, particularly as regards arbitrariness. For instance, he is interested in the way the choice of frontal or profile position of the head or body is grounded in the everyday experience of the human body—as when a frontal face is endowed with an implicit address to the spectator. This would seem to imply that the profile figure is, conversely, less endowed with inner life. Yet as Schapiro notes, Giotto's dramatic rendition of *The Betrayal of Christ* suggests that this is not so (figure 24). While in much medieval picturing Christ and Judas are set off against each other in a sharp contrast of frontal and profile, Giotto greatly enhances the dramatic intensity of the confrontation by juxtaposing two contrasting faces in profile. For Schapiro, there is an analogy to be made here with third-person narration, which can communicate as much a sense of an inner life as first-person narration. No fixed meaning can be attached to either position: the frontal head can be intimate, confrontational, transcendent, or "blind." This plurality of possible meanings should not, however, force the conclusion that they are purely differential, arbitrary, and conventional. It is just that different latent meanings are given weight in particular contexts. In the "Frontal and Profile" chapter, Schapiro demonstrated that something analogous to the differential phonemes in language also inflect the visual image. The cumulative effect of Schapiro's work is to diminish the distance between word and image by establishing common ground for them through semiotics.

Schapiro did not write in a general way about art-historical procedures. One searches in vain for a statement of how he conceived of the discipline. Yet there is one essay that is particularly revealing about what he valued. It

is a tribute to the nineteenth-century critic Eugène Fromentin, famous for his *Old Masters of Belgium and Holland*.[85] Fromentin is that unusual thing, wrote Schapiro, a critic who is "an accomplished artist [and] also a first rate writer."[86] The critic is praised for having found a way of writing about pictures that gives weight to the material properties and formal interest of paintings while at the same time seeing these as revelatory of the artist and his time. He observes the fabric of the painting as a sensory matter, yet this facture is seen as "a product of feeling, a result of the whole psychic disposition of the artist."[87] More striking is that Schapiro praised the manner in which the critic included the response of the observer; Fromentin's prose "could evoke the observed and the observer together, without dissolving the object in the sensation or mood."[88] This is the language of Merleau-Ponty, who found in Cézanne a painter whose work is a fusion of self and world, yet who, after Impressionism, "wanted the find the object again behind the atmosphere."[89]

We have seen how the work of Lyotard, Barthes, and Schapiro converges around Merleau-Ponty and the idea of the figurality inherent in the sign.

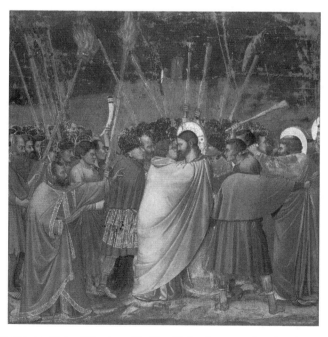

FIGURE 24. Giotto di Bondone, *The Kiss of Judas*. Scrovegni Chapel, Padua, Italy. Cameraphoto Arte, Venice/Art Resource, NY.

While Schapiro emphasized the way nonfigurative aspects of depiction help to constitute the meaning of the image, Lyotard and late Barthes were more interested in how figurality destabilizes determinate meanings and escapes the net of discourse. Unlike Schapiro, they tended to set a value on whatever is outside discourse—sensuous materiality, affect, intensities of all kinds—and they are inclined to regard these as having a liberating or subversive value. Yet their writing, their language, and their conceptual delicacy evoke these mute realities and so to some extent reconcile seeing and reading. In his less rhetorical moments, Barthes fully appreciated this. In 1978 he paid tribute to Jakobson's contribution to cultural theory by saying that he gave linguistics to critics and so conjoined scientific and creative thought. He showed that it was possible to go beyond the easy opposition of spontaneity and codification. Poetry is coded but always inflected by drives, fantasy, dream.[90] Although Barthes found it difficult to reconcile his own ambivalence, here he seems to point the way forward.

POSTSCRIPT ON T. J. CLARK

We have mainly been concerned in this chapter with debates from the 1960s and 70s, a time when these issues were vigorously contested, so it might be worth citing, in closing, a more recent book where they reemerge. *The Sight of Death* by T. J. Clark ought in any case to find its way into the pages of this book, since it is subtitled *An Experiment in Art Writing*.[91] Its special pertinence here is Clark's passionate plea for preserving figurality, or what he calls the materiality of painting.[92]

> I believe the distance of visual imagery from verbal discourse is the most precious thing about it. It represents one possibility of resistance in a world saturated by slogans, labels, sales pitches, little marketing meaning-motifs. To see the distance narrowed day by day, and intellectuals applauding the narrowing in the name of some wholly illusory "transition from the world of the word to that of the image"—when what we have is a deadly reconciliation of the two modes, via the utter banalization of both—this is bitter to me.[93]

The book consists of diary entries recording Clark's patient daily viewing and reviewing of two paintings by Nicolas Poussin. This slow process over several months is for Clark a form of resistance to the regime of media "image flow" and the culture of quick consumption.[94] The work of art's figurality

does not release its sense all at once, and so we are drawn back to it again and again—not to the image, whether photographic or remembered, but to the thing itself, which alone is able to "interfere with our preconceptions."[95] Although he does not mention it, a very important aspect of the process of coming to terms with the paintings is the note-taking, not just the repeated viewing. It is the very act of articulating what he sees and then testing those descriptions against the painting that enables Clark to see more and better. While the visual, material work of art is on the edge of the verbal, Clark insists that we must not allow it to be eclipsed by discourse. Writing about art makes sense of mute things, but "it should invent ways for this explicitness to be overtaken again by the thing-ness, the muteness, of what it started from."[96] This will certainly mean resisting totalizing or conclusive interpretations. But it might also be a matter of finding a tone of voice in one's critical prose that is interrogative, tentative, and intimate.

Plasticity

THE HEGELIAN WRITING OF ART

The modern discipline of art history emerges to a high degree out of a series of struggles with the complex account of art and its history given by G. W. F. Hegel in a series of lecture courses at the University of Berlin between 1820 and 1829. If Immanuel Kant's *Critique of Judgment* had laid down a view of beauty, and so also of art, that has continued to be central to aesthetics and has been particularly important for formalist accounts of art, there is little in that text or argument that might lead one to imagine a discrete discipline that would take art in its historical existence and transformation as its object; "art" itself is taken as a derivative and somewhat compromised—"dependent"—mode of the beautiful, and what we quite comfortably call "history" shows up only indirectly as a pressure that inflects the discussions of originality and genius, particularly in their obscure connection with the experience of the sublime. By contrast, Hegel's lectures begin by dismissing any serious interest in natural beauty, taking "fine art" as the primary object of aesthetics and as an object that can be fully grasped only by an account that is both historical and deeply responsive to art's particular internal division into the distinct practices of architecture, sculpture, painting, music, and poetry. While she may well find much to object to in Hegel's account and find herself also struggling with the many difficulties of Hegel's vocabulary and mode of argument, the modern art-historical reader of Hegel's lectures is likely to feel fundamentally at home with the kind of account it offers as well as the kind of treatment it gives to the many actual works of art it considers.

Hegel's modern familiarity cuts deeper still: Hegel's lectures were given in what amounts to the first modern university—an institution in whose formation Hegel took a deep and active interest—and were exactly contemporary with the construction of what is generally recognized as the first modern museum of art (they were in fact delivered mere blocks away from

that ongoing work of construction). While in his lectures Hegel takes no particular interest in and offers no account of this new institution, the museum itself enacts in its plan a view of art deeply resonant with that proposed by the philosopher.

That Hegel did not see himself as announcing a new discipline is presumably deeply tied to one of the best-known features of his aesthetics: the claim that art, now, is a thing of the past, the driving impulse of which has effectively passed over into philosophy. Those among Hegel's readers who saw in his lectures the possibility of a new discipline—Heinrich Wölfflin, Alois Riegl, and (somewhat differently) Aby Warburg would certainly figure prominently among such readers—found themselves more or less immediately at odds with that claim. At the same time, it seems clear that a part of what they found compelling in Hegel's account was its ability to articulate the relation between art's history and the emergence of art as a historical object—between, say, art's history and our modern interest in, and capacity for, talking about it. A slightly later generation of art historians—of whom Erwin Panofsky and Ernest Gombrich are certainly the most influential—were much more inclined to cut through the complicated knot that seemed to keep on entangling the nascent discipline with Hegel's terms, seeking instead a methodologically guaranteed objectivity that could set art history on epistemological ground broadly shared with modern science. The sense that this cut has still not been fully accomplished continues to be strong in contemporary disciplinary reflection.[1]

Given the scope and complexity of Hegel's thought on art, the goal of this chapter is modest and highly specific; it is simply to explore, and in a sense renew, the Hegelian question of the relation between art's history—its being historical—and the writing of that history. It means then to open up one particular and explicit address to a claim that has animated this book throughout. The claim is that art history is a discipline of texts, integrally informed by practices of reading and of writing, and can find neither its object nor its proper objectivity apart from such practices. The implicit contrast is with an understanding of art history that takes "art" to be more or less directly available as an object of knowledge—the understanding advanced by Panofsky and, following him, Gombrich. It is also in contrast with a position that first appears to be at odds with that held by Panofsky and Gombrich, because it takes "art" to be unavailable as an object of knowledge. However, because this position continues to rely on the same general picture of objec-

tive knowledge, it ends up demanding that the discipline shift its attention toward an object—most frequently referred to as "visual culture"[2]—that would be available in this way.

We can begin from a highly schematic overview of the most general terms of Hegel's account of art—that is, its most general view of "art," the broadest historical terms it offers for exploring this, and the sense Hegel proposes for the variousness and discreteness of artistic mediums or practices.

1. That Hegel sees philosophy succeeding on art already indicates that he sees art as a particular form of thought, a moment of its history. As such it is necessarily meaningful, and so he takes it that any adequate dealing with art cannot be purely formal but must work through both form and content. Unsurprisingly, he says that in great art "form" finds a special adequacy to "content," but this familiar claim takes on an unusual force and consequence when he goes on to say that what counts in any given instance as "adequacy" depends on what the content actually is: where, for example, the content is essentially and necessarily inchoate, adequate form will look very different from adequate form in the case of a more tightly delimited or explicitly differentiated content (and that the content of a work of art may be inchoate does not preclude its being the content of great art).

2. That the relation between form and content can vary in this way means that artistic achievement can be highly variable over space and time; the terms in which one may properly appreciate or explicate a Greek sculpture will not necessarily be appropriate to a medieval cathedral or a Persian miniature (it is again a feature of Hegel's distinctive modern world, as opposed to Kant's, that Persian miniatures are in it and are to be taken account of: that we are often not happy with the particular things Hegel says about such works should not blind us his embrace of them as a part of what demands address). Hegel argues that this variation has a particular historical sense and can be ordered as development. The most abstract and general form of this development is from art he calls "Symbolic" through the "Classical" to the "Romantic." These represent, in terms that are a mixture of the historical and the geographical ("Eurocentric," then), (1) all pre-Greek and non-Western art; (2) Greek art; and (3) post-Greek, essentially Christian, art. They are conceptually distinguished as three distinct kinds of content—very roughly: abstract universality, concrete individuality, and concrete universality.

3. The arts themselves are distinguished in terms of their aptness—at any and every historical moment—for providing form for one or another kind of content, thus answering to one or another ideal of adequacy.

Given this general scheme, it's unsurprising that architecture turns out to be the privileged art of the Symbolic moment as sculpture is that of the

Classical, and that painting, poetry, and music will be the leading arts of the Romantic period, thus yielding a general sense that art itself develops from architecture through sculpture to what are, for Hegel, the distinctively modern arts.

PERIOD	MEDIUM
Symbolic	Architecture
Classical	Sculpture
Romantic	Painting, Poetry, Music

There is, of course, already a good bit to object in this: The claim about the end of art strikes almost all of Hegel's readers as simply false (sometimes because they also believe that art is not the kind of thing that can end, and sometimes because they imagine some other ending of art, with, say, Duchamp or Warhol or perhaps someone yet to come). Readers are also mostly unwilling to accept the large-scale historical schema of Symbolic-Classical-Romantic (sometimes on the grounds that such schemas—"grand narratives"—are in general unacceptable, and sometimes on the narrower grounds of this particular scheme's overt ethnocentrism), and many contemporary readers have trouble taking seriously the depth to which notions of medium enter into Hegel's view of art (perhaps because we take ourselves now to be significantly beyond medium or too aware of the proliferation of new media to operate with such a short and historically arbitrary list of possibilities).

But there are also reasons why one might want not to simply set these objections aside but to at least go slowly with them. If we take the end-of-art claim to be first of all a claim about the relation between art's history and a certain achieved visibility of that history, we may be willing to wear it lightly for a time. Similarly, if we see the historical scheme as at least aimed at capturing certain features if not of art itself then of "art," a particular term that emerges out of a particular history, we may again be willing to let things float a bit to see where they might finally settle. And finally, if we recognize that a term like "painting" itself covers a wide range of actual technologies, we may be willing to suspend for a time our certainties about what might and might not constitute a new medium or what difference one

or another new technology might make to art's possibilities. Refusing to put Hegel down in the face of the most obvious and immediate objections has the dual virtues of letting us see the potential richness of Hegel's terms once they are set into concrete play and of allowing us to ask about the underlying logic to which they are presumably finally answerable. Our primary business in this chapter will be with the second of these, but just as it was useful in some degree to peel off the most external layer of Hegel's argument, it will be useful as well to look briefly at the second layer that becomes visible as Hegel moves beyond mere schematization and into his actual, and notably extended, account of art and its history.

Here it is a matter of wheels within wheels—somewhat like the children's drawing toy called a Spirograph or that other child's toy that allows one to make systems of plastic gears in which several turns of the smallest gear result in one revolution of the next largest gear, which itself slowly turns a still larger one, which may in turn cause several smaller gears to turn over within it.

Hegel's historical terms work this way inside one another—the Symbolic in its largest sense works its own way through the whole scheme of Symbolic, Classical, and Romantic (Wölfflin's remark that "the Baroque has its classical" is readable in part as a displaced echo of this bit of Hegel), and whatever medium one or another moment may privilege, the full range of artistic mediums is always active, so any given moment has both a complexly

sedimented historical depth and an interesting and consequential breadth. It's perhaps worth noticing that Hegel's history has "periods" because such punctuation is the natural consequence of this kind of dialectical movement—much the way a bicycle wheel with a dab of paint on it will leave a marked-out line in its wake.

These pictures may help give not only some sense of the potential richness of the analytical work Hegel's machinery can perform but also an intuitive sense for the major figures Hegel's system tends to gather to itself; Hegel himself most frequently speaks in terms of the circle and circles of circles, and readers tend also to appeal quite strongly to the image of a sort of spiraling development to Hegel's histories and arguments, with later moments emerging as repetitions, "at a higher level," of earlier developments.[3] Why things should assume this shape for Hegel is, in the end, a question of the nature of Hegelian argument, but before we take up that question, it is worth pausing a bit longer over the shape itself. "Circle of circles" is a figure for what Hegel more formally calls "the system" and takes to be the proper form of fully achieved philosophic thought—the shape, then, of what is often called "the Absolute" (it will be important that Hegel for the most part uses "absolute" not as a noun but as a modifier, typically of "knowledge"). Hegel's insistence that absolute knowledge takes the form of a system is in distinct contrast with Kant's appeal to an "architectonic" picture of philosophy. Where Kant's picture invokes foundations and what can be solidly built on them once they are properly laid, Hegel's aims at something that is radically self-supporting, having no foundations outside itself and so stable only, one might say, in its completion (and so also importantly unfounded in its inception—Hegelian beginnings are always in some sense middles, in need of securing).

From Hegel's point of view, there are two things one can sensibly say

about Kant's architectonic model: on the one hand, to the extent that the picture of well-secured foundations suggests that philosophy has relation to a ground that continues to lie outside it, it offers an inadequate image of philosophy, and on the other hand, to the extent that Kant's actual achievement outraces this picture, the picture itself presents an internal obstacle to its fullest realization. Hegel's phrase "absolute knowledge" means, then, to name a form of knowledge absolved of external relation—what it is knowledge "of" does not lie outside of it—and to this extent it is a form of knowledge that will strike later thinkers (Heidegger would be the primary instance here, but Nietzsche would be another important instance) as more or less directly convertible into ontology, a showing of what is as it is (or, mimicking some of Heidegger's bendings of language, as it "ises").

Hegel repeatedly picks out the *Critique of Judgment* as the place where something crucial happens to the Kantian conception of philosophic form and argument. What Hegel is presumably getting at can be picked up in rough ways easily enough, either by noticing that the *Third Critique* is peculiarly disunified by contrast with the earlier critiques of Pure Reason and of Practical Reason and is so because it has for its fundamental object various relations among capacities of mind rather than those capacities themselves (the *Critique of Judgment* adds no further faculty to the Kantian universe of Reason, Understanding, Intuition, and Imagination), or by noticing that Kant's two main systems of philosophic metaphor—the architectonic system and a closely related set of metaphors of domains or territories and the legislations they are answerable to—both start showing signs of strain and of shifting internal emphases in the *Critique of Judgment*. The architectonic appeal to foundations reaches out for the rather different image of the keystone with its movement beyond the dynamics of post-and-lintel.[4] Kant similarly finds himself having to address the question of a legislation that happens without a territory to which it applies and worrying at how to think about the relation between, for example, islands and the water that both divides them and is at the same time their actual means of communication, or exploring the metaphorical possibilities of the bridge rather than the building.

Heidegger devoted a fair amount of attention to understanding Hegel's insistence on philosophy as a system in its relation to the claim for the Absolute, and although one doesn't often appeal to Heidegger for clarification, some of his words here may be useful:

> If . . . a tendency toward system remains everywhere since the beginning of the modern period [it's worth noting this specifically historical term], yet through Kant and since Kant . . . something different is added to the will to system. What is different, however, comes completely to light [and this phrase to is worth noting in the context of our worrying over the horizon, its modern fate and figures] only in the moment when philosophy is urged beyond Kant. What is urgent about going beyond Kant is nothing other than the task of system. . . .
>
> For the development of the demand of a system urges precisely toward understanding system less and less only as the framework of knowledge of beings and more and more as the jointure of Being itself, and toward shaping it accordingly.[5]

Or, on the Absolute:

> For knowledge to be qualitatively other than relative knowledge, for it to be other than a knowledge which is carried over to what is known and is bound there, it must not remain bound but must liberate and ab-solve itself from what it knows and yet as so ab-solved, as ab-solute, still be a knowledge. To be ab-solved from what is known does not mean "abandoning" it, but "preserving it by elevating it." This elevation is an absolving which *knows*; that is, what is known is still known, but in being known it is now *changed*.[6]

And finally this, bringing the two thoughts together:

> *The unbounded origin of the unity of both* self-consciousness and conscious-ness, *as they belong together, is a knowledge that is aware of itself as the purely unbounded, purely absolved absolute knowledge,* which provisionally we call reason.[7]

The double stroke of "unbounded" marks the job done: there are no lim-its to absolute knowledge that are not absolutely its own, touching, then, no outside. "Absolute knowledge is genuine knowledge, the science. That science which knows in an absolute way 'knows the absolute.' Science as ab-solute knowledge is *in itself system*, according to its most essential character. The system is not an optional framework or ordering of absolute knowledge by way of addition."[8]

We will shortly have more sustained business with elements of these formulations, but for the moment it's probably worth taking out just one point of special relevance to Hegel's discussion of art and its history. That philosophy has a proper form is an important feature of it, and it is rea-

sonable to assume that a part of what Hegel must mean in saying that art eventually passes over into philosophy is that philosophy's form—its ability to find and assume its proper shape—is one outcome of art's history. While this thread is nowhere placed by Hegel in the foreground of his view of art, there is good reason to say that he holds that art, at every moment divided into a multiplicity of practices, has a continuing stake in imagining its unity and that these historically variable imaginations of art's unity are steps along the way to philosophy's ability to grasp its proper, self-grounding unity and form. Staying at the level of Hegel's largest structures, one would then say that a part of what it means to speak of a particular art's being privileged at one or another historical moment must include some account of its projected sense of what art as a whole is. In the case of architecture this amounts to a recognition of a multiplicity merely externally ordered. In the case of sculpture it is more nearly a matter of a tightly bound central meaning or value. And in the case of the Romantic constellation of painting, poetry, and music, art gives itself as the subject of an internally necessary and necessarily ordered dispersion—a version of what came in the eighteenth and nineteenth centuries to be called, precisely, the system of the arts.

Symbolic	Architecture	Everything under one roof *
Classical	Sculpture	Art as an essentially unified practice or value
Romantic	Painting, Poetry, Music	A system of the arts

*As we will see, this is more accurately put as "one thing after another," but we are not at present able to recognize that as an architectural image.

These differences in the imagined overall shape of art point both toward a certain work that art historically does in bringing thought to its proper shape and toward the notably distinct types of thinking that architecture, sculpture, and the Romantic arts evidently are (that is, as we move closer to Hegel's specific accounts of each of these arts, we should see more clearly why they pose art as a whole in the way they each do). We also see, for the first time in this chapter, a typically Hegelian argumentative and historical movement—from the architectural recognition of multiplicity through a sculptural suppression of that multiplicity, to its recovery under the new

conditions that follow from that suppression—the all-too-familiar pattern of A, -A, --A: thesis, antithesis, synthesis.[9]

To understand this more closely, we will have to start looking at some of Hegel's sentences. In particular, we want to look at this remark—taken not from the *Lectures on Fine Art* but from the *Phenomenology of Spirit*:

> One difficulty which should be avoided comes from mixing up the speculative with the ratiocinative methods, so that what is said of the Subject at one time signifies its Notion, at another time merely its Predicate or accidental property. The one method interferes with the other, and only a philosophical exposition that rigidly excludes the usual way of relating the parts of a proposition could achieve the goal of plasticity.[10]

This statement will matter to us because, intended as a statement about logic, about the "speculative proposition" that Hegel understands to be the essential stuff of philosophic argument, it turns in part on a word—"plasticity"—that we cannot understand except by turning toward a particular moment in Hegel's aesthetics.

But first the logical stakes: In the immediately preceding sections of the *Phenomenology*'s preface, Hegel has worked his way through an example of the difficulty he is here giving in general summary. "God" is the Subject of the proposition "God is good," and "goodness" is that Subject's Predicate. When Hegel says that "ratiocinative method" sometimes understands God's goodness as its Notion and at other times as its merely accidental property, he means that this usual understanding of the proposition is unsure whether it means that God is good but might under different circumstances have been bad ("goodness" is an accidental property, then—one that merely got attached to God, who was God before that property got attached and would still be God if it were replaced by another), or that goodness is simply integral to God as God, irreplaceable, already implicit in the bare Notion of God and made explicit in and as that Notion's propositional unfolding.[11]

What this means for Hegel is that any proposition must be subject to a sort of double reading, forward and backward as it were, so that the essential interlacing of Subject and Predicate within the Notion is made fully explicit—God's goodness means that goodness is Godly, Subject and Predicate affirming in their reversibility their utter interdependence. And this in turn means that Hegelian argument cannot be imagined as a sequence of

propositions set in appropriate relation to one another but happens instead as the writing of sentences that continuously rewrite one another in an ongoing movement of explication ("rendering explicit" but also "unfolding" or "folding out"), each new sentence repeating, revising, and securing its predecessor even as it opens itself toward further repetition, revision, and securing (so we can now say that Hegel's "periodicity" is also that proper to a sentence, to the necessity of its punctuation). One might equally say that every Hegelian sentence is immediately the necessary object of a reading that can be realized only as a further sentence, and putting it this way may make clear how far Hegel's idea of philosophic achievement must be involved with some sense of creating a text that can show itself to have come to the end of its reading—a certain kind of finality, a closure of reading, that must be achieved and is neither simply given with ("natural") language nor to be attained just by being clear about what one means (as in the various seventeenth- and eighteenth-century projects aimed at a more adequate artificial language or calculus). It's far from clear that "transparency" is an adequate figure for this.

The word *plasticity* as it shows up at the conclusion of our passage points, at a minimum, to the persistence for a purely philosophical exposition of a question of "form" that is deeply bound up with the fact and necessity of expression, of language, and of writing. And the fact of writing as it is discovered here is inseparable from the fact of reading: reading is writing's internal motor, and writing is itself the event of reading (we are worlds away from any understanding of these things as encoding and decoding, production and reception—and so also worlds away from the imagination of time that allows us to imagine such separate and sequential moments). Given all this, it is perhaps not surprising to find in the *Phenomenology*'s preface also this account of the speculative proposition:

> Formally, what has been said can be expressed thus: the general nature of the judgment or proposition, which involves the distinction of Subject and Predicate, is destroyed by the speculative proposition, and the proposition of identity which the former becomes contains the counter-thrust against that subject-predicate relationship.—This conflict between the general form of the proposition and the unity of the Notion which destroys it is similar to the conflict that occurs in rhythm between metre and accent. Rhythm results from the floating centre and the unification of the two. So, too, in the philosophical proposition the identification of Subject and Predicate is not meant

to destroy the difference between them, which the form of the proposition expresses; their unity, rather, is meant to emerge as a harmony.[12]

The word "formally" with which this passage opens seems to promise a fully "technical" account of the proposition—but of course by the end it has taken on the scope we associate with the word as we use it in speaking of poetry or music.[13]

If we step back a bit and look at the words "plastic" and "plasticity" more broadly, we're likely to be struck by how unsure our sense of their shared meanings actually is—at one pole, "plastic" seems to be a way of saying "form," and at an opposite pole the reference is likely to strike us more material and specific than that, "plasticity" as a quality of what is materially formable, subject to molding and the like. Hegel's lectures took as their topic "the fine arts"—arts we now refer to more often as "the visual arts" but that also have at times been called "the plastic arts," although this latter phrase probably strikes us as putting a premium on architecture and sculpture just where "visual arts" places its premium on painting and other arts that appeal strongly to "the image." For some, the qualifier "plastic" will bring music into interesting proximity to its more directly visual counterparts.

Despite its striking place in the remarks we've been exploring, "plastic" is not an explicit technical term in Hegel and not one he uses a great deal.[14] But it does figure very importantly in one particular section of the *Aesthetics*—the treatment of classical sculpture (itself divided, in keeping with Hegel's dual focus on history and medium, between the discussion of the Classical in the first volume and the treatment of sculpture in the second).

As we've seen, Hegelian argument has a very particular structure, and we can make some sense of this location even before turning to the details of the actual discussion. We've seen, for example, the more or less familiar pattern of Hegelian dialectic with its moments of return and transformation, and when we graph this out roughly we can see also the equivalences the scheme sets up:

Or, as we might fill in concretely for our current concern:

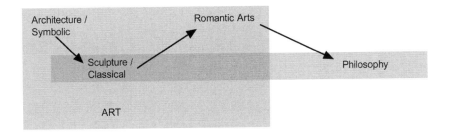

The diagram helps make it clear how philosophy is, outside of art, the repetition ("at a higher level") of sculpture within it, and so how the term "plasticity" might figure interestingly in descriptions of both. The diagram is also misleading in one respect—it appears to present both sculpture and philosophy as "negative" moments in the dialectic, whereas philosophy is clearly intended as the positive outcome of art's history, what succeeds on its dissolution. So we ought properly to invert the whole picture. Doing so will significantly shift our sense of its primary features and bring new elements into play:

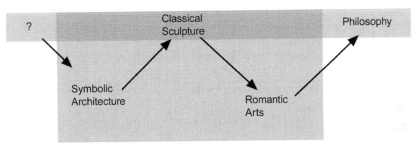

This gets the Hegelian shape of art's history right—an incipience that rises to something like a moment of achievement and then falls into a dissolution that does not amount to the shape of a self-subsisting object but can be only an episode within the demonstration of a larger object. If we put this in terms of the grammar of the speculative proposition, "art" begins as a predicate of something other than art and gives rise to an apparent subject whose further predication carries the proposition beyond art's ability to provide its subject. "Philosophy," Hegel writes in the introduction to the *Lectures on Fine Art*, "has to consider an object in its necessity, not merely according to subjective necessity or external ordering, classification, etc.; it has to unfold and prove the object, according to the necessity of its own inner nature."[15] In the particular case of art, the unfolding ends as, in

this sense, a disproof of the object—although that disproof is an important part of the larger proof of thought. The rearranging of diagrams that helped bring this point out also, and necessarily, introduced a new element that must belong to any attempt to make sense of the role of "plasticity" in and beyond Hegel's aesthetics. This new element is the extraartistic origin of art that is in some sense rediscovered and revised first as classical sculpture and then as philosophy.

As one would expect, characterizations of this element figure in the introductions to Hegel's discussions of both architecture and the symbolic form of art. In the first instance, this characterization is very brief and is uneasily balanced between analogy and argument:

> The primary and original need of art is that an idea or thought generated by the spirit shall be produced by man as his own work and presented by him, just as in language there are ideas which man communicates as such and makes intelligible to others. But in a language the means of communication is nothing but a sign and therefore something purely external and arbitrary; whereas art may not avail itself of mere signs only but must give to meaning a corresponding sensuous presence.[16]

The introduction to the discussion of symbolic art is more expansive and more clearly argumentative. "The symbol," Hegel writes, "in the meaning of the word used here, constitutes the beginning of art, alike in its essential nature and its historical appearance, and is therefore to be considered only, as it were, as the threshold of art."[17] He then goes on to detail the finer gradations of this threshold, defining the symbol as a sign, but importantly not a "*mere* sign" in which the "connection which meaning and its expression have with one another is only a purely arbitrary linkage."[18] The symbol that matters to art begins from "kinship, relation, and concrete interpenetration of meaning and shape."[19]

That a problem with language should find its first working through as architecture may seem somewhat surprising, but it may seem to make a bit more sense when one realizes that for Hegel architecture's most "primitive" (earliest, but also most fully architectural) forms are processual—temple precincts, labyrinths, colossal colonnades—defined by neither walls nor roof but by their articulation of a space or a way (see figure 25).[20] This of course also shows something about Hegel's conception of language—that it is more nearly a means of articulation than a set of containers of meaning,

FIGURE 25. Processional way of ram-sphinxes. Temple of Amun, Karnak, Thebes, Egypt.
Vanni/Art Resource, NY.

or that in it the imagination of discrete meanings is a consequence of a work of articulation prior to those meanings. Given the role of the sentence in Hegelian logic, this will hardly be surprising.

To take out the most general moral: Art is a response to the arbitrariness of the material imposition on thought that language first of all seems to be. Art's ending is thought's coming to be at peace with its own material conditions, and art's history matters because it is the concrete working through of thought's radical answerability to the world, the necessity of our speaking. To say, evidently against Hegel, that art has not yet ended would be to say that our language is not yet simply or wholly our own. Jacques Derrida has famously taken writing as the permanent marker of this condition; *plasticity* appears to be Hegel's word for language's capacity to not so much undo as redeem its arbitrariness. Absolute Knowledge does not involve some kind of passage beyond language (toward, say, some realm of "pure" thought) but makes itself of language in some special way, and this "special way" is evidently a sort of repetition or revision of sculpture's way of realizing its specific thought.

As we turn, then, to Hegel's account of Classical sculpture, we have to

begin from the recognition that *plasticity* cannot be taken up first of all as a formal term of some sort, a shorthand for the particular nature of sculptural making. Sculpture's highest achievements are integrally linked to the content to which it gives form: its "plasticity" matters only because it is the form taken by a content that is itself essentially and crucially "plastic." In the case of Classical Greek sculpture, this content is, above all, the Greek gods, and so Hegel's account is to a high degree an account not of sculptural technique or form but of the becoming plastic of the gods, an event that he takes to be one of the central explicit features of Greek myth and religious life.

This means that Classical Greek sculpture neither articulates (as sculptural colossi do in their Symbolic solidarity with architecture) nor gives form to (as sculpture does within the Romantic arts) anything. Rather, something takes form in it, or, more accurately, as it. There is nothing "inside" it and, in that sense, nothing it expresses: it is the direct and complete exposure or exposition of its content, all "outside." You cannot have these gods without having them as sculpture, and in having them that way the Greeks become capable of a particular kind of self-recognition.

A useful contrast here may be between the mixed (as we would say) architectural/sculptural temple that articulates a procession, creating social parts unified only by their unfolding along a common path, with Hegel's understanding of the Greek temple as an emanation or further expression of the sculpture that stands at and as its center for a people who become one people in being thus centered (and one gets the full weight of Hegel's claim by insisting that for him the sculpture does not have a center but is itself a center, a point with no interior). To be Greek is to participate in the formative process that makes the Greek gods what they are—selves in a strict Hegelian sense[21]—and so makes Greek culture and identity what it is.

It's worth noticing that the major controversies over late modern sculpture can seem in many ways to repeat or rework this Hegelian contrast. Think, for example, of the arguments around public sculpture and most saliently over the U.S. Vietnam War Memorial—Maya Lin's winning entry is notably processual, broadly "architectural," and highly articulatory, giving up on any attempt at a center or central image around which we might gather as "Americans" in favor of a sequence of individual encounters. Those who have been unhappy with it have evidently wanted to believe that it was still possible to make something—like the earlier Iwo Jima Memorial—around which a people could gather in some kind of mutual recognition of shared

FIGURE 26. Maya Lin, Vietnam Veterans Memorial (1982). Photo © Greer Pagano.

struggle, losses, and identity (that Frederick Hart's countermemorial is in fact a group sculpture already marks its falling away from the Greek ideal).

Or think of the contrast between the sculptural work of David Smith and that of Donald Judd. Both bodies of work seem to assume—this would be their Romanticism, as Hegel would say, or Modernism, as we might more comfortably say—that there is some kind of absence or emptiness or finitude to be addressed or registered, which is to say that both have a problem of sorts about the relation between the sculpture's "center" and the achievement of a fully sculptural presence, exposure, or exhibition. Smith thus works, on the best accounts of his work, to make something that will be fully present to each of its viewers at every position while also admitting a kind of structural vacancy and self-interference that make our individuality

and separateness a distinct feature of an experience that we nonetheless take as essentially shared, personal but not private. This is sculpture that means to, as it were, force the recognition that it is all outside (Greek sculpture has no need to force this recognition; it just is what it is in its showing of itself) without allowing that outside to conceal or point toward a distinct inside. This is its way of being a center, but given a certain late-modern artistic and more broadly social awareness that "we" no longer find ourselves resolvable into some larger identity (one might say that the point has become something more like a knot, its exteriority a function of its own self-interference).

In Judd's work the vacancy moves to a distinct interior, becomes, in Michael Fried's compelling description of such work, a hollowness, and this relation of interior and exterior, the one both expressing and concealing the other, unfolds with a certain logical immediacy into the individual unit's

FIGURE 27. Frederick Hart, *The Three Soldiers*, part of the Vietnam Veterans Memorial (1984). Washington, DC, USA/Peter Newark Military Pictures/The Bridgeman Art Library.

FIGURE 28. Photograph taken by David Smith, *Cubi XVIII, 1964, Cubi XVII, 1963, and Cubi XIX, 1964, at Bolton Landing* (ca. 1964). Art and photo © Estate of David Smith/Licensed by VAGA, New York, NY.

FIGURE 29. Donald Judd, *Untitled* (1971). Collection of the Walker Art Center, Minneapolis. Gift of the T. B. Walker Foundation, 1971. © Judd Foundation, Licensed by VAGA, New York, NY.

repetition, opening the work toward the condition of the mixed architec-
tural/sculptural processional (Judd's seriality thus makes explicit an internal
relation to architecture already implicit in the individual unit's situation in,
and in relation to, the gallery).[22] Where Smith's work still aims to claim
a collective audience of a certain dispersed kind (Smith tended to docu-
ment his works as conversational groups, asking them to manifest among
themselves something like the terms they imagine for their audience),
Judd's work makes the individual in his or her enforced privacy its leading
social fact.

One motive for Judd's work is a desire for a radical abstraction in sculp-
ture equivalent to that achieved by painting at midcentury and for which the
overt anthropomorphism of Smith's sculpture is a clear problem. There is a
great deal that might be said about this, but for Hegel the key point would
surely be that sculpture is necessarily and essentially anthropomorphic:
what *plasticity* means is, essentially, having the shape of a self, so sculpture
wishing not to have this shape wishes not to be sculpture (and, to the extent
that it is nonetheless still sculpture, evidently has that shape in the distinct-
ly self-like mode of evasion or concealment).[23] Classical Greek sculpture
necessarily finds its fullest realization in the single figure, god or hero, in
reposeful self-possession. Correspondingly, what Classical sculpture ren-
ders only badly or unhappily includes, prominently, individuals in action
and groups of individuals in relation to one another (this is why, one might
say, "history sculpture" has never emerged as a major genre the way it did
for painting). Or to put it the other way around, the rise of group sculpture
belongs to the dissolution of the Classical and is more properly a Romantic
form of sculpture.

TWO QUESTIONS THEN: What does all this tell us about Hegel's writing?
And what can it tell us about our own?

Saying that the speculative proposition has as its goal "plasticity" means
first of all that it aims to wear its meaning on the outside; understanding it,
we do not grasp some inner thing that the words have somehow conveyed
to us but take it for what it is—take it for thought in the enworded condi-
tions under which we only ever find it—and so do not find the thought
imposed upon by language, submitted to that mere accident. Rather, we
now grasp that accident as it has been, in a Hegelian phrase, raised to es-
sentiality. It's just this that art's history has worked through for thought and

as thought. Thought realizing itself this way has a specific shape that we can now see as both repeating and transforming the shape of sculpture: it is the shape of self, and its implicit geometry, surfacing again and again in Hegel's metaphors of system, is the sculptural thought and fact of center made absolute; the circle of circles, the Cusan circle whose center is everywhere and circumference nowhere (absolutely unbounded, then). And it is that because its content is likewise a repetition and dialectical transformation of sculpture's content—the reposeful individual in full self-possession returned as "the Bacchanalian revel in which no member is not drunk; yet because each member collapses as soon as he drops out, the revel is just as much transparent and simple repose."[24] Hegel writes art's history on its outside, his sentences delivering the promise that sculpture made for art but that art itself couldn't live up to.

One could say more here, but perhaps the drift is clear enough. Try for example rewriting some of our earlier sentences in this register:

> Rather, something takes form in [Hegel's writing], or, more accurately, as it. There is nothing "inside" it and, in that sense, nothing it expresses: it is the direct and complete exposure or exposition of its content, all "outside." You cannot have [this world] without having [it] as writing, and in having [it] that way [you] become capable of a particular kind of self-recognition.

And as for us: we do not believe this. And we do not believe it even if—and indeed especially if—we find Hegel's argument deeply powerful. We know—it is built precisely into our identity as art historians and not philosophers—that we, like Hegel, write from within art's ongoing Romantic dissolution. And this means, if we are to stay with what we find powerful in Hegel, both that our words cannot be fully disentangled from their objects and the thoughts and promises those objects also are, and that our words are everywhere traversed by a plasticity that cannot be fully secured and so also cannot be insured against arbitrariness but that also cannot be simply shed in the name of method or epistemological lucidity or stylistic clarity. The art historian does not write from anywhere other than the history of art, and that writing remains answerable to that history and those objects.

The "we" that does not believe in the complete plasticity of Hegel's prose is not an empirical matter; neither is it hortatory: it is an analytic consequence of the distinction implicit in Hegel between the philosopher and another figure that can identify itself in its distinctness only insofar as it

accepts that it belongs to—is an expression of—art's ending and not a sequel to it.

"The end of art" claimed by Hegel turns out to be a peculiarly complex matter: on the one hand, art's end is most fully realized as Classical sculpture, which is, for Hegel, art if anything is. It is of course part of the problem that in the end, again for Hegel, nothing is—art's achievement is incomplete and given over to dissolution, the distance between art's teleological end and historical ending a consequence of art's status as a vanishing moment of thought. This means that art's highest end is achieved prior to its becoming visible as art, as if "art" were a latecomer on its own scene.[25] This is perhaps a clue to the role the Renaissance recurrently plays for us, and certainly a clue to a deep strangeness in the temporality of art history. It may also be an important clue to how one might imagine the stakes in the contemporary dialogue between art history and visual culture, Classical achievement being in its moment a fact of culture not distinguishable as art (this is a part of what it means to say that the plasticity of Greek sculpture is as fully a fact of the Greek gods as it is of their rendering), and "art's" subsequent visibility evidently registering a certain inadequacy of culture to the demands of thought (the desire to identify art and culture is then a particular desire, subject to diagnosis, as are also the desires to distinguish them or to imagine one more simply supplanting the other).

Greek sculpture is perfect: that's how to understand Hegel's remark that "art is for us now a thing of the past," as well as how to understand the terms of art's continuing imperfect presence: one does not have "art" without having it also as a thing of the past, art's actual life wholly coincident with its dying, impossible and unthinkable outside that permanent circumstance.

We get art history's writing wrong if we take it to come essentially after art. If we are to get the shape of that writing right (if we are to understand the terms on which it gives itself essentially to reading), we have to see it as belonging to—emergent within—the terms of its object's visibility, and so need to think about it as structured by that particular shape—by a certain deep impossibility of sculpture and its radical plasticity, that leaves us as if condemned to write back and forth between art's architectural incipience and its more or less painterly dissolution without being able to fully order those moments in relation to any fixed and present center. Art history's writing does not find its audience the way Greek sculpture did, nor in the way Hegel imagined his philosophy should.

On this Hegelian account, a thoughtful art history is necessarily and actively interested in the ineluctable obduracy of words—not in the concealedness or inaccessibility of their meanings, but in their continuing to have faces across that meaning, inseparable from that act. Such an art history may dream, like art itself, of a kind of perfected opacity (a version, perhaps, of the absoluteness of the words in our dreams). That this dream is also something that certain strands of recent philosophy have also found themselves obliged to grapple with is one way of making out the nonmethodological interest of contemporary theory for art history's writing. It is also, and for the same reason, a way of making out art history's particular capacity to address those writings, to extend and transform their sense, thus opening a particular interdisciplinarity that happens at the heart of the disciplines in question, at the place where they are deeply and peculiarly knotted about one another, fused as the limit that severs them.

To fully succeed in such writing, to find ourselves without these limits, would indeed be to find ourselves at the end of art, as also at a certain version of the end of language. And by the same token, to refuse the question of writing would be to refuse the inner connection of art and thought, ending it at once everywhere and nowhere, depriving oneself of one's object in the very moment one imagines it secured. This is the fantasy of method.

Curriculum

This book has explored across a variety of sites within art history what it might mean to refuse to take a broad range of writings often grouped under the general rubric "theory" as bearing primarily on method. It has tended to argue that taking theory as method is not helpful in discerning the actual stakes and achievements of much of the best contemporary work in art history, and it has at times pushed quite strongly the assertion that a fuller grasp of the claims of figures as diverse as Wölfflin and Lacan and Baxandall and Benjamin has significant implications for one's understanding of the discipline as a whole—for what we can mean by such terms as "object" and "objectivity," for how we are to understand such fundamental activities as reading and writing within the actual practice of art history, and so on. If these claims are interesting, there is good reason to expect that they should have addressable institutional consequences—consequences in particular for the ways in which we imagine and participate in the reproduction or transformation of an intellectual practice within the particular larger institution of the university.

THE CURRENCY OF RESEARCH

In 1938 Martin Heidegger offered an analysis of the contemporary university that can still seem remarkably prescient. He begins from the thought that "a science today, whether physical or humanistic, attains to the respect due to a science only when it has become capable of being institutionalized," and then offers the following extended description of the forms of contemporary academic life:

> What is taking place in this extending and consolidating of the institutional character of the sciences? Nothing less than the making secure of the prece-

dence of methodology over whatever is (nature and history), which at any given time becomes objective in research. . . . Therefore historiographical or archeological research that is carried forward in an institutionalized way is essentially closer to research in physics that is similarly organized than it is to a discipline belonging to its own faculty in the humanistic sciences that still remains mired in mere erudition. Hence the decisive development of the modern character of science as ongoing activity also forms men of a different stamp. The scholar disappears. He is succeeded by the research man who is engaged in research. These, rather than the cultivating of erudition, lend to his work its atmosphere of incisiveness. The research man no longer needs a library at home. Moreover, he is constantly on the move. He negotiates at meetings, and collects information at congresses. He contracts for commissions with publishers. The latter now determine along with him which books must be written.

The research worker necessarily presses forward of himself into the sphere characteristic of the technologist in the essential sense. Only in this way is he capable of acting effectively and only thus, after the manner of his age, is he real. Alongside him, the increasingly thin and empty Romanticism of scholarship and the university will still be able to persist for some time in a few places. . . .

The real system of science consists in the solidarity of procedure and attitude with respect to the objectification of whatever is—a solidarity that is brought about appropriately at any given time on the basis of planning. The excellence demanded of this system is not some contrived and rigid unity of relationships among object-spheres, having to do with content, but is rather the greatest possible free, though regulated, flexibility in the shifting about and introducing of research apropos of the leading tasks at any given time.[1]

There are a number of features of these remarks, including of course their casual sexism, that date them well enough: the repeated contrast with the erudite scholar with a personal library is far too deeply a thing of the past now to be able to strike us with any real force (although it may be worth noting that art history is one of the last places in which that figure still has some purchase), and we are more likely to phrase the change Heidegger is noting in terms of a continuing professionalization of academic life and work than in terms of institutionalization *tout court*.[2] What matters is the particular interlocking of professionalization, understood as the formation of a closed, self-regulating, and self-reproducing institutional practice, and

research, where "research" names the subsumption of a generalized formal objectivity under a panoply of independently justified strategies and methods that Heidegger takes to guarantee an ongoing but essentially groundless activity. More than fifty years later, Bill Readings can seem to be directly continuing Heidegger when he writes:

> Today, all departments of the University can be urged to strive for excellence, since the general applicability of the notion is in direct relation to its emptiness. . . . The assumption is that the invocation of excellence overcomes the problem of value across disciplines, since excellence is the common denominator of good research in all fields.[3]

Or again:

> The point is not that no one knows what excellence is but that everyone has his or her own idea of what it is. And once excellence has been generally accepted as an organizing principle, there is no need to argue about differing definitions. Everyone is excellent, in their own way, and everyone has more of a stake in being left alone to be excellent than in intervening in the administrative process.[4]

The marks of the dominance of research and its deep entanglement with "excellence" are visible all across the contemporary university. One can point to things as trivial as two e-mails that arrived on the same day as this chapter was being revised, one from the university declaring October "Research Awareness Month" and the other from an outside agency offering to revise faculty Web sites:

> As you know, your web site is visited by prospective students, researchers, and others. Visitors should be greeted with a vibrant and comprehensive presentation of your research.
>
> We have created many web sites for departments and professors. Our client list includes virtually every major university in the country and we have years of experience working with professors and administrators. We work quickly and intelligently and our prices are highly competitive. We would be happy to provide you with a quote.[5]

One can of course also point to much more massive signs, particularly the overwhelming institutional shift toward defining and ranking departments exclusively in terms of research and the concomitant effort to establish ever more abstract and quantifiable professional criteria for measurement. The

increasingly clear ideal here is that nothing need ever be read—an adequate system for the evaluation of research will turn on a sociology of the field, relating research to ranked places of publication and the like—and nothing need ever be related to anything else.

In between these two poles one can list one feature after another of the shifting landscape of the contemporary university: the reduction of administrative writing to bulleted PowerPoints; the addition of "outcomes assessment" to the familiar apparatus of grading and evaluation; the repackaging of the university in terms of "new paradigms," "interdisciplinarity," and "new knowledges," and so on. This is increasingly the daily currency of life in the contemporary research university, and it is not particularly to the present point to tease out the full texture of all this. But it is certainly worth noticing that one further bit of it is the ongoing conversion of basic writing classes into "research methods" classes.

A WORLD INVISIBLE TO ITSELF

For Heidegger, the professionalization of research and the concomitant primacy of method are specific aspects of the more general dominance of what he calls "technology." His fuller glossing of this is perhaps best taken up in two parts, one general and one arguably of more particular pertinence to art history.

Heidegger's most general description of the world as it appears under the dominance of technology turns on the preeminence of what he calls the *Gestell*. The translation of this term is difficult and will in fact turn us toward the second part of our gloss; for the moment we will try to get by with a functional description. The *Gestell* is a specific shaping of the world such that it appears as a reservoir of objects available to knowledge. It's tempting, then, to call the *Gestell* a particular "worldview," but Heidegger presents it more nearly as a shape in which it makes sense to think that what one has (what everyone has) of the world is, in the first instance, a view. Looking up from the computer I'm writing on, I see out the window parts of various building on the campus, students strolling by, bicycles in a rack, traffic passing. If I turn away from my desk, I get a different view—of the grassy oval and the students crossing it on their way to one or another class. These things are all equally available to me, and collectively they constitute the *Bestand*—"stock" or "standing reserve"—that amounts to the world as a set

of things ordered to view by the merely external and accidental limits of my window's frame. Heidegger writes:

> As soon as what is unconcealed no longer concerns man even as object, but does, rather, exclusively as standing-reserve, and man in the midst of object-lessness is nothing but the orderer of the standing-reserve, then he comes to the brink of a precipitous fall; that is, he comes to the point where he himself will have to be taken as standing-reserve. Meanwhile man, precisely as the one so threatened, exalts himself to the posture of lord of the earth. In this way, the impression comes to prevail that everything man encounters exists only insofar as it is his construct.[6]

It's perhaps useful to unpack this complex moment as the ultimate sense of a certain history that begins with the reduction of apparent objects to their calculability—Heidegger is thus coupling scientific objectivity with a special kind of objectlessness—and so establishes the possibility of what will emerge as the social sciences, the objective claims of which will ultimately give way to claims about the cultural constructedness of that objectivity.[7] The moment itself amounts to a kind of whirligig—just because what counts as objectivity depends on and conceals a specific objectlessness, the subject comes to a certain primacy, but does so already pledged to a deep skepticism from which it will be unable to exempt even itself. "Cultural construction" becomes the terrain on which we both face and evade merely ourselves, on which the world has been lost.

We can take Heidegger's description as an implicit account of how a curriculum once ordered to history—that is, to a logic of objects and events essentially given to transformation and passage—might invisibly pass over into a curriculum that is nothing more than the ordering of a standing-reserve, fated ultimately to imagine itself answerable not to its objects but to method, the purest form of which will be a theory of cultural construction that has no ground outside the present's self-regard. "Theory" emerges as what in each case validates *my* reading, and *my reading* turns out to be a crucial professional good in what Readings calls "the university of excellence." Heidegger's would then be a plausible account of why our curricula no longer make sense, why our standing arguments about them are empty, and why—to put the point at its most extreme, which is not at all to say most unrealistic—curriculum is essentially undiscussable within the contemporary university, a word whose meaning is no longer understood (or

understood as meaning no more than something like "the list of what is on offer," an inventory of what's in stock or on special this week).

Much of the language that has figured in this general description already points toward Heidegger's more particular gloss on the dominance of technology as amounting to the reduction or transformation of the world to a picture. It's in trying to attend to these dimensions of Heidegger's description that we will find ourselves struggling with the translation of *Gestell*. A standard German-English dictionary will offer us a range of equivalents: "stand, rack, shelf; trestle, horse; support; frame (as of a bicycle, spectacles); holder, mount(ing); pedestal . . ." One might do well also to look at the related participle, *Gestellung*: "making available, furnishing; reporting for service; call(ing)-up order; induction order."[8] Considered simply as a German word, the pastness (*Ge-*) is certainly worth noticing, as is its evident relation to *Gestalt*, shape or figure. It also belongs to the philosophically important cluster of words ending in -*stellen*, of which *Vorstellung* and *Darstellung* are the most visible and significant (both can be rendered as "representation"; the contrast between them is often taken to be as between representation and presentation). The standard French translation has been *dispositif*, a term that interestingly recurs in the writings of Jean-François Lyotard. English translations of Heidegger sometimes leave the term untranslated and have otherwise favored "enframing," usually without the qualification of "as of a bicycle, spectacles," thus inviting the image of a picture or window frame more strongly than the German itself does (both picture frames and sculptural pedestal have their own preferred German equivalents, *Rahmen* and *Sockel*, respectively).[9]

Heidegger is clearly worrying a good bit at things like frames as he approaches "The Age of the World Picture." You get a nice snapshot of these worries in his 1936 seminar on Schelling:

> Between these extreme opposites of meaning—inner jointure and mere manipulation—stands that which gives system its name: a framework, not an inner order, but also not a mere external accumulation.
>
> System can signify several things—on the one hand, an inner jointure giving things their foundation and support, on the other hand, mere external manipulation, and finally in between something like a framework. This fact points out that this inner possibility of wavering between jointure and manipulation and framework always belongs to a system, that every genuine system always remains threatened by the decline into what is

spurious, that every spurious system can always be given the appearance of being genuine.[10]

In the historical account that unfolds over the next several pages, Heidegger in effect argues that the "framework" that is the defining feature of system is the ambiguous means by which the articulated complexity of a world of things gives way to the blank availability of a standing-reserve. In putting the contrast this way, we place in the foreground the sense of a jointedness proper to a world over and against the seamlessness of an objectless reserve, but one should hear also in Heidegger's affirmative term "jointure" the sense of articulation as the bringing of discreteness or spacing out of a background continuum, thus of its realizing an order both distinct from that continuum and deeply bound to it, as thought to unthought, expressed to unexpressed, unconcealed to concealed.[11] This is for Heidegger always the actual condition of thought and speech. The world become picture is thus not exactly no longer a world—that is, no longer a play of concealment and unconcealment—but it is a world whose being a world has become invisible to it. One might equally say it is a world whose visibility is taken as if devoid of shadow, having no invisibility in it. What is concealed in "the unconcealment in which everything that is shows itself at any given time" is concealment itself, or, to risk one step too far into Heideggerean singsong, what is concealed in unconcealment precisely as that unconcealment is concealment. It is our lucidity itself that is in question; that we now have or imagine ourselves to have a world in which nothing is hidden, does not mean that the world itself is not in hiding.

How obscure a thought is this really?

WHAT SHOWS

It is at least not a thought unknown to art history.

Wölfflin's *Principles of Art History* famously begins with an anecdote taken from Ludwig Richter's autobiography about two painters setting out to paint as realistically as possible the same landscape and producing, predictably enough, two paintings that look quite different from one another. Ernst Gombrich retells this same anecdote in *Art and Illusion*. As with the anecdote's two painters, we get two very different pictures.

For Wölfflin, the story makes clear that there is no normative seeing of

the world and so demands that one think through the historicity of art, whereas for Gombrich the same story poses epistemological questions. Gombrich begins by suggesting that the differences between the two pictures may strike us as matters of "stylization," and then lets that intuition (itself deeply foreign to Wölfflin) license a shift of ground that now sets a Cézanne landscape against a photograph of the motif as it exists in nature. Next he writes:

> Such comparisons will always retain their fascination since they almost allow us to look over the artist's shoulder—and who does not wish he had this privilege? But however instructive such confrontations may be when handled with care, we must clearly be aware of the fallacy of "stylization." Should we believe the photograph represents the "objective truth" while the painting records the artist's subjective vision—the way he transformed "what he saw"? Can we compare "the image on the retina" with the "image in the mind"?
>
> . . .
>
> Does this mean, then, that we are altogether on a useless quest? That artistic truth differs so much from prosaic truth that the question of objectivity must never be asked? I do not think so. We must only be a little more circumspect in our formulation of the question.[12]

The shifting burden of the examples as we move from Wölfflin to Gombrich both reflects and further secures Panofsky's fundamental transformation of the major categories of art history. The particular inflection Gombrich's *Art and Illusion* brings out has been vastly influential in setting the terms for much of an art-historical reception of French, broadly semiotic theory that essentially continues Gombrich's way of imagining picturing even as it raises greater doubts about the possibility of arriving at Gombrich's affirmative response to his own questions.[13]

The contrast between the same story's different morals is between a Gombrichian view in which the world is taken to be available (however problematically) for picturing and a Wölfflinian position for which there is only visibility and a certain historical play within visibility without any particular room for, and certainly no necessity for, asking about the adequacy of a picture to something outside of it. The Wölfflinian position is significantly close to Heidegger's. For Heidegger, as for Wölfflin, the difference between the two paintings testifies to the kinds of difference proper to there being a world—that is, to the ways in which concealment is a continuing feature of

what is at every moment also the unconcealment of the world (both pictures show what is to be seen; their differences cannot be attributed to what one or the other of them hides).

By contrast, Gombrich's way of sorting out pictures makes manifest one aspect of what it means to say that the world has become picture—that we then take it as a field of things available to representation, some of which we may further distinguish as "works of art." For Heidegger this is evidently continuous with the reduction of the world to an essentially objectless standing-reserve. But since this is pretty much the world in which we live and which we have no trouble understanding as built in just this way, and which thus not only does not seem objectless to us but seems to ground our strongest accounts of objectivity, Heidegger has to show us both what other shape the world might have and something about how the one shape might have supplanted the other. What we are looking for here cannot be found within the *Gestell* but also cannot be some direct and, so to speak, external alternative to it; it will have to have the form of an interpretation that shows the *Gestell* to be a certain kind of peculiarly difficult limit case (as Heidegger puts it, "the essence of technology is nothing of the technological").[14]

Much of this job falls to the 1935–38 essay "The Origin of the Work of Art," in many ways a pendant to "The Age of the World Picture." The overt argumentative structure of the opening sections of this essay is, for Heidegger, surprisingly straightforward and surprisingly "Gombrichian." Asking after the origin of the work of art, we are asking about something that is a particular subspecies of equipment or artifact which is itself a particular subspecies of thing, so determining what a work of art is it might reasonably enough entail making out, first, what a thing is, then what an artifact is, and finally what a work of art is.[15] While Heidegger does work a certain number of characteristically Heideggerean turns into the prose—all of which merit an attention we will not give them and which become notably more salient on rereading—he does by and large stick to this basic scheme, at least at first. In particular, he begins by working his way through three understandings of a thing—as (1) a substance possessed of properties, (2) the unity of a manifold given to the senses, and (3) a particular conjunction of form and matter. In each case, he briefly airs the understanding in question, poses some criticisms of it, and, having found no satisfaction, moves on to the next. With the last understanding, it becomes part of the criticism of the view that it apparently draws on terms—"form" and "matter"—that are

actually proper to a later stage of the argument: "Reference to the copious use made of this conceptual framework in aesthetics might sooner lead to the idea that matter and form are specifications stemming from the nature of the art work and were in the first place transferred from it back to the thing."[16] On further reflection, this seems to Heidegger to go too far: the opposition of form and matter is more nearly proper to artifacts in general than to works of art in particular. In any case, Heidegger takes it that there is good enough reason to suspect that our accounts of things are so suspiciously dependent on our grasp of artifacts that we may as well drop the question of the thing and take up the question of the artifact more directly.

Famously, he does so by asking his readers, or better, his audience—as we will see, the real work of this part of the essay is accomplished through a certain kind of performance—to consider as humble a piece of equipment as a pair of shoes.[17] A certain amount of fussy hand-waving accompanies their introduction: we don't really need to introduce them, since you all already know them, but still it might be helpful to have something to look at, and a representation of some shoes might be a good way to do that, even though now that I've got the slide up you can see that there's nothing there we didn't know, nothing we really need to see, and so on.

Things are going on here: the shoes as an example of equipment are being redoubled by a representation of them, itself also a piece of equipment we are all familiar with and have presumably no more need to see than we have need of seeing shoes (so of course we are presumably not looking at the representation as such but only at the shoes it represents, just as in wearing the shoes we do not consider them as such but stand, and walk, and generally do what shod people do). Heidegger takes his audience through the ins and outs of this—one can almost write out the stage directions as he glances toward and away from a slide one can imagine him to have called up behind him in the lecture hall—until he turns away one last time from the now thoroughly exhausted image and then dramatically checks himself: "Und dennoch—" (And yet—)

As Heidegger appears to turn back toward, or perhaps merely to stop his movement as if held at the very moment of turning away from, the image he can now seem both fixed upon and in a certain sense blind to (or perhaps blinded by), the new paragraph unleashes an astonishing surge of fantasy: pretty much everything already said in descriptions of the image returns but now puffed up with meaning, narrative, life. At certain moments this

FIGURE 30. Vincent van Gogh, *A Pair of Shoes* (1886). Van Gogh Museum, Amsterdam, The Netherlands. Art Resource, NY.

new description is at clear odds with the earlier, much more careful description (there, for example, we could not tell where the shoes stood and no earth clung to them, but now "the dampness and richness of the soil lies upon them" and "the loneliness of the field-path" slides beneath them). A lot of ink has been spilled on the contents of this fantasy—it is clearly Romantic, significantly nostalgic, at once antimodern and antitechnological, deeply embedded in a certain discourse that binds nature, class, and gender in familiar ways, and (at a minimum) not out of place amid contemporary Nazi talk of blood and earth. Heidegger is at least willing to mean all this, although the clear signals of disparity with the image's less fantastic description suggests he also has no serious stake in it. It exists to dramatize the difference between the painting seen as mere representational equipment and as the work of art it actually is—just as the passage also dramatizes the passage from a generic "Van Gogh" that had merely represented Van Gogh to the specificity of a particular work (while Meyer Schapiro, Heidegger's fiercest critic, taxes him with irresponsible vagueness here, it's worth noting

that the text provides him with an account good enough to let him pick out the particular painting in question).

With this evocation of the abrupt emergence of the work of art as if through the mask of its artifactuality, Heidegger's essay has essentially won its rhetorical way to its actual argumentative ground by delivering with a vengeance on the earlier suspicion that our dealings with things might be dependent on a certain priority of the work of art (art is the origin, not something that has an origin; to speak of "originality" is not to speak of some human capacity but of a work's relation to the world). Calling Heidegger's work here "rhetorical" is probably too weak: those who find these passages compelling presumably do so not because of Heidegger's "interpretation" (if that's even the right word) of the van Gogh but because the passage through that moment successfully enacts and makes unavoidable the difference between the painting and the representation we are so deeply willing to mistake for it. To be compelled by Heidegger's demonstration is to feel both that the he has both done good enough justice to our strong sense that a work of art is a particular subspecies of thing and artifact and that he has shown well enough how that sense reverses the actual order of things, in which it is the work that opens the actual terms of our imagination of both things and artifacts.

It is a demonstration or performance and not an argument, and it is clearly enough accomplished by a certain sleight of hand. By getting the painting in front of us as a mere representation, Heidegger gets it in place without having to do any particular worrying over its status as a work of art, so that we are, in effect, free to be surprised by its showing itself as such. The whole positive point of the demonstration is that the work of art is capable of doing this, and the implied negative point is that our taking the world itself as a picture is a particular way of standing wrong way around within the fact of art's originality.[18] Much of this can be emblematically reduced to the question of the work's frame, a feature that clearly bothers Heidegger just because it seems integrally involved with the ways in which we impose a certain sheerly conventional if also vaguely honorific "aesthetic" status on the work and so also make of it a mere commodity or artifact ("the painting hangs on the wall like a rifle or a hat").[19] Heidegger so arranges things that we first encounter the painting apart from its frame, in what he will be able to claim as its proper autonomy. The actual textual movement of that discovery is important:

And yet—

From the dark opening of the worn insides of the shoes the toilsome tread of the work shows forth. . . .

Perhaps it is only in the picture that we notice all this about the shoes. . . .

The painting spoke. In the vicinity of the work we were suddenly elsewhere than we usually tend to be. . . .

In the work of art the truth of an entity has set itself to work. "To set" means here: to bring to a stand. Some particular entity, a pair of peasant shoes, comes in the work to stand in the light of its being. The being of beings comes into the steadiness of its shining.[20]

We move from a particular feature of the painting—the dark opening of the shoes—to the discovery of the painting as a whole and then back to the thing standing "in the light of its own being," so that in the end we will take the painting as the self-showing of the shoes in their worldliness, at once wholly self-opening and wholly self-limiting, submitted to no external frame. As a reading of the painting, Heidegger's account treats the opening of the boots as continuous with the limits of the painting itself—the autonomy of the work thus demonstrated in the tying of this knot.

The opposition between the world framed as a picture and the complex world-opening autonomy of the work of art could hardly be more stark, but the two remain seamed to one another by the difficult ambiguities of the *Gestell* as charted in the Schelling essay—so we should not be surprised that one outcome of Heidegger's demonstration is a certain quasi-compositional sense for that term. Heidegger writes, drawing heavily on the language of earth and world he takes to be the ground within the work of art for such derivative terms as "form" and "matter":

The strife that is brought into the rift and thus set back into the earth and thus fixed in place is *figure, shape, Gestalt.* Createdness of the work means: truth's being fixed in place in the figure. Figure is the structure in whose shape the rift composes and submits. This composed rift is the fitting or joining of the shining of truth. What is here called figure, *Gestalt,* is always to be thought of in terms of the particular placing (*Stellen*) and framing or framework (*Gestell*) as which the work occurs when it sets itself up and sets itself forth.[21]

It is then in the mistaking of what in the work is compositional for what merely and apparently externally frames it that the world becomes picture, its essential horizonality misconstrued as the simpler limits of the window

through which we view it or the invisible and unthought frame in which it appears. The world is, as Heidegger says of equipment generally, "dismissed beyond itself, to be used up in serviceability."[22] This is, one might say, fine for equipment—that's just what it is—but it is a problem for the world, its essential relation to things, equipment, and works of art now not so much directly broken as rendered invisible and unthinkable—persistent but out of reach.

If Heidegger's engagement with technology opens the way toward certain recognitions and critiques of the contemporary university (his and, still more ferociously, ours), the institutional carry of "The Origin of the Work of Art" is considerably less obvious. One thought might be that the essay's "example" of the Greek temple actually is the university's counterpart, and the active inheritor of much of the language of Heidegger's rectorate—the language of nation and people, *Volk*, of battle, struggle, and destiny.[23] The appearance of such a conflation of university and temple may well have its diagnostic value, in relation not only to Heidegger's past and the evident confusion of his politics but perhaps also to our present with its oppositions and conflations of politics and religion, but it does nothing to extend or transform our imagination of the university. We appear dead-ended here, as if now pledged to an object framed solely by itself and so refusing all disciplinary or institutional articulation.

A PART

It is a minor element of the opposition between the world framed as a picture and the world-opening autonomy of the work of art that the former assumes an eye essentially external to the picture it sees (it's part of the problem of such objectivity that it posits the availability of the world to someone implicitly outside it) whereas van Gogh's painting is, in Heidegger's description, granted the force of a certain gaze ("the toilsome tread ... stares forth").[24] If we take this remark as seriously about the particular painting still before us, we may be tempted to say that the essay implicitly reads "the dark opening of the worn insides of the shoes" as something like a pair of eyes, and that, whether we accept it or not, may be enough to alert us to a certain larger descriptive slipperiness at work in the passage: what's presented as one opening is in fact divided and plural. Noticing that, we may wonder whether we want to say that at some level for

Heidegger those two openings, very nearly sketching out a figure eight at the center of the painting and doing so out of the play of each shoe's inside and outside, describe a Möbius strip that renders the painting's internal attachment to its limits topologically complex in ways Heidegger does not fully recognize.

We are pushing hard here, both in our reading of Heidegger and in our dealings with the painting, although it is far from clear that we are pushing too hard. It will in any case result in our becoming increasingly tempted to say that whatever the power of Heidegger's account, we cannot quite fully accept it: that we cannot accept the dark opening or openings and whatever complexity may be packed into it or them as any more than allegorical of the painting's limits, and this will mean that we will also be inclined to reject the starkness of Heidegger's underlying contrast between work and picture, art and technology. It may also mean that we will come to suspect that Heidegger's acuteness as a critic of the university and the apparent capacity of such terms as *Gestell* and *Bestand* to describe the current collapse of curriculum within it go hand in hand in him with a certain refusal of curriculum altogether.[25]

The more critical reading of Heidegger's "Origin of the Work of Art" that we've begun to sketch by appealing to such things as the actual fact of two openings rather than one is most fully carried out by Jacques Derrida in a long "polylogue" titled "Restitutions, of the Truth in Pointing."[26] While this piece of writing has been most often addressed in terms of the particular debate between Heidegger and the art historian Meyer Schapiro that it obsessively engages, it's important to see that it also belongs to a series of critiques of Heidegger that constitutes one of the central threads of Derrida's work as a whole—from the early harnessing of Derrida's key question of writing to the Heideggerean constellation of science, technology, and the future as "absolute danger,"[27] through repeated reworkings of Heidegger's view of language, examinations of his politics, and what it might mean that we have as it were no choice but to say, in whatever language we speak, that "there is . . ." ("es gibt," "il y a" . . .).[28] One way to put the force of this central line in Derrida is to say that he begins by refusing the apparent Heideggerean reduction of writing to an external and secondary technology imposed on the primacy of poetic speaking.

Where Heidegger's lecture on the van Gogh painting is dramatically punctuated by a notable surge of interpretive fantasy, Derrida's essay is all

but continuously interrupted by leaps of interpretive and associative excess as an uncertain number of voices—whose distinctness is not reducible to the proper names that standardly organize a philosophic dialogue[29] and for whom gender is a fact at once pronounced and intermittent—repeatedly address the painting, Heidegger's essay, and Meyer Schapiro's attack on it without coming to any apparent conclusion about any of these things. The closing snatch of dialogue is, as the translation does not fail to note, untranslatable, which is to say that it can only be read—offering no escape from the language in which it is written (except into another language in which that writing will be at once continued and interrupted):

—Ça vient de partir.

[This one might render, as translators Geoffrey Bennington and Ian McLeod in fact do, "It's just gone," but also "It's just parted" or "It's just departed," which seem to mean the same but will sound differently depending on how one's translation continues, or again, more literally in the French but more loosely and idiomatically in English, "It comes from going" or "It comes from parting." The translations vary partly according to the semantic valence one assigns to "partir," partly according to how one makes out the syntax of "venir de," and partly according to the particular English resources one chooses through which to register these things. And it is a further question how and how far one wants to catch in the initial "ça" something of its weight as the standard French translation of Freud's "Es"—"Id" in the Latinizing English translation—and how and how far one hears in "ça vient" Derrida's futural revision of "es gibt."]

—Ça revient de partir.

[We lose a syntactic ambiguity here, and gain a semantic resonance with the new verb's proximity to *revenant*, ghost, the departed returned.]

—Ça vient de repartir.

[Now the new infinitive makes an issue of the repetition and mobility of the prefix *re-*, at the same time as it makes explicit the linkage between a movement of coming and going and a fact of allotment—division, partition, sharing out. Derrida's close associate Jean-Luc Nancy uses the French word *partage* to work much of the same terrain in ways that might interest us—might, for example, help us hear more clearly and so ask more sharply

about the verbs—the acts—informing words like "compartment" or "department."[30]]

[And we do not, this whole time, know exactly what "ça" refers to; it arrives here in the way such things do in conversation, and its referent is as vague and complex as the conclusion the essay does not have, the debate or the painting it addresses, and the rhythm of the voices in their uncertain coming and going and their uneasy sharing and partitioning.]

IT IS NOT TO our purpose to work through Derrida's argument in any particular detail. The polylogue is held together to a high degree by a series of complex variations on thoughts of inside and outside, front and back: the weaving of the threads that make a canvas, the passage of laces through a shoe's eyelets, the continuous passage of the frame between the painting and the world, the passage of voices before and behind one another, the interlacing of Heidegger and Schapiro in which each ends by showing himself "more naïve, more excessive . . . than the other,"[31] and the odd play of philosophy and art history that they at least partially incarnate. In being held together—and apart: partitioned, comparted—this way, Derrida's essay makes itself out of the question of limits at once posed and elided by Heidegger's treatment of van Gogh's *Old Shoes*—very much as the other major essay in *The Truth of Painting*, "Parergon," makes its writerly and argumentative turns out of the play between the "pure cut" taken as central to Kant's sense of beauty's capacity to show itself apart from any interest or concept (thus figuring only against its own "ground") and the frame or *parergon* whose relation to the painting or work of art Kant cannot cleanly make out. Indeed, Derrida's two essays make and enact essentially the same argument about painting—that it is made both out of and at its limits, which thus traverse it everywhere.

As we move from Heidegger to Derrida we may feel that we are moving deeper into complications attendant on a particular thought of art's specificity and objectivity, what's often called its "autonomy" but which in its Derridean iteration goes hand in hand with something very much like its undoing, its continuing passage beyond itself. Can we take art understood this way as a curricular object? Can we imagine a department of art history as a particular moment or rhythm of lacing and unlacing, departure and return, sharing and partition, within the larger logic of a university in which inquiry remains irreducible to research?

CURRICULAR GOODS

Curriculum is what defines the university as a teaching institution. While there are any number of social and institutional ways to organize research, the ways of organizing education are much more limited, and "curriculum" is the general term for them.

The structure of the standard American department of art history is easily enough laid out. The curriculum is essentially chronologically ordered and built as a series of pyramids tending toward increasing specialization. At the bottom is the survey on which are laid a set of more period-specific courses, on top of which there may be another such set of still more specific courses, with the whole topped off by very specific research seminars.

Off to the side of this scheme there is usually a handful of additional courses, most frequently one on theory and method, sometimes a course in historiography, perhaps a special undergraduate "writing course," a course in materials and techniques and so on; all of these are typically devoid of any historical descriptor. "Theory" in such a curriculum simply means method—a set of tools and procedures independently teachable and applicable across the range of "period" courses that are the primary structure of the curriculum. Writing courses are similarly instrumental, with teachers often finding themselves stuck with having to find a way to mix very basic writerly instruction (such courses are often in the curriculum at all only in response to a university demand for teaching writing "across the curriculum") with what amounts to an introduction to the primary etiquettes of professional art-historical writing: the catalog entry, the book review, the research article. Typically such courses do not include (1) any consideration of criticism (initially excluded from art history for not meeting its criteria of scientificity, criticism fares little better under more recent theoretical dispensations in which its broadest claims are considered empty unless methodologically framed by a prior politico-methodological location); (2) any consideration of the shifting historical relations between art and writing of the kind that inform Baxandall's *Patterns of Intention* and his more historically specific work on Renaissance description and composition; or (3) any address to the close reading of art-historical writing, especially in the distinctive forms it assumes in the work of figures as otherwise various as Michael Baxandall, T. J. Clark, Michael Fried, Rosalind Krauss, Joseph Koerner, and Leo Steinberg, to name some of the most prominent such figures in contemporary art history.[32]

There are unlikely to be strong extradepartmental distribution require-
ments; where there are such requirements, or even expectations, they are
typically of further period-specific work in history "proper." Language re-
quirements are often significant, although there is rarely any explicit demand
for literary competence (language matters primarily as a research skill).
Courses in aesthetics, or philosophy more generally, are optional at best.

The scheme takes its primary bearings from Western art, and non-
Western art, if it is a minor presence in the department, floats uneasily be-
tween the dominant chronological core of the curriculum and the ahistori-
cal options alongside it. Where it is a major presence, it is likely to have its
own large-scale scheme, sometimes chronological but more often regional,
that is weakly articulated, if at all, with the Western scheme. Where fuller
articulation is attempted, it is most often through the development of a sur-
vey ordered to a global history of art that has no further curricular carry.

It's far from clear what this scheme, standard as it may be, actually
amounts to. Arthur Danto has recently suggested that now that (as he sees
it) the history of art has ended, we no longer have it as a history but rather
as a certain kind of realized cultural whole. Addressing Daniel-Henry Kahn-
weiler's account of Cubism, Danto writes:

> And this more or less meant that the larger history of art was after all not
> developmental, since there seemed to be no obvious sense in which cubism
> represented a development beyond impressionism. In this respect, Kahnwei-
> ler's thesis bears a distant resemblance to the remarkable view of art's history
> articulated by Erwin Panofsky, according to which it consists in a sequence
> of forms that replace one another but do not, as it were, constitute a devel-
> opment. Panofsky's almost breathtaking move consisted in taking a discov-
> ery that had virtually emblematized progress, that of linear perspective, and
> transforming it instead into what he termed a symbolic form, where it simply
> represented a different way of organizing space. As a way of organizing space,
> it belonged to a certain underlying philosophy manifest in other aspects of a
> culture, like its architecture, its theory, its metaphysics, even its moral codes,
> which formed cultural wholes of a kind to be studied through what Panofsky
> called *iconology*. But as between these cultural wholes, and hence as between
> the art which expressed them, there was no continuous developmental his-
> tory. Rather, as I see it, having a developmental history belonged to the art
> of one of those cultural wholes, namely that which belonged to Western art
> from roughly 1300 to 1900.[33]

There's a somewhat uneasy balance here between the cultural whole that interests Danto—"the era of art"—and the panoply of such wholes he sees Panofsky putting into play, but the underlying suggestion that we do not in fact know what the things we casually call "periods" actually are and so do not understand how they function to articulate our object can seem extraordinarily apt. The core contrast, unelaborated by Danto, is presumably with some sense of period as properly historical because answerable to a profoundly temporal logic—as, for example, in the logics of repetition and difference we've seen in Hegel and in Wölfflin (logics in which the linkage between historical periodicity and the periodicity of, for example, a sentence remain visible).[34]

If our periods are in fact cultures, some of the things that strike us as major curricular issues—say, tensions between the structure of Western and non-Western components within a curriculum or between art history and a challenge to it emerging from claims to the study of visual culture—may be a good bit less substantial than we have imagined. If art history is already to a high degree the study of visual culture and is shielded from recognition of that fact by Panofsky's insistence that the ultimate object of iconology is something properly called "the history of human meaning," it may matter to see that this key phrase is deeply ambiguous: if it means "human acts of meaning," it may indeed point to something historical, and something best addressed as a form of action, but not toward a deeply interpretive discipline. If on the other hand it means meanings shared by all humans, it does point toward a strongly interpretive discipline, but one that is not essentially historical and that will, as our skepticism about "the human" grows, be driven back on what will increasingly appear as the fact of cultures in (what we take to be) their mutual incommensurability. We find ourselves here on the edge of a perhaps somewhat curious thought: that an interpretive art history of the Panofskian kind and the claims to visual culture go essentially hand in hand, over and against what may seem a surprising conjunction of formalist concerns and social history of art.

We also find ourselves returned interestingly to the terms of Heidegger's critique of the university in its modernity: "A fourth modern phenomenon manifests itself in the fact that human activity is conceived and consummated as culture. Thus culture is the realization of the highest values, through the nurture of the highest goods of man. It lies in the essence of culture, as such nurturing, to nurture itself in its turn and thus to become

the politics of culture."[35] This is another point where Readings's critique of the contemporary university appears very close to Heidegger's, arguing that culture has lost its power to organize the university and that the emergence of "cultural studies" and its institutional kin is best seen as a symptom of that collapse and a form of rear-guard resistance to it—thus a peculiar extension of the vanishing university to which it is often imagined to be opposed.

THIS STANDARD ART HISTORY curriculum is curriculum as "standing-reserve," and one notable feature of it is just how far it is describable without reference to the larger university and its curriculum. Such reference is in fact unnecessary: that larger curriculum is nothing more than the sum total of all the little curricula that look more or less like this, which is to say like a list of goods on offer.

Not too long ago the university looked significantly different, at least to the extent that in many places this whole arrangement stood on a larger, nondisciplinary base that was taken to constitute a common core of shared knowledge. By the mid-1970s these courses were, with a few notable exceptions, pretty much all gone. We were, evidently, no longer in the mood for them. The determinants of this mood were presumably complex—certainly a turn toward cultural and identity politics played a role; so also did the increasing professionalization of an American professoriate that more and more begrudged time spent outside of proper disciplinary competence and professional reward. These courses don't look likely to be back anytime soon, and their disappearance has been lamented often enough for a variety of reasons, most often having to do with a the loss of some socially binding common heritage or a general breadth of cultural reference, but sometimes also because with them a certain number of figures of some importance—Freud and Marx would be perhaps the most notable modern examples—vanished from college curricula almost entirely.

There is, however, a rather different reason to pause over this event. For all that such courses can seem just further and more general extensions of the broad base of what ultimately emerges as specialized disciplinary knowledge, they were in fact interestingly heterogeneous with respect to the disciplinary knowledges they also supported. They were places within the college or university curriculum from which one could think or imagine that curriculum and that institution as a whole. They weren't mostly taught that way—such considerations formed no part of their explicit content—and

indeed there's a sense in which they were taught in no particular way and to no particular end. Especially for students, but no doubt at least at times for faculties, they were primarily there to be gotten through and forgotten—except of course that students would often enough find themselves somewhere down the line wanting to remember what they'd forgotten, having found some thread of that course cropping out across their present tense in a way it hadn't done at its assigned and proper time. The essential teaching of these courses had a curious way of not happening in their proper present, emerging instead at subsequent moments where it might variously shape, contextualize, thicken, or complicate a particular disciplinary fact or thought.

Most schools have tried to make up for the loss of these broad courses by introducing some set of general education distribution requirements—so many courses in the humanities and in the social sciences and so on. But these are typically department-based courses, offered as introductions to the discipline and understood as sources for recruitment to the major—an increasingly important activity as universities shift their budget systems to reward departmental entrepreneurship and enrollment. So what's really been lost here is a specific kind of disciplinary and temporal heterogeneity that did properly curricular work. The ripples of a shift like this can sometimes be astonishing: on one side of this line, the inclusion of Wölfflin's *Principles* among the required texts in the art history survey looks perfectly sensible and almost natural; on the other side it looks just plain silly. As the survey slides toward the pure transmission of the disciplinary archive, the history of the discipline looks increasingly unlike a dimension of the discipline and more and more like an adjunct to it, a course of its own off to the side of the core curriculum.

These examples gives us at least two things with which to move forward: a first sketch of properly curricular action and structure, and a recognition that once the university abdicates its defining interest in curriculum, the question of the university becomes askable—if it continues to be askable at all—only in and through the disciplines themselves. Should it not be askable there, the University of Excellence will find its fulfillment as a purely administrative apparatus. This means not only that it is driven by its administration rather than its faculties but also that what is so driven is the administration of knowledge and that what is thus administered is, above all, the knowledge of administration, mediated by faculty members whose primary activity is the management of their own professionalism.[36]

FACULTIES

A faculty, one might imagine, ought to agree about what a curriculum is. One might begin by saying that it is something like the parts of a field or discipline or department pedagogically articulated and so should include delineated sequences of courses where necessary, choices among courses, and some requirement of breadth. A curriculum might also take some stab at locating the field itself in relation to other fields by including various kinds of requirements and recommendations that go beyond the department proper, and it should reflect a developed understanding of the relation between the properly disciplinary or departmental and the larger shape of the surrounding institution. A curriculum that does these things does not necessarily depend on a unified and homogeneous understanding of the field—where it does reflect that, you are presumably dealing with something like a particular "school" within the field—but it does have to make sense of its heterogeneity.

Saying that a curriculum should make sense means at least two things.

It should make sense to students, enabling them to move within an oriented field in which they know what choices and sequences mean. Completing a major, they should be able to see how their courses relate to another (beyond simply being more of the same) and how they amount to a good acquaintance with the field. The reduced description of a curriculum we started from—a set of rules governing choices and sequences—is very close to Ferdinand de Saussure's description of the minimal mechanisms of language, and so one might try saying that a student who has completed a major—satisfied the requirements, mastered a given curriculum—ought to be able to produce sentences in that language: not only sentences he or she has been taught but new sentences that belong to that language.

A curriculum should also make sense to the faculty. That is, they should be able to recognize their teaching as belonging to it—as opposed to the frequent tendency of faculty to recognize themselves as teaching only or primarily within their research specialty and the professional identity it supports. But this last is also to say that a faculty, as a faculty, doesn't agree on a curriculum. It agrees, or disagrees, within a curriculum—is a correlative of it (where there is no curriculum, there is nothing worth calling "a fac-

ulty"). A curriculum that permits us only to recognize our individual selves as instantiated in discrete courses is, in the end, no curriculum at all; the job of curriculum is to show us what we are, so to speak, beyond ourselves, standing in one another's light—or, more accurately, standing in the complex and refracted light of our teachings as borne and transformed by our students.

Because it represents a faculty in this active sense, curriculum renders teaching not an individual but a departmental matter and so plays an important normative or criterial role. It establishes, for example, the ground for such things as course evaluation, which is otherwise hard put to rise above the level of the customer-satisfaction survey in which courses and instructors are routinely conflated and jointly judged according to criteria set by various prevailing winds (so where the curriculum is just more of the same, one can expect little more of course evaluations than that they recognize it as such, which is what they mostly do). This also of course suggests that evaluation itself is a part of what is learned in the student's movement through a curriculum—as if more or less continuous with the other capacities for making sense that we separate out as the object of a faculty's grading. The current proliferation of segregated processes of evaluation, grading, and outcome assessment is worth pondering as the administrative translation of the primacy of method in research.

All of this presses toward recognition of curriculum as a complex social fact, oriented to a work of articulation not reducible to economic exchange—curriculum is what defines a student as other than a customer—and bound as well to a certain contingency (a curriculum is in each case ours, what we recognize ourselves as answerable to) that the standard curriculum often appears to defend against—even as it also ends by reducing us to our most merely empirical individual selves.

WOUNDS AND LIMITS

The French philosopher Gerard Granel writes, both within and against Heidegger: "There is no 'domain' of the fundamental. There is, however, a fundamentality for every (real) domain which cannot be regained from within it, so that without the disruption of thought a practice will remain buried in itself.[37] He goes on to argue that every positive domain is marked by the

general form of a wound without there being any "general wound"—as if to say that we do not sustain an intellectual object over and against the background of the world from which it has been abstracted without paying the cost of the cut that frees it to our attention. Since there are no intellectual objects apart from such cuts, what is fundamental to a discipline shows only at and as its limits. Where we take those limits to be no more than an external frame set around some piece of the world, we mistake both our object and the place of thought within it. What Granel's formulation pushes into the foreground is the thought that the university is the institution of thinking because (and just insofar as) it makes itself out of its internal cuts, frames, and limits (it sponsors no more embracing domain than that). Where it fails in—or refuses—this task, it can imagine itself only as the primary investor in a number of disparate enterprises or practices, buried in themselves, thus essentially closed to thought (and, as Readings would have it, freed to excellence).

If there is still to be something of the university now, it will depend on the ability of the university's various parts—its disciplines or departments or fields or domains—to make themselves out of their limits. This is presumably why a department of art history might recognize itself as having a stake in Heidegger on the world become picture beyond the notional aesthetic relevance of "The Origin of the Work of Art," and why it might find in Derrida's polylogue a spur to curricular imagination—so many places where, at the apparent margins of its object, it might also discover something fundamental to the constitution of that object even as it is carried beyond itself. These texts can, of course, not be imagined to do this work in any or every department, but they perhaps point as well as any particular set of texts can to the general demand that the university be reinvented on the grounds of its departments, in their contingency and limitation.

The discovery here would be of curriculum, but it would not, or would only very exceptionally, be the discovery of a curriculum. Curricular models and templates matter in the end only because they either baffle or permit some particular play of reading and writing, knowing and seeing, that is what it means to actively have an object. "The standard curriculum," for all that it has served as a whipping boy for this exploration, is as capable of doing this as any other particular template (indeed, one—but only one—of the reasons it is standard is that it is reasonably commodious and so often

good enough). If some particular suspicion is to fall on this general model, it should probably fall most squarely on such things as an "introduction to theory" that, sitting alongside the remainder of the curriculum, implicitly locks theory into method and in so doing blocks as well any actual reflection on the larger terms of discipline and objectivity. More generally, one might worry about those moments in the curriculum where things taught, however regularly, remain unreadable—devoid of curricular preparation or consequence.

But this is of course also to assert that reading is a primary pedagogical concern within any art history curriculum. If the overarching animus of this book has been to underline how far art history is essentially and crucially a practice of writing, that must equally be a claim on the necessity of reading. Art-historical inquiry—as opposed to the busy and empty excellence of research—finds its shape and standards in this conjunction. Inquiry's aptest model here is conversation, a model long prized by the university but now increasingly incomprehensible to it.[38] The university may be far from alone in this, but it is unique in its ability to enter a central appeal to curriculum as the institutional condition for consequential conversation and so also the site for such community as conversation can discover or invent.

QUESTIONS OF READING AND writing tend to cluster, among other places, along the lines within a discipline where concerns for intellectual structure and institutional practice meet (or, as may be, diverge), which is certainly one of the reasons that such questions can and do open onto an interest in objectivity that is not easily taken up in terms of an individual subject facing his or her object, just as they tend also to cluster in those places where the heart and limits of a discipline abruptly fold on or into one another. Because they do this, the prospects of objectivity they raise are, in their deepest form, prospects of a world some "we" can imagine itself inhabiting—say, a world in which we might take the claims of experience seriously. This is, one supposes, one way of putting the traditional claims of the humanities; that such claims are evidently no longer sustainable at that level of generality, nor at the still more general level of the university, is surely a symptom of what only grows ever more difficult in modernity itself.

One does not ask art history, any more than art, to save the world, but it is certainly right that it should remind us of the world, and it is even more

certainly right that it should understand some crucial part of its current task to be to recall the university to itself. An art history that has no reasons but its own can only vanish into a professionalism that we may be tempted to call "empty," but that is in fact wholly transparent to and so everywhere filled by the withdrawal or aversion of the world. Call this the logic of nihilism or capitalism or calculative rationality or technology or power, as you will—this book has not been about that, but its interest does not go apart from some reckoning of such conditions.

NOTES

CHAPTER ONE

1. Erwin Panofsky, "The History of Art as a Humanistic Discipline," 24.

2. Ibid., 39.

3. There have been quite a few publications, some primers, some more advanced surveys, and a number of anthologies of essays that have opened onto this ground. Mention should be made here of some particularly pertinent examples: Mark A. Cheetham, Michael Ann Holly, and Keith Moxey, eds., *The Subjects of Art History*; Donald Preziosi, ed., *The Art of Art History: A Critical Anthology*; Dana Arnold and Margaret Iversen, eds., *Art and Thought*; Open University texts, including Steve Edwards, ed., *Art and Its Histories: A Reader*, and Michael Hatt and Charlotte Klonk, *Art History: A Critical Introduction to Its History*; and the various volumes of the Clark Art Institute's Studies in the Visual Arts.

4. Lacan — "Don't give up on your desire!"

5. "What now is the medium of music? If one wishes now to answer, 'Sound. Sound itself,' that will no longer be the neutral answer it seemed to be, said to distinguish music from, say, poetry or painting (whatever it means to 'distinguish' things one would never have thought could be taken for one another); it will be one way of distinguishing (more or less tendentiously) music now from music in the tradition, and what it says is that there are no longer any known structures which must be followed if one is to speak and be understood. The medium is to be discovered or invented out of itself." Stanley Cavell, *Must We Mean What We Say? A Book of Essays*, 221.

6. G. W. F. Hegel, *Aesthetics: Lectures on Fine Art*.

7. Terry Pinkard, *Hegel: A Biography*.

8. But see Beat Wyss's *Hegel's Art History and the Critique of Modernity* for an exploration of Hegel's aesthetics cast in terms of such an imagined encounter.

9. Chapters 3, 5, 6, and 7 are by Margaret Iversen; chapters 2, 4, 8, and 9 are by Stephen Melville.

10. This is certainly a place where our specific attention to Anglo American art history matters. Panofsky holds no such determining place in French art history, and the recent German discussions of *Bildeswissenschaft* reflect a significantly different reception of his work.

CHAPTER TWO

1. Erwin Panofsky, "The Concept of Artistic Volition."

2. Dürer is an important relay within both the Wölfflinian and Pansofkian constructions of art history, and his figurative relation to Friedrich Hölderlin in particular will come up again.

3. Erwin Panofsky, "The History of the Theory of Human Proportions as a Reflection of the History of Styles," 98.

4. Erwin Panofsky, *Perspective as Symbolic Form*, 65–66.

5. Panofsky, "History of the Theory of Human Proportions," 99.

6. Ibid., 106–7.

7. Panofsky, *Perspective as Symbolic Form*, 40–41.

8. Ibid., 67–68, 72. "Anthropocracy," coined here to rhetorically balance "theocracy," is of course what Panofsky will subsequently defend as art history's essential humanism, thus ordering its inquiry to what the perspective essay calls "psychology, in its highest sense," and the major methodological essay "Iconography and Iconology" will pose in terms of the "essential tendencies of the human mind."

9. Michael Podro, *The Critical Historians of Art*, 188.

10. Ibid., 185.

11. This is a slightly simplified description of a more complex object.

12. Erwin Panofsky, "The First Page of Giorgio Vasari's 'Libro,'" 223–24.

13. Ibid., 205.

14. Erwin Panofsky, "Iconography and Iconology: An Introduction to the Study of Renaissance Art," 50–51.

15. Panofsky, *Perspective as Symbolic Form*, 67.

16. Martin Heidegger, *Being and Time*, 138 (translation modified). "Da-sein" is generally left untranslated in Heidegger texts. In ordinary German, it is one of several words that mean "existence," and Heidegger particularly favors it in part because it seems to capture within its own etymology (*Da* = "here" or "there"; *Sein* = "being") the play of distance and proximity that *ent-fernung* also addresses.

17. G. W. F. Hegel, *Phenomenology of Spirit*, 46–47.

18. And it's probably worth noting that Hegel's testing of our imagination of the instrumentality of knowledge raises questions about vision and optics. In Hegel's case, this is less directly a question of perspective than of the general opposition between Newtonian or Cartesian optics and Goethe's very different account of the visible. Heidegger to some extent inherits this contrast, no longer at the level of optical theory but at the level of metaphor, so that he speaks frequently of "the lighting up of Being" and tends to cast this lighting as a matter of "horizons" within which things are variously lit up or cast in shadow—a world shaped, finally, very differently from the infinite, homogenous, and fundamentally mathematical space Panfosky claims for rational perspective.

19. "In Heidegeger's Kantbuch finden sich einige bemerkendswerte Sätze über das Wesen der Interpretation—Sätze, die sich zunächst nur auf die Auslegung philosophischer

Schriften beziehen, die aber im Grunde das Problem jeglicher Interpretation bezeich-
nen: 'Gibt nun eine Interpretation lediglich das wieder, was Kant ausdücklich gesagt hat,
dann ist sie von vornherein keine Auslegung sofern einer solcehn die Aufgabe gestellt
bleibt, dasjenige eigens sichtbar zu machen, was Kant über die ausdrückliche Formulie-
rung hinaus in seiner Grundlegung ans Licht gebracht hat; dieses aber vermochte Kant
nicht mehr zu sage, wie denn überhaupt in jeder philosophischen Erkenntnis nicht das
entscheidend werden muß, was sie in den ausgesprochenen Sätzen sagt, sondern was sie
als noch Ungesagtes durch das Gesagte vor Augen legt. . . . Um frielich dem, was die Wort
sagen, dasjenige abzuringen, was sie sage wollen, muß jede Interpretation notwending
Gewlat brauchen.' Wir werden einsehen müssen, dass auch unsere bescheiden Bildbe-
schreibungen und Inhaltsdeutungen, insofern sie eben nicht einfache Konstatierungen,
sondern auch schon Interpretationen sind, durch diese Sätze getroffen werden." Panof-
sky, "Zum Problem der Beschreibung und Inhaltsdeutung von Werken der bildenden
Kunst," 1072. The passage can seem to present a number of problems of translation, par-
ticularly around Heidegger's contrast between *Interpretation* and *Auslegung*, but it is clear
from Panofsky's introduction of the Heidegger passage that he either does not see or sim-
ply disregards Heidegger's contrast, and my (Melville's) translation follows accordingly.
For a rendering more fully in accord with the standards of contemporary Heidegger trans-
lation, see George Didi-Huberman, *Confronting Images: Questioning the Ends of a Certain
History of Art*, 101–2; it may be worth noting that the French Heidegger translation on
which Didi-Huberman draws is itself closer to the passage as I've rendered it here. The
Heidegger passage is given in *Kant and the Problem of Metaphysics*, 140–41. This edition
includes a range of materials related to Heidegger's exchanges with Cassirer at Davos, on
which see also Michael Friedman, *A Parting of the Ways: Carnap, Cassirer, and Heidegger*.

20. Heidegger's remark, in *Being and Time*, that "the circle must not be degraded to
a *vitiosum*, not even to a tolerated one" is at direct odds with Panofsky's footnote 4 in
"Iconography and Iconology." See Heidegger, *Being and Time*, 195.

21. Panofsky, "Iconography and Iconology," 27.

22. Gadamer's work, particularly his major book *Truth and Method*, is widely known, al-
though not taken up in art historical contexts as frequently as it might be. Jean-Luc
Nancy's work, which has direct relevance to questions of art history at several points,
does not yet have the familiarity it should have in Anglo American contexts; this book
will draw on several of his essays at various points.

23. Michael Baxandall, *Patterns of Intention: On the Historical Explanation of Pictures*. A
valuable set of reflections on Baxandall's work can be found in Adrian Rifkin, ed., *About
Michael Baxandall*.

24. See Michael Baxandall, *The Limewood Sculptors of Renaissance Germany; Giotto
and His Orators: Humanist Observers of Painting in Italy and the Discovery of Pictorial
Composition, 1350–1450*; and *Painting and Experience in Fifteenth-Century Italy: A Primer
in the Social History of Pictorial Style*.

25. Baxandall, *Patterns of Intention*, vii.

26. Ibid., 1.

27. Ibid.,. 34.

28. Ibid., 39.

29. Ibid., 46.

30. Ibid., 30.

31. Ibid., 32.

32. Ibid., 33.

33. Ibid., 7–8. Notice how far Baxandall is worrying all through here about a particularly complex pun offered as an explanation: the design is firm because the design is firm.

34. Ibid., 34.

35. Ibid., 21, fig. 4.

36. "Spanning" (*spannung*) emerges in certain of Heidegger's essays as a sort of translation or revision of *Being and Time*'s "de-distanciation" or "de-severance" (*ent-fernung*) in ways that may seem to have striking resonances, despite the vast difference in intellectual idiom, with what Baxandall is doing. See, for example, Heidegger, "Poetically Man Dwells."

37. One may be struck throughout by the strong resonances between Baxandall and aspects of the literary criticism of T. S. Eliot, Cleanth Richards, and the general terms of American New Criticism, but they are now clearly in service to a distinctly historical project.

38. Ibid., 105. Should one see in this coupling of "proportion" and "perspective" something like an allusion to the twin essays through which Panofsky sorts subjectivity and objectivity?

39. Ibid., 109.

40. Ibid., 113.

41. Ibid., 114.

42. This shift has in certain ways been prepared by the treatments of "color" and "distinctness" in the immediately preceding chapter on Chardin.

43. Ibid., 115.

44. Ibid., 130.

45. The questions of exposure and of experience that emerge here place Baxandall in interesting implicit conversation with both Jean-Luc Nancy and the threads developed out of Wittgenstein by Stanley Cavell and taken up strongly in Michael Fried's writings.

CHAPTER THREE

1. The job was initially given to Karl Giehlow, a Viennese art historian who had written an article called "Dürers Kupferstich *Melencolia I* und der Humanistenkreis Maximilians I," but he left it unfinished as he died in 1913.

2. Erwin Panofsky and Fritz Saxl, *Dürer's Melencolia I: Eine Quellen- und Typen- Geschichtliche Untersuchung*. There is also an expanded version of the 1923 book: Raymond Klibansky, Erwin Panofsky, and Fritz Saxl, *Saturn and Melancholy: Studies in the History of Natural Philosophy Religion and Art*. I mainly refer to Panofsky, rather than

Saxl, and tend to refer to the 1943 Dürer book for simplicity's sake and ease of access and also because it crystallizes Panofsky's view.

3. See Wolfgang Kemp, "Fernbilder: Benjamin und die Kunstwissenschaft."

4. Erwin Panofsky, "The History of Art as a Humanistic Discipline," 17–18.

5. E. H. Gombrich, *Aby Warburg: An Intellectual Biography*. The book includes many translated excerpts from otherwise inaccessible documents in Warburg's archive. An early and trenchant critique of the book can be found in Edgar Wind, "Aby Warburg's Concept of *Kulturwissenschaft*."

6. Gombrich, *Aby Warburg*, 13. See also E. H. Gombrich, "Aby Warburg (1866–1929)."

7. Friedrich Nietzsche, *The Birth of Tragedy and The Case of Wagner*, 46. Warburg's annotated copy of *Die Geburt der Tragödie* is in the Warburg Institute. He seems to have taken particular interest in section 5.

8. Aby Warburg, "Pagan-Antique Prophecy in Words and Images in the Age of Luther," 621.

9. Ibid., 598.

10. Aby Warburg, "Dürer and Italian Antiquity," 555. See Philippe-Alain Michaud, *Aby Warburg and the Image in Motion*, especially chapter 2 on "bodies in motion."

11. Spyros Papapetros makes the valid point that after World War II Gombrich may have had just cause to shy away from the 1920s rise in interest in humankind's irrational side. He continues, "The point could also be made that shying away has never made these monsters disappear. On the contrary, it can make them all the more persistent." "The Eternal Seesaw in Warburg's Revival," 173.

12. Warburg, "Dürer and Italian Antiquity," 555.

13. The German is "ruhiger Widerstandskraft," more precisely translated as "calm power of resistance."

14. Warburg, "Dürer and Italian Antiquity," 558.

15. Gombrich, *Aby Warburg*, p. 237. Quotation from unpublished notes in Warburg archive.

16. Warburg, "Pagan-Antique Prophecy," 599.

17. Ibid.

18. Ibid., 613.

19. Ibid., 636.

20. Ibid., 637.

21. Ibid.

22. Ibid., 641.

23. Ibid.

24. For an authoritative account of this complex of ideas from antiquity to the Renaissance see Klibansky, Panofsky, and Saxl, *Saturn and Melancholy*. For an overview and pertinent extracts from the entire history of melancholia see Jennifer Radden, ed., *The Nature of Melancholy from Aristotle to Kristeva*.

25. Warburg, "Pagan-Antique Prophecy," 641.

26. Ibid., 643.

27. Ibid.

28. Ibid., 644.

29. Warburg, journal 7 (1929), 255, 249; quoted in Gombrich. *Aby Warburg.*

30. See, for example, Giorgio Agamben, *Stanzas: Word and Phantasm in Western Culture,* and Howard Caygill, "Walter Benjamin's Concept of Cultural History."

31. Warburg, 'Pagan-Antique Prophecy," 645.

32. Warburg, "Notebook" (Bayonne), unpublished material from 1927 archive; quoted in Gombich, *Aby Warburg,* 250.

33. Warburg, "Pagan-Antique Prophecy," 644.

34. See Marsilio Ficino, *The Three Books of Life.*

35. Erwin Panofsky, *The Life and Art of Albrecht Dürer,* 166.

36. Marsilio Ficino, quoted in Panofsky, "The History of Art as a Humanistic Discipline," 2.

37. Panofsky, "The History of Art as a Humanistic Discipline," 2.

38. Panofsky, *The Life and Art of Albrecht Dürer,* 162. An expanded version of this analysis is in Klibansky, Panofsky, and Saxl, *Saturn and Melancholy.*

39. Panofsky, *The Life and Art of Albrecht Dürer,* 168. See also Heinrich Wölfflin, *The Art of Albrecht Dürer.*

40. Panofsky, *The Life and Art of Albrecht Dürer,* 160.

41. Ibid., 168.

42. Ibid. Paul Wood discusses the print in relation to the emergence of the idea artistic genius. See his "Genius and Melancholy: The Art of Dürer."

43. Panofsky, *The Life and Art of Albrecht Dürer,* 156.

44. Ibid.

45. Ibid., 164.

46. Ibid., 171. The remark seems to refer, however, to the human condition generally, not particularly the position of the artist.

47. Giehlow reproduces an illustration from an early German translation of Ficino's *The Three Books of Life,* published in 1508, which shows Melancholia as an alchemist; a brazier with urn and bellows is in the background for melting metal.

48. Georges Didi-Huberman, *Confronting Images: Questioning the Ends of a Certain History of Art,* xvii. See also Georges Didi-Huberman, *L'image survivante: Histoire de l'art et temps de fantômes selon Aby Warburg),* especially chapter 1, "L'exorcisme du Nachleben: Gombrich et Panofsky." This is a theme I treated in "Retrieving Warburg's Tradition."

49. Michael Ann Holly, *Panofsky and the Foundations of Art History,* 108.

50. Giorgio Agamben, "Aby Warburg and the Nameless Science," 97. Warburg quote from Gombrich, *Aby Warburg,* 303.

51. Walter Benjamin, *The Origin of German Tragic Drama.*

52. Egyptian hieroglyphs were thought to be "replicas of divine ideas" by early decipherers.

53. See Walter Benjamin, "On Language as Such and on the Language of Man," 72.

54. Benjamin, *Origin,* 164. For a comparison of Warburg and Benjamin, see Matthew Rampley, "Mimesis and Allegory: On Aby Warburg and Walter Benjamin."

55. Benjamin, *Origin of German Tragic Drama*, 160.

56. Ibid., 161.

57. Ibid., 162.

58. Ibid., 179.

59. Ibid., 166. *Facies hippocratica*: the symptoms recognized in ancient Greek medicine as indicating that a patient was near death.

60. Ibid., 176.

61. Ibid., 178. Max Pensky's otherwise excellent book on Benjamin, *Melancholy Dialectics: Walter Benjamin and the Play of Mourning*, is somewhat marred by an entirely Gombrichian characterization of Warburg (see 95–96). See also Michael Camille, "Walter Benjamin and Durer's *Melencolia I*: The Dialectics of Allegory and the Limits of Iconography."

62. Benjamin, *Origin of German Tragic Drama*, 224.

63. Ibid., 157.

64. Chronos is the Greek Saturn.

65. Benjamin, *Origin of German Tragic Drama*, 152.

66. Ibid., 157. See Karen Lang's treatment of Warburg in her book *Chaos and Cosmos: On the Image in Aesthetics and Art History*, where she contrasts Warburg's oscillation between reason and unreason to Kant's unidirectional and teleological development (117).

67. Benjamin, *Origin of German Tragic Drama*, 165.

68. Ibid., 153.

69. Joseph Koerner, *The Moment of Self-Portraiture in German Renaissance Art*, 23.

70. This mirrors the extreme polarity of affect characteristic of melancholy, which oscillates between "abject despondency and divine elatedness." Beatrice Hanssen, "Portrait of Melancholy (Benjamin, Warburg, Panofsky)," in *Benjamin's Ghosts: Interventions in Contemporary Literary and Cultural Theory*, ed. Gerhard Richter, 179.

71. See Margaret Cohen, *Profane Illumination: Walter Benjamin and the Paris of the Surrealist Revolution*, especially chapter 7, "Benjamin Reading the *Rencontre*."

72. See Walter Benjamin, "On the Concept of History."

73. In 1926, four of Atget's photographs were published in *La Révolution surréaliste*.

74. Walter Benjamin, "Little History of Photography," 518.

75. Ibid., 519.

76. Walter Benjamin, "The Work of Art in the Age of Its Technological Reproducibility," 108.

77. See Max Pensky, *Melancholy Dialectics*, especially chapter 3, "Melancholia and Allegory."

78. Benjamin, *Origin of German Tragic Drama*, 166.

79. Walter Benjamin, "Agesilaus Santander," 713. On Benjamin's melancholic pose in photographs of him and a discussion of Klee's drawing *Angelus Novus* (owned by Benjamin) in relation to *Melencolia I*, see Hanssen, "Portrait of Melancholy (Benjamin, Warburg, Panofsky)."

80. For an interesting account of Warburg's descent into madness and his treatment

by Ludwig Binswanger, see Michael P. Steinberg, "Aby Warburg's Kreuzlingen Lecture: A Reading." Warburg gave the lecture in the asylum as proof that he had recovered.

81. Michael Ann Holly, "Interventions: The Melancholy Art," and the accompanying responses.

82. Sigmund Freud, "Mourning and Melancholia," 249.

83. Panofsky, "The History of Art as a Humanistic Discipline," 24.

84. In her tribute to Warburg, his friend and assistant Gertrud Bing notes that Darwin on the emotions was important for Warburg, as was Gotthold Ephraim Lessing's essay "Laocoön." He thought of expressive gestures as diminished traces of past forcible actions. Gertrud Bing, "Aby Warburg," 300.

85. Didi-Huberman, *L'image survivante*, 273. See also Georges Didi-Huberman, "Dialektik des Monstrums: Aby Warburg and the Symptom Paradigm."

86. Warburg, "Pagan-Antique Prophecy," 623.

87. He called Burckhardt and Nietzsche "highly sensitive seismographs." See Kurt W. Forster's introduction to Aby Warburg, *The Renewal of Pagan Antiquity*.

88. Gombrich, *Aby Warburg*, 355.

89. Benjamin, "On the Concept of History," 390.

90. See Benjamin Buchloh, "Gerhard Richter's Atlas: The Anomic Archive," as well as his influential account of postmodernist art, "Allegorical Procedures: Appropriation and Montage in Contemporary Art," and Hal Foster, "An Archival Impulse." A comprehensive account of the cycle is Gerhard Richter and Robert Storr, *Gerhard Richter, October 18, 1977*. See also Richter's Web site, www.gerhard-richter.com. A thought-provoking essay is Peter Wollen, "October 18, 1977." For a collection of texts relating to art and the archive see Charles Merewether, ed., *The Archive*.

91. Benjamin, "On the Concept of History," 395.

CHAPTER FOUR

1. Clive Bell, *Art*, 17–18.

2. Heinrich Wölfflin, *Principles of Art History*, 11.

3. This argument was first made, on a more purely textual basis, by Marshall Brown in "The Classic Is the Baroque: On the Principle of Wölfflin's Art History."

4. Vico, Rousseau, and Nietzsche all held views of this kind. The commitment to such a view is a substantially more important feature of the structuralist impulse than the recognition of language as a system that is often placed in the foreground.

5. Hans-Georg Gadamer, *Truth and Method*, 306.

6. For a closely related argument, see Jean-Luc Nancy, "Sharing Voices."

7. Wölfflin, *Principles*, 11.

8. The resulting model of the relation between "art history" and "visual culture" has interesting resonances with the view developed by Georges Didi-Huberman, primarily out of Aby Warburg's writings, in *L'image survivante : Histoire de l'art et temps des fantômes*

selon Aby Warburg. See also Didi-Huberman, "Dialektik des Monstrums: Aby Warburg and the Symptom Paradigm."

9. The frequently noted "viciousness" of this circle is a misrendering of *vitiosus*—"empty." But of course the point for those committed to the disciplinary model is precisely that the circle captures something, renders an object. The argument here is, unsurprisingly, closely related to the quarrel between Panofsky and Heidegger outlined earlier (see chap. 2, n21).

10. The persistent life of this particular example is no doubt linked to its way of suggesting that such thinking itself amounts to dogmatic slumber.

11. Wölfflin, *Principles of Art History*, 18.

12. Ibid., 17.

13. Ibid., 13–14.

14. Ibid., 14.

15. Jean-Luc Nancy, *The Muses*, 87. Nancy's closing ellipsis trails off, as Kamuf notes, into the opening line of Stéphane Mallarmé's "Tombeau pour Edgar Poe."

16. And Nancy's remarks continue, as if commenting on Wölfflin when in fact he is worrying at Hegel, "But this completion without end—or rather, this *finite finishing*, if one attempts to understand thereby a completion that limits itself to what is, but that, to achieve that very thing, opens the possibility of another completion, and that therefore is also *infinite finishing*—this paradoxical mode of per-fection is doubtless what our whole tradition demands one to think and avoids thinking *at the same time*" (Nancy, *Muses*, 87).

17. Friedrich Hölderlin, *Essays and Letters on Theory*, 149–50.

18. This "looping" of ancient and modern, early and late, through "north" and "south" is the grammar in which the question of "being German" is asked all across the nineteenth century and into the twentieth. Seeing this helps make clear why Wölfflin's book both repeatedly asserts and sets aside considerations, like nationality, that it takes to be "external"—only to return to exactly that topic in its closing pages. One will want particularly to catch the force of Wölfflin's antihumanism here: "With this is certainly connected the fact that, in northern architecture, formations were admitted which for southern imagination could no longer be understood, that is, experienced. In the south, man is the 'measure of all things,' and every line, every plane, every cube is the expression of this plastic anthropocentric conception. In the north there are no binding standards taken from the human being" (Wölfflin, *Principles of Art History*, 236).

19. See Joseph Leo Koerner, *The Moment of Self-Portraiture in German Renaissance Art*. In this context, also see Whitney Davis, "Visuality and Pictoriality."

20. Wölfflin, *Principles of Art History*, 20–21.

21. Ibid., 21.

22. Ibid., 21–22. The insistent presence of the word "sign" (*zeichnung*) in this passage is worth noticing. If language provides valuable analogies for Wölfflin's argument, it also has a distinct way of figuring within those arguments. The central reference in this

passage is to Velázquez's *Spinners*; Wölfflin's largely implicit account of the painting is interestingly continuous with Svetlana Alpers's reading of it in her *The Vexations of Art: Velázquez and Others*.

23. The German text of the last few sentences reads: "Erst die Verundeutlichung macht das Rad laufen. Die Zeichen der Darstellung haben sich völlstandig getrennt von der realen Form. Ein Triumph des Scheins über das Sein." "Lauf" here does not repeat the earlier "rollenden," and carries a distinctly more temporal sense; "umlauf," which Wölfflin does not use, would carry a stronger sense of revolution or rotation—"Only the becoming obscure makes the wheels run," perhaps. The English translator has omitted the next sentence altogether: "The signs of presentation have fully separated themselves from the real form." The word for "revolution" in the previous passage was the relatively unusual "Umorientierung," a word carrying more the force of "reorientation" than (political or intellectual) revolution, "turning about," one might say.

24. One might feel that something of this is given oblique expression in Wölfflin's observation that "even the roundness of the felly has lost its pure geometric form."

25. Clement Greenberg, "Modernist Painting," 87. In her *Eyesight Alone: Clement Greenberg's Modernism and the Bureaucratization of the Senses* Caroline Jones suggests a larger and earlier influence from Wölfflin but offers no particular evidence in support of the claim.

26. Wölfflin, *Principles of Art History*, 87.

27. Ibid., 85.

28. "It is self-evident that there will be no special part for the power of judgment . . . since in regard to that critique serves instead of theory." Immanuel Kant, *Critique of the Power of Judgement*, 58.

29. "Lacking the past of art, and the need and compulsion to maintain its standards of excellence, Modernist art would lack both substance and justification" (Greenberg, "Modernist Painting," 93). This can be usefully considered alongside Kant's remark that the products of genius are exemplary in a special sense: "Since the gift of nature must give the rule to art (as beautiful art), what sort of rule is this? It cannot be couched in a formula to serve as a precept, for then the judgement about the beautiful would be determinable in accordance with concepts; rather the rule must be abstracted from the deed, i.e. from the product, against which others may test their own talent, letting it serve them as a model not for *copying* but for *imitation*. How this is possible is hard to explain" (Kant, *Critique of the Power of Judgement*, 188).

30. Clement Greenberg, "Avant-Garde and Kitsch," 12.

31. Greenberg, "Modernist Painting," 93–94.

32. See Sigmund Freud, *The Interpretation of Dreams*, 152–53.

33. "The flatness toward which Modernist painting orients itself can never be an absolute flatness." Greenberg, "Modernist Painting," 90.

34. Scare quotes: "quotation marks used to foreground a particular word or phrase,

esp. with the intention of disassociating the user from the expression or from some implied connotation it carries," says the OED.

35. Michael Fried, *Art and Objecthood*, 148.

36. Ibid., 148–49.

37. Ibid., 160–61.

38. Stanley Cavell, *Must We Mean What We Say?* 216, 218.

39. Ibid., 191.

CHAPTER FIVE

1. G. W. F. Hegel, *Aesthetics: Lectures on Fine Art*, 2:806.

2. Ibid., 2:806.

3. Ibid., 2:523.

4. Ibid., 2:806.

5. Michael Podro, *The Critical Historians of Art*, 19.

6. This chapter condenses, updates, revises and further elaborates portions of Margaret Iversen, *Alois Riegl: Art History and Theory*.

7. I take the term "formal strategy" from Benjamin Binstock's lively article "I've Got You under My Skin: Rembrandt, Riegl, and the Will of Art History." My remarks on formalism and description are in response to Jas' Elsner, "From Empirical Evidence to the Big Picture: Some Reflections on Riegl's Concept of *Kunstwollen*."

8. There is a superficial resemblance between this positivist view and Baxandall's practice of inferential criticism, since he prefers the word "explanation" to "interpretation" and also attends to the processes of making in his account to works. But the "circumstances" that, for Baxandall, enable us to form an account of a work of art are certainly not reducible to materials and techniques.

9. Alois Riegl, *Die spätrömische Kunstindustrie nach den Funden in Österreich-Ungarn*, 19.

10. Ibid., 26–27.

11. Clement Greenberg, "Sculpture in Our Time," 60.

12. Alois Riegl, *Group Portraiture of Holland*.

13. I find Benjamin Binstock's argument, that the Syndics are looking at sketches of themselves and responding to Rembrandt as the artist they've commissioned, a little over elaborate and not convincing because the painting itself does not suggest this interpretation. In my view, one doesn't need to supply any definitive narrative. See Binstock, "Seeing Representations, or The Hidden Master in Rembrandt's *Syndics*."

14. Riegl, *Group Portraiture of Holland*, 75.

15. Arthur Schopenhauer, *The World as Will and Representation*, 197.

16. Riegl, *Group Portraiture of Holland*, 82.

17. On the ethical dimension of Riegl's concept of attention see Margaret Olin, *Forms of Representation in Alois Riegl's Theory of Art*.

18. Leo Steinberg, "The Philosophical Brothel."

19. See Steinberg's reference to Riegl's *Das Holländische Gruppenporträt* in his footnote 9.
20. See Lisa Florman, "The Difference Experience Makes in 'The Philosophical Brothel.'"
21. In the early 1870s Riegl was an active member of the German Students' Reading Society at the University of Vienna, where he would have been exposed to the philosophies of Schopenhauer and Nietzsche, including the latter's *The Birth of Tragedy* and *Untimely Meditations*. See Karen Lang, *Chaos and Cosmos: On the Image in Aesthetics and Art History*, 136, where a PhD dissertation on this subject is cited.
22. Steinberg, "The Philosophical Brothel," 14.
23. Leo Steinberg, "Velázquez's *Las Meninas*."
24. Steinberg, "The Philosophical Brothel," 14.
25. Steinberg, "Velázquez's *Las Meninas*," 48.
26. Ibid., 51.
27. See Michel Foucault, *The Order of Things: An Archaeology of the Human Sciences*, 3–16. See also chap. 9, "Man and His Doubles," 307.
28. A germane commentary on Foucault's "Las Meninas" is Gary Shapiro, *Archaeologies of Vision: Foucault and Nietzsche on Seeing and Saying*, chap. 7. Many other commentaries take issue with the detail of Foucault's analysis of the painting, especially as regards its perspectival construction.
29. Émile Benveniste, "The Correlations of Tense in the French Verb." The article was originally published in 1959.
30. Ibid., 208.
31. Steinberg, "Velázquez's *Las Meninas*," 54.
32. Svetlana Alpers, *The Vexations of Art: Velázquez and Others*, 259.
33. Steinberg, "Velázquez's *Las Meninas*," 48.
34. Michael Fried, *Absorption and Theatricality: Painting and Beholder in the Age of Diderot*.
35. Ibid., 83.
36. Ibid., 64.
37. Ibid., 367.
38. See Alex Potts, *The Sculptural Imagination: Figurative, Modernist, Minimalist*, especially the sections on Herder in the Introduction.
39. Maurice Merleau-Ponty, *The Visible and the Invisible*, 134.
40. These remarks particularly refer to Morris's *Blind Time IV: Drawing with Davidson* (1991). See Robert Morris, *Blind Time Drawings, 1973–2000*, edited by Jean-Pierre Criqui, Steidl (2005), and "Writing with Davidson: Some Afterthought after Doing *Blind Time IV: Drawing with Davidson*."
41. Robert Morris, "The Present Tense of Space."
42. See ibid., 177.
43. George H. Mead, *Mind, Self, and Society: From the Standpoint of a Social Behaviorist*.
44. Morris, "Present Tense of Space," 177.

45. Ibid., 176.

46. Ibid., 186.

47. Ibid., 187.

48. Ibid.

49. Ibid., 175.

50. Ibid., 199.

51. Morris, "Present Tense," 204.

52. Ibid.

53. Ibid., 206.

54. Maurice Merleau-Ponty, *The Phenomenology of Perception*, 320.

CHAPTER SIX

1. See Jonathan Crary, *Techniques of the Observer*, 139.

2. Merleau-Ponty, "Cézanne's Doubt," 69.

3. Ibid., 69.

4. Ibid., 65.

5. Ibid., 62.

6. Ibid.

7. Galen A. Johnson, "Phenomenology and Painting," 13.

8. Merleau-Ponty, "Cézanne's Doubt," 64.

9. Ibid.

10. Merleau-Ponty, "Eye and Mind," 135. On this same page Merleau-Ponty provides a tendentious gloss of the argument of Panofsky's perspective paper that suggests that he read in it what he wanted to find.

11. A fairly large excerpt is translated in Christopher Wood, ed., *The Vienna School Reader: Politics and Art Historical Method in the 1930s*.

12. Fritz Novotny, *Cézanne und das Ende der wissenschaftlichen Perspektive*, 4.

13. Ibid., 137.

14. Ibid.

15. Merleau-Ponty, "Cézanne's Doubt," 66.

16. Ibid., 69.

17. Ibid., 70.

18. See Merleau-Ponty, *The Visible and the Invisible*, and in particular the section titled "The Intertwining—The Chiasm."

19. Jacques Lacan, "The Mirror Stage as Formative of the Function of the *I* as Revealed in Psychoanalytic Experience."

20. Ibid., 75.

21. Ibid., 76.

22. Jean-Louis Baudry, "Ideological Effects of the Basic Cinematographic Apparatus," 286.

23. Ibid., 292.

24. Ibid;., 294.

25. Ibid., 295.

26. Christian Metz, "The Imaginary Signifier," 4.

27. Ibid., 53.

28. Laura Mulvey, "Visual Pleasure and Narrative Cinema," 25.

29. Ibid., 25.

30. Ibid., 20.

31. Jacqueline Rose, "The Imaginary."

32. Joan Copjec, "The Orthopsychic Subject: Film Theory and the Reception of Lacan." See the chapter on Dalí, Lacan, and paranoia in Margaret Iversen, *Beyond Pleasure: Freud, Lacan, Barthes,* for a full account of the ambivalence of the mirror image.

33. Copjec, "The Orthopsychic Subject," 23.

34. See Jean-Paul Sartre, *Being and Nothingness: An Essay on Phenomenological Ontology.*

35. Stephen Melville, "Division of the Gaze, or Remarks on the Color and Tenor of Contemporary 'Theory,'" 119.

36. Copjec, "The Orthopsychic Subject," 34.

37. Roland Barthes, *Camera Lucida: Reflections on Photography.* I mention this because Barthes's book relies on Jacques Lacan's *The Four Fundamental Concepts of Psychoanalysis.* See Iversen, "What Is a Photograph?" (expanded version in Iversen, *Beyond Pleasure*).

38. Joan Copjec, "The Strut of Vision: Seeing's Corporeal Support," 184.

39. Jacques Lacan, "Seminar XIII: L'objet de la psychanalyse," May 4, 1966.

40. Hubert Damisch, *The Origin of Perspective,* 3.

41. Erwin Panofsky, *Perspective as Symbolic Form,* 41.

42. Michael Podro, *The Critical Historians of Art,* 189.

43. Joseph Leo Koerner, "The Shock of the View," 34.

44. Leon Battista Alberti, *On Painting.*

45. Hubert Damisch, *Theory of /Cloud/: Toward a History of Painting,* 124.

46. Damisch, *The Origin of Perspective,* 283.

47. Ibid., 263.

48. Claude Lévi-Strauss, *The Way of the Masks.*

49. Damisch, *The Origin of Perspective,* 197.

50. Damisch's book, along with Panofsky's *Perspective as Symbolic Form,* can be considered a response to Edmund Husserl's "The Origin of Geometry."

51. Damisch, *The Origin of Perspective,* 44.

52. See ibid., 45.

53. Ibid., 425.

54. Ibid., 46.

55. Ibid., 51.

56. Ibid., 46.

57. Ibid., 233.

58. Ibid., 184–85.

59. Damisch, *Theory of /Cloud/*, 181.

60. According to Manetti, Brunelleschi's first biographer, there were two panels: the one of the Baptistery and one of the Palazzo de'Signori. For an attempt at reconstruction of these and the technicalities associated with them, see Martin Kemp, *The Science of Art: Optical Theories in Western Art from Brunelleschi to Seurat*.

61. See Damisch, *The Origin of Perspective*, 115.

62. Ibid., 446.

63. Émile Benveniste, *Problems in General Linguistics*, 227.

64. See Damisch, *The Origin of Perspective*, 227.

65. Ibid., 388.

66. Ibid., 266.

67. Ibid., 341.

68. Ibid., 443.

69. Lacan, *The Four Fundamental Concepts of Psychoanalysis*, 81.

70. Damisch, *The Origin of Perspective*, 443–444.

71. See Panofsky's realignment of Riegl's concept of *Kunstwollen* along these lines. Erwin Panofsky, "The Concept of Artistic Volition," and Erwin Panofsky, "On the Relationship of Art History and Art Theory: Towards the Possibility of a Fundamental System of Concepts for a Science of Art."

72. Stephen Melville, "The Temptation of New Perspectives."

73. Damisch, *The Origin of Perspective*, 123.

CHAPTER SEVEN

1. Susan Sontag, "Against Interpretation," 9.

2. See, for example, the respective essays by Yve-Alain Bois and Rosalind Krauss in Lynn Zelevansky, ed., *Picasso and Braque: A Symposium*.

3. Yve-Alain Bois and Rosalind Krauss, *Formless: A User's Guide*.

4. The debate has a very long history. See W .J. T. Mitchell, *Iconology: Image, Text, Ideology* for an overview.

5. Gilles Deleuze, *Francis Bacon: The Logic of Sensation* (first published in France, 1981).

6. Jean-François Lyotard, *Discours, figure* and *The Postmodern Condition: A Report on Knowledge*.

7. Ferdinand de Saussure, *Course in General Linguistics*. I use the French-derived *semiology* when referring to the Saussurean tradition and Charles Sanders Peirce's preferred term, *semiotics*, when referring to work relating to his theory of the sign.

8. See, for example, Mieke Bal, "Seeing Signs: The Use of Semiotics for the Understanding of Visual Art," 81.

9. Roland Barthes, "Myth Today," 158.

10. Roland Barthes, "The Death of the Author," in *Image-Music-Text*.

11. Roland Barthes, "Inaugural Lecture, Collège de France," 470.

12. Jean-François Lyotard, "Taking the Side of the Figural," 36.

13. Ibid., 36–37.

14. Ibid.

15. Bill Readings, *Introducing Lyotard: Art and Politics*, 12.

16. Lyotard, *Discours, figure*, 86.

17. Ibid., 27.

18. Lyotard, "Taking the Side of the Figural," 39.

19. Ibid., 35.

20. Lyotard, *Discours, figure*, p. 21.

21. Lyotard, "Taking the Side of the Figural," p. 39.

22. Readings, *Introducing Lyotard*, 45.

23. Anton Ehrenzweig, *The Hidden Order of Art: A Study in the Psychology of Artistic Imagination*.

24. Jean-François Lyotard, "The Dream-Work Does Not Think," 23.

25. Peter Dews, "The Letter and the Line: Discourse and Its Other in Lyotard," 47.

26. Lyotard, "The Dream-Work Does Not Think," 30.

27. Ibid., 51.

28. Lyotard, *Discours, figure*, 238. Lyotard refers to Breton's "convulsive beauty" in this context.

29. See Lyotard, *The Postmodern Condition*, and Jean-François Lyotard, *The Inhuman: Reflections on Time*.

30. "Rhetoric of the Image" and "The Third Meaning" are both available in Barthes, *Image-Music-Text*.

31. Roland Barthes, "Myth Today," 158–59.

32. Roland Barthes, *Camera Lucida: Reflections on Photography*, 8.

33. Barthes, "Myth Today," 159.

34. Roland Barthes, *The Pleasure of the Text*, 60.

35. Roland Barthes, "Introduction to the Structural Analysis of Narratives."

36. Ibid., 252.

37. Claude Lévi-Strauss, *Structural Anthropology*, 210.

38. The English translation of this text is readily accessible in two anthologies—"The Eiffel Tower" in *A Roland Barthes Reader*, ed. Sontag, and in *The Eiffel Tower and Other Mythologies*—but it represents only half of the original French version of *La Tour Eiffel*. I will refer to both English versions; thus *Roland Barthes Reader*, 242; *Eiffel Tower*, 9.

39. *Roland Barthes Reader*, 243; *Eiffel Tower*, 9.

40. *Roland Barthes Reader*, 242; *Eiffel Tower*, 9.

41. *Roland Barthes Reader*, 249; *Eiffel Tower*, 16.

42. *Roland Barthes Reader*, 237; *Eiffel Tower*, 4. For the "floating signifier" see Claude Lévi-Strauss, *Introduction to the Work of Marcel Mauss*, 62.

43. Roland Barthes, *Roland Barthes by Roland Barthes*, 103.

44. Ibid., 71.

45. Roland Barthes, *Elements of Semiology*, 24.

46. Maurice Merleau-Ponty, *The Phenomenology of Perception*, 177.

47. Ibid., 184.

48. Ibid., 184.

49. Ibid., 187.

50. Martin Heidegger, *Being and Time*, 211f–<??>.

51. Roland Barthes, "Masson's Semiography," 154.

52. Ibid., 155.

53. Harold Rosenberg, "The American Action Painters," 31.

54. Roland Barthes, "Cy Twombly: Works on Paper," 160; see also "The Wisdom of Art."

55. Roland Barthes, "The Third Meaning," 52–68.

56. See Barthes, "Cy Twombly," 171–72.

57. Ibid., 172. The Lacanian resonance in the quotation where imaginary and real are contrasted is no doubt intended.

58. Ibid.

59. Norman Bryson, *Word and Image: French Painting of the Ancien Régime*.

60. Ibid.,, 23, 27.

61. Lyotard, "The Dream-Work Does Not Think," 20.

62. Charles Sanders Peirce, "Icon, Index, Symbol" and "Logic as Semiotic: The Theory of Signs."

63. Peter Wollen, *Signs and Meaning in the Cinema*.

64. Roman Jakobson, "Quest for the Essence of Language," 412.

65. Ibid.

66. Ibid.

67. Roman Jakobson, "Shifters, Verbal Categories, and the Russian Verb."

68. Rosalind Krauss, "Notes on the Index," pt. 1, 203.

69. Ibid.

70. Ibid., 209.

71. Ibid., 205.

72. Krauss, "Notes on the Index," pt. 2, 211.

73. From a series of interviews by David Craven (July 15, 1992–January 22, 1995) with Meyer Schapiro and Lillian Milgram Schapiro, subsequently published in *RES* 31 (Spring 1997): 165.

74. There is a reference in the 1968 Cézanne essay to George H. Mead, *The Philosophy of the Act*, a phenomenological work that also influenced Robert Morris (see chap. 5 above).

75. See Meyer Schapiro, "The Apples of Cézanne."

76. Meyer Schapiro, "On Some Problems in the Semiotics of Visual Art: Field and Vehicle in Image-Signs," 1.

77. Ibid.

78. Ibid., 7.

79. Ibid., 12.

80. Ibid.

81. Meyer Schapiro, *Words and Pictures: On the Literal and the Symbolic in the Illustration of a Text.*

82. See Sigmund Freud, "Considerations of Representability," in *The Interpretation of Dreams.*

83. Hubert Damisch, "Six Notes on the Margin of Meyer Schapiro's *Words and Pictures.*" 32.

84. Schapiro, *Words and Pictures*, 43.

85. Meyer Schapiro, "Eugène Fromentin as Critic."

86. Ibid., 103.

87. Ibid., 104.

88. Ibid., 109.

89. Maurice Merleau-Ponty, "Cézanne's Doubt," 62.

90. Roland Barthes, "Avant-propos à Jakobson," and "L'age de l'homme," 251–52.

91. T. J. Clark, *The Sight of Death: An Experiment in Art Writing.*

92. With regard to questions of materiality and figurality raised by Clark in relation to Cézanne and Paul de Man, see T. J. Clark, "Phenomenality and Materiality in Cézanne."

93. Clark, *The Sight of Death*, 122–23.

94. Ibid., 176.

95. Ibid.

96. Ibid., 216.

CHAPTER EIGHT

1. See Ernst Gombrich, *In Search of Cultural History*, and "The Father of Art History: A Reading of the Lectures on Aesthetics of G. W. F. Hegel (1770–1831)." For a more recent negative appraisal of the Hegelian influence, see Keith Moxey, "Art History's Hegelian Unconscious: Naturalism as Nationalism in the Study of Early Netherlandish Painting."

2. This is a field within which art, art history, and aesthetics represent only a highly particular, historically and geographically local formation and so cannot provide fundamental terms for the field as a whole.

3. This is of course the ground on which Wölfflin takes up his imagination of art history's shape (see chapter 4 above).

4. In the separate register of the *Lectures on the Fine Art* Hegel does, of course, have to address this moment of art history, and his remarks here are a useful gloss on what he must find to read in Kant's metaphors. See, in particular, the discussion of Romantic architecture in Hegel's *Aesthetics*, vol. 2, where the Gothic dissolution of "the fixed and express difference between a load and its support" can be taken as step toward the philosophic thought of system.

5. Martin Heidegger, *Schelling's Treatise on the Essence of Human Freedom*, 39.

6. Martin Heidegger, *Hegel's Phenomenology of Spirit*, 15. On Heidegger's reading of Hegel, see also Jean-Luc Nancy, *The Speculative Remark (One of Hegel's Bon Mots)* and *Hegel: The Restlessness of the Negative.*

7. Heidegger, *Hegel's Phenomenology of Spirit*, 16.

8. Ibid., 17.

9. For all its familiarity, this is not a scheme Hegel ever actually employs, and it is used in these pages as no more than a useful shorthand with which to bring out certain highly general features of Hegel's system. It's typically said that Hegel's actual practice is more complex than any such schema captures; more pointedly, the scheme assumes some underlying logical form for Hegelian argument, but for Hegel argument finds its actual form in the sentences of natural language.

10. G. W. F. Hegel, *Phenomenology of Spirit*, 39.

11. In Kant this is put as a difference between two kinds of proposition, analytic and synthetic. From Hegel's point of view, this distinction is a way of not coming to grips with the actual question of logic, say its necessary grammar or grammaticality ("is" cannot be replaced by some blanker, nonsentential sign like "=").

12. Hegel, *Phenomenology of Spirit*, 38. This passage is central to any discussion of Hegel's views on language and logic. Relating it to the material from the *Lectures on Fine Art*, as this chapter does, is rather more maverick. For a more general view of these matters, see Jere O'Neill Surber, ed., *Hegel and Language*.

13. So one way of pursuing Hegel's logical remarks leads back through his complex relation to Hölderlin, and so also connects up with some of our earlier remarks on Dürer's place in competing visions of art history.

14. On "plasticity," see also Catherine Malabou, *The Future of Hegel: Plasticity, Temporality, and Dialectic*. Malabou's interest in plasticity is more oriented to lability than to material formation, so she somewhat downplays the passages we've focused on, but her study brings out a number of larger dimensions of the term as Hegel uses it throughout his writing.

15. Hegel, *Lectures on Aesthetics*, 1:11.

16. Ibid., 2:635.

17. Ibid., 1:303. Jason Gaiger has pointed to the particular influence of the work of George Friedrich Creuzer on Hegel's formulation of Symbolic art. See in particular the passages excerpted from Creuzer's *Symbolism and Mythology of the Ancient Peoples, Particularly the Greeks*, in Charles Harrison, Paul J. Wood, and Jason Gaiger, *Art in Theory, 1648–1815: An Anthology of Changing Ideas*.

18. Hegel, *Lectures on Aesthetics*, 1:304.

19. Ibid.

20. Such architecture is notably friendly to language: "In their purely independent effect, without serving as a habitation or enclosure for a god or the worshipping community, [Egyptian temple-precincts] amaze us by their colossal proportions and mass, while at the same time their individual forms and shapes engross our whole interest by themselves because they have been erected as symbols for purely universal meanings or are even substitutes for books since they manifest the meanings not by their mode of configuration but by writings, hieroglyphics, engraved on their surface." Ibid., 2:644.

21. "Self-consciousness" is not in the first instance for Hegel a matter of reflexivity but of the "self-shapedness" of a consciousness that had not in its earlier moments felt its identity to be at stake in its claims to knowledge. Its first form is thus a simple assertion of self-subsistence ("I am I") that rapidly finds itself engaged with various forms of otherness. See Hegel, *Phenomenology of Spirit*, 104–5.

22. These descriptions are then of the fate or recurrence of the sculptural Classical and Symbolic under Romantic conditions. As such, they point toward ways in which one might want to think about the end or ending of art both with and against Hegel's own pronouncements.

23. Thus the Hegelian pointedness of Michael Fried's remark that minimalism's anthropomorphism lies in its concealment of its relation to the human.

24. Hegel, *Phenomenology of Spirit*, 27.

25. See Arthur C. Danto, *After the End of Art: Contemporary Art and the Pale of History*, and Hans Belting, *The End of the History of Art?*

CHAPTER NINE

1. Martin Heidegger, "The Age of the World Picture," 125–26.

2. Heidegger's tendency to pick out only a highly general fact of "institutionalization" rather than a specific and problematic form of it already suggests that his positive usefulness in thinking about questions of the university will be limited.

3. Bill Readings, *The University in Ruins*, 23–24.

4. Ibid., 32–33.

5. E-mail from Academicwebpages.com, September 26, 2007.

6. Martin Heidegger, "The Question concerning Technology," 26–27.

7. Much of Michel Foucault's work can be usefully understood as inheriting—extending and transforming—these Heideggerean concerns, and the implied critique of the social sciences in particular.

8. It's worth noticing that this range of meaning brings the apparently visual or structural notion of *Gestell* right up to the borders of notions of "interpellation" or "arraignment" (*arraisonnement*) as they appear in Louis Althusser or Jacques Derrida. Heidegger himself is very alert to this dimension of the word, speaking of the modern subject's "ordering forth" of objects, although he is apparently blind to any larger social or political dimension.

9. On *Gestell*, see also the translator's note to Martin Heidegger, "The Origin of the Work of Art."

10. Heidegger, *Schelling's Treatise on the Essence of Human Freedom*, 26.

11. Both sides of this reemerge as notions of "cut" and "fold" in the work of such figures as Gilles Deleuze and Jean-Luc Nancy

12. E. H. Gombrich, *Art and Illusion: A Study in the Psychology of Pictorial Representation*, 56–58.

13. See Norman Bryson, "Semiology and Visual Interpretation," as well as Mieke Bal and Norman Bryson, "Semiotics and Art History."

14. Heidegger, "The Question concerning Technology," 35.

15. Heidegger prefers throughout the term "equipment" to "artifact." The relation to the argument about technology needs no particular underlining.

16. Heidegger, "The Origin of the Work of Art," 27.

17. Although the shoes are thus introduced at a particular point in the essay, they have been hanging around, like a silent and unnoticed participant in a conversation, for a while. They are in fact introduced more than once, as if they keep on needing introduction.

18. The argument has, then, strong affinities with Nietzsche's reading of the birth, and death, of tragedy. I'm grateful to Matthew Bowman for suggesting that this might be a good place to acknowledge the more general impact and implicit presence of *The Birth of Tragedy* in a number of essays in this volume. As he put it, "It's as if Nietzsche's role in the foundations of art history is as a ghostly counterpart to Hegel (rather than, say, his opponent)."

19. Heidegger, "The Origin of the Work of Art," 19.

20. Ibid., 34–36.

21. Ibid., 64.

22. Ibid.

23. On the *Rektoratsrede* see Bill Readings, *The University in Ruins*, and Christopher Fynsk, *The Claim of Language: A Case for the Humanities*.

24. So this bit of Heidegger can be woven back through the various remarks about perspective, the gaze, and so on elsewhere in this volume.

25. In this Heidegger participates in what seem a broader problem disciplinarity has often seemed to pose for philosophy—as if philosophy were regularly tempted to imagine itself able to order the disciplines in a way they cannot order themselves (and this can sometimes also seem to mean that if the disciplines were to be indeed properly ordered, there would in fact only be philosophy).

26. Jacques Derrida, *The Truth in Painting*.

27. Hölderlin, in "The Turning": "But where danger is, grows/The saving power also." And as glossed by Heidegger: "The closer we come to danger, the more brightly do the ways into the saving power begin to shine and the more questioning we become." Heidegger, "The Question concerning Technology," 35.

28. See especially Jacques Derrida, *Of Grammatology*, "The *Retrait* of Metaphor," and *Of Spirit: Heidegger and the Question*.

29. The voices structuring many of Maurice Blanchot's *recits* are presumably an important model for Derrida; the play of voices in the nonfiction of *The Infinite Conversation* is perhaps even more interesting.

30. See, for a central instance, Nancy's essay "Partage des voix," translated as "Sharing

Voices." Arguably, the best English rendering of *partager* is the now obsolete verb "to compart," which can indicate both sharing and sharing out.

31. Derrida, *The Truth in Painting*, 318.

32. It's interesting to note that the College Art Association instituted an annual prize for "Distinguished Lifetime Achievement for Writing on Art," which has, to date, been awarded to none of these figures and seems to function simply as a lifetime scholarly achievement award.

33. Arthur C. Danto, *After the End of Art: Contemporary Art and the Pale of History*, 64–65.

34. One way of taking Michael Baxandall's implicit quarrel with Panofsky in the closing chapter of *Patterns of Intention: On the Historical Explanation of Pictures* is to say that he is showing Panofskian art history to mistake historical relation for cultural distance—even to actively convert the one into the other—and so working against that to return art history to fully historical modes of understanding and explanation.

35. Heidegger, "The Age of the World Picture," 116.

36. It follows from this that the university's self-definition now emerges above all from the social sciences. The recognition of the social sciences as essentially administrative and tending toward the creation of subjects that simply are their own administration owes a substantial debt to the work of Michel Foucault, whose work from *The Order of Things* on can be strongly characterized as a genealogical critique of the modern sciences of administration. Recognition of the way in which the social sciences find their fullest expression and representation in the fact of administration helps clarify how the central problem of the University of Excellence is not captured by opposing faculty to administration (as, say, labor to management) but by understanding the force and consequence of the dissolution of any such opposition; it is a question of a university that has become administration all the way down.

37. Gerard Granel, *Traditionis traditio*, 11–12. See also Fynsk, *The Claim of Language*.

38. Here our prolonged wanderings through Heidegger and Derrida rejoin Baxandall's more economically stated remarks on the ways in which "newly professionalized and academicized activities like art criticism tend to don special authority rather fast" and at odds with "the authority of common visual experience"—and particularly with his closing remarks on the origins of art history in dinner conversations characterized in terms of both their rationality and their democratic sociability. See Baxandall, *Patterns of Intention*, 137.

Agamben, Giorgio. "Aby Warburg and the Nameless Science." In *Potentialities: Collected Essays in Philosophy*. Stanford, CA: Stanford University Press, 1999.

———. *Stanzas: Word and Phantasm in Western Culture*. Trans. Ronald L. Martinez. Minneapolis: University of Minnesota Press, 1993.

Alberti, Leon Battista. *On Painting*. Trans. Cecil Grayson, with an introduction by Martin Kemp. London: Penguin, 1991.

Alpers, Svetlana. *The Vexations of Art: Velázquez and Others*. New Haven, CT: Yale University Press, 2005.

Arnold, Dana, and Margaret Iversen, eds. *Art and Thought*. Oxford: Blackwell, 2003.

Bal, Mieke. "Seeing Signs: The Use of Semiotics for the Understanding of Visual Art." In *The Subjects of Art History*, ed. Cheetham, Holly, and Moxey.

Bal, Mieke, and Norman Bryson. "Semiotics and Art History." *Art Bulletin* 73, no. 2 (June 1991).

Barker, Emma, Nick Webb, and Kim Woods, eds. *The Changing Status of the Artist*. New Haven, CT: Yale University Press, 1999.

Barthes, Roland. "L'age de l'homme." In *Oeuvres complètes*. Paris: Éditions du Seuil, 1993–95.

———. "Avant-propos à Jakobson." In *Oeuvres complètes*, Paris: Éditions du Seuil, 1993–95.

———. *Camera Lucida: Reflections on Photography*. Trans. Richard Howard. New York: Hill and Wang, 1981.

———. "Cy Twombly: Works on Paper." In *The Responsibility of Forms: Critical Essays on Music, Art, and Representation*, trans. Richard Howard. New York: Hill and Wang, 1985.

———. "The Death of the Author." In *Image-Music-Text*, trans. Stephen Heath. London: Fontana, 1977.

———. "The Eiffel Tower." In *The Eiffel Tower and Other Mythologies*, trans. Richard Howard. Berkeley: University of California Press, 1997. Also in *A Roland Barthes Reader*, ed. Susan Sontag. London: Vintage, 1982.

———. *Elements of Semiology*. Trans. Annette Lavers and Colin Smith. New York: Hill and Wang, 1967.

———. "Inaugural Lecture, Collège de France." In *A Roland Barthes Reader*, ed. Susan Sontag. London: Vintage, 1982.

——. "Introduction to the Structural Analysis of Narratives." In *A Roland Barthes Reader*, ed. Susan Sontag. London: Vintage, 1982.

——. "Masson's Semiography." In *The Responsibility of Forms: Critical Essays on Music, Art, and Representation*, trans. Richard Howard. New York: Hill and Wang, 1985.

——. "Myth Today." In *Mythologies*, trans. Annette Lavers. New York: Noonday, 1988.

——. *The Pleasure of the Text*. Trans. Richard Miller. New York: Hill and Wang, 1975.

——. "Rhetoric of the Image." In *Image-Music-Text*, trans. Stephen Heath. London: Fontana, 1977.

——. *Roland Barthes by Roland Barthes*. Trans. Richard Howard. New York: Hill and Wang, 1977.

——. "The Third Meaning." In *Image-Music-Text*, trans. Stephen Heath. London: Fontana, 1977.

——. *La Tour Eiffel*. With photographs by André Martin. Paris: Centre Nationale de la Photographie et Éditions du Seuil, 1964.

——. "The Wisdom of Art." In *The Responsibility of Forms: Critical Essays on Music, Art, and Representation*, trans. Richard Howard. New York: Hill and Wang, 1985.

Baudry, Jean-Louis. "Ideological Effects of the Basic Cinematographic Apparatus." In *Narrative, Apparatus, Ideology: A Film Reader*, ed. Philip Rose. New York: Columbia University Press, 1986.

Baxandall, Michael. *Giotto and the Orators: Humanist Observers of Painting in Italy and the Discovery of Pictorial Composition, 1350–1450*. Oxford: Oxford University Press, 1971.

——. *The Limewood Sculptors of Renaissance Germany*. New Haven, CT: Yale University Press, 1980.

——. *Painting and Experience in Fifteenth-Century Italy: A Primer in the Social History of Pictorial Style*. 2nd ed. Oxford: Oxford University Press, 1988.

——. *Patterns of Intention: On the Historical Explanation of Pictures*. New Haven, CT: Yale University Press, 1985.

Bell, Clive. *Art*. Oxford: Oxford University Press, 1987.

Belting, Hans. *The End of the History of Art?* Trans. Christopher Wood. Chicago: University of Chicago Press, 1987.

Benjamin, Walter. "Agesilaus Santander" (1933). In *Selected Writings*, vol. 2, *1927–1934*, ed. Michael W. Jennings et al. Cambridge, MA: Belknap Press/Harvard University Press, 1999.

——. "Little History of Photography." In *Selected Writings*, vol. 2, *1927–1934*, ed. Michael W. Jennings et al. Cambridge, MA: Belknap Press/Harvard University Press, 1999.

——. "On Language as Such and on the Language of Man." In *Selected Writings*, vol. 1, *1913–1926*, ed. Marcus Bullock and Michael W. Jennings. Cambridge, MA: Belknap Press/Harvard University Press, 1996

——. "On the Concept of History." In *Selected Writings*, vol. 4, *1938–1940*, ed. Howard

Eiland and Michael W. Jennings. Cambridge, MA: Belknap Press/Harvard University Press, 2003.

———. *The Origin of German Tragic Drama.* Trans. John Osborne. London: New Left Books, 1977.

———. "The Work of Art in the Age of Its Technological Reproducibility." In *Selected Writings*, vol. 3, *1935–1938*, ed. Howard Eiland et al., trans. Edmund Jephcott et al. Cambridge, MA: Belknap Press/Harvard University Press, 2002.

Benveniste, Émile. "The Correlations of Tense in the French Verb." In *Problems in General Linguistics*, trans. Mary Elizabeth Meek. Miami: University of Miami Press, 1971.

Bing, Gertrud. "Aby Warburg." *Journal of Warburg and Courtauld Institutes* 28 (1965).

Binstock, Benjamin. "I've Got You under My Skin: Rembrandt, Riegl, and the Will of Art History." In *Framing Formalism*, ed. Richard Woodfield. New York: G&B Arts, 2000.

———. "Seeing Representations, or The Hidden Master in Rembrandt's *Syndics.*" *Representations* 83 (Summer 2003).

Blanchot, Maurice. *The Infinite Conversation.* Trans. Susan Hanson. Minneapolis: University of Minnesota Press, 1992.

Bois, Yve-Alain, and Rosalind Krauss. *Formless: A User's Guide.* Cambridge, MA: MIT Press, 1997.

Brown, Marshall. "The Classic Is the Baroque: On the Principle of Wölfflin's Art History." *Critical Inquiry* 9, no. 2 (December 1982).

Bryson, Norman. "Semiology and Visual Interpretation." In *Visual Theory: Painting and Interpretation*, ed. Bryson, Holly, and Moxey.

———. *Word and Image: French Painting of the Ancien Régime.* Cambridge: Cambridge University Press, 1981.

Bryson, Norman, Michael Holly, and Keith Moxey, eds. *Visual Theory: Painting and Interpretation.* London: Polity, 1991.

Buchloh, Benjamin. "Allegorical Procedures: Appropriation and Montage in Contemporary Art." *Artforum* 27 (September 1982).

———. "Gerhard Richter's Atlas: The Anomic Archive." *October* 88 (Spring 1999).

Camille, Michael. "Walter Benjamin and Dürer's *Melencolia I*: The Dialectics of Allegory and the Limits of Iconography." *Ideas and Production* 5 (1986).

Cavell, Stanley. *Must We Mean What We Say? A Book of Essays.* Updated ed. Cambridge: Cambridge University Press, 2002.

Caygill, Howard. "Walter Benjamin's Concept of Cultural History." In *The Cambridge Companion to Walter Benjamin*, ed. David S. Ferris. Cambridge: Cambridge University Press, 2004.

Cheetham, Mark, Michael Ann Holly, and Keith Moxey, eds. *The Subjects of Art History: Historical Objects in Contemporary Perspectives.* Cambridge: Cambridge University Press, 1998.

Clark, T. J. "Phenomenality and Materiality in Cézanne." In *Material Events: Paul de Man and the Afterlife of Theory*, ed. Tom Cohen et al. Minneapolis: University of Minnesota Press, 2001.

———. *The Sight of Death: An Experiment in Art Writing*. New Haven, CT: Yale University Press, 2006.

Cohen, Margaret. *Profane Illumination: Walter Benjamin and the Paris of the Surrealist Revolution*. Berkeley: University of California Press, 1993.

Copjec, Joan. "The Orthopsychic Subject: Film Theory and the Reception of Lacan." In *Read My Desire: Lacan against the Historicists*. Cambridge MA: MIT Press, 1994.

———. "The Strut of Vision: Seeing's Corporeal Support." In *Time and the Image*, ed. Carolyn Bailey Gill. Manchester: University of Manchester Press, 2000.

Crary, Jonathan. *Techniques of the Observer*. Cambridge, MA: MIT Press, 1990.

Crome, Keith, and James Williams, eds. *The Lyotard Reader and Guide*. Edinburgh: Edinburgh University Press, 2006.

Damisch, Hubert. *The Origin of Perspective*. Trans. John Goodman. Cambridge, MA: MIT Press, 1994.

———. "Six Notes on the Margin of Meyer Schapiro's *Words and Pictures*." *Social Research* 45, no.1 (Spring 1978).

———. *Theory of /Cloud/: Toward a History of Painting*. Trans. Janet Lloyd. Stanford, CA: Stanford University Press, 2002.

Danto, Arthur. *After the End of Art: Contemporary Art and the Pale of History*. Princeton, NJ: Princeton University Press, 1997.

Davis, Whitney. "Visuality and Pictoriality." *Res* 46 (Autumn 2004).

Deleuze, Gilles. *Francis Bacon: The Logic of Sensation*. Trans. Daniel W. Smith. New York: Continuum, 2003.

Derrida, Jacques. *Of Grammatology*. Trans. Gayatri Chakravorty Spivak. Baltimore: Johns Hopkins University Press, 1976.

———. *Of Spirit: Heidegger and the Question*. Trans. Geoffrey Bennington and Rachel Bowlby. Chicago: University of Chicago Press, 1989.

———. *The Truth in Painting*. Trans. Geoffrey Bennington and Ian McLeod. Chicago: University of Chicago Press, 1987.

———. "The *Retrait* of Metaphor." In *Psyche: Inventions of the Other*, vol. 1, ed. Peggy Kamuf and Elizabeth Rottenberg. Stanford, CA: Stanford University Press, 2007.

Dews, Peter. "The Letter and the Line: Discourse and Its Other in Lyotard." *Diacritics* 14, no. 3 (Fall 1984).

Didi-Huberman, Georges. *Confronting Images: Questioning the Ends of a Certain History of Art*. Trans. John Goodman. University Park: University of Pennsylvania Press, 2005.

———. "Dialektik des Monstrums: Aby Warburg and the Symptom Paradigm." *Art History* 24, no. 5 (November 2001).

———. *L'image survivante: Histoire de l'art et temps de fantômes selon Aby Warburg.* Paris: Les Éditions de minuit, 2002.

Edwards, Steve, ed. *Art and Its Histories: A Reader.* New Haven, CT: Yale University Press, 1999.

Ehrenzweig, Anton. *The Hidden Order of Art: A Study in the Psychology of Artistic Imagination.* London: Weidenfeld and Nicolson, 1967.

Elsner, Jaś. "From Empirical Evidence to the Big Picture: Some Reflections on Riegl's Concept of *Kunstwollen.*" *Critical Inquiry* 32 (Summer 2006).

Ficino, Marsilio. *The Three Books of Life.* Trans. Carol Kaske and John Clark. Binghamton, NY: Renaissance Society of America, 1989.

Florman, Lisa. "The Difference Experience Makes in 'The Philosophical Brothel.'" *Art Bulletin* 85, no. 4 (December 2003).

Foster, Hal. "An Archival Impulse." *October* 110 (Fall 1004).

Foucault, Michel. *The Order of Things: An Archaeology of the Human Sciences.* London: Routledge, 1989.

Freud, Sigmund. *The Interpretation of Dreams.* In vol. 5 of *The Standard Edition of the Complete Psychological Works of Sigmund Freud.* London: Hogarth, 1966–74.

———. "Mourning and Melancholia." In vol. 14 of *The Standard Edition of the Complete Psychological Works of Sigmund Freud.* London: Hogarth, 1966–74.

Fried, Michael. *Absorption and Theatricality: Painting and Beholder in the Age of Diderot.* Chicago: University of Chicago Press, 1980.

———. *Art and Objecthood: Essays and Reviews.* Chicago: University of Chicago Press, 1998.

Friedman, Michael. *A Parting of the Ways: Carnap, Cassirer, and Heidegger.* Chicago: Open Court, 2000.

Fynsk, Christopher. *The Claim of Language: A Case for the Humanities.* Minneapolis: University of Minnesota Press, 2004.

Gadamer, Hans-Georg. *Truth and Method.* 2nd rev. ed. Trans. J. Weinsheimer and D. G. Marshall. New York: Continuum, 2000.

Giehlow, Karl. "Dürers Kupferstich *Melencolia I* und der Humanistenkreis Maximilians I." *Metteil.d.Ges. fur vervielfalt. Kunst,* no. 2 (1903).

Gombrich, E. H. *Aby Warburg: An Intellectual Biography.* Chicago: University of Chicago Press, 1986.

———. "Aby Warburg (1866–1929)." In *Tributes: Interpreters of Our Cultural Tradition.* London: Phaidon, 1984.

———. *Art and Illusion: A Study in the Psychology of Pictorial Representation.* London: Phaidon, 1977.

———. "The Father of Art History: A Reading of the Lectures on Aesthetics of G. W. F. Hegel (1770–1831)." In *Tributes.*

———. *In Search of Cultural History.* Oxford: Clarendon, 1969.

———. *Tributes: Interpreters of Our Cultural Tradition*. Ithaca, NY: Cornell University Press, 1984.

Granel, Gerard. *Traditionis traditio*. Paris: Gallimard, 1972.

Greenberg, Clement. "Avant-Garde and Kitsch." In *Collected Essays and Criticism*, vol. 1, *Perceptions and Judgments, 1939–44*, ed. John O'Brian. Chicago: University of Chicago Press, 1986.

———. "Modernist Painting." In *Collected Essays and Criticism*, vol. 4, *Modernism with a Vengeance, 1957–1969*, ed. John O'Brian. Chicago: University of Chicago Press, 1993.

———. "Sculpture in Our Time." In *Collected Essays and Criticism,* vol. 4, *Modernism with a Vengeance, 1957–1969*, ed. John O'Brian. Chicago: University of Chicago Press, 1993.

Hanssen, Beatrice. "Portrait of Melancholy (Benjamin, Warburg, Panofsky)." In *Benjamin's Ghosts*, ed. Richter.

Harrison, Charles, Paul J. Wood, and Jason Gaiger. *Art in Theory, 1648–1815: An Anthology of Changing Ideas*. London: Wiley-Blackwell, 1991.

Hatt, Michael, and Charlotte Klonk. *Art History: A Critical Introduction to Its History*. Manchester: Manchester University Press, 2006.

Hegel, G. W. F. *Aesthetics: Lectures on Fine Art*. Trans. T. M. Knox. Oxford: Clarendon, 1975.

———. *Phenomenology of Spirit*. Trans. A. V. Miller. Oxford: Clarendon, 1977.

Heidegger, Martin. "The Age of the World Picture." In *The Question concerning Technology and Other Essays*, trans. William Lovitt. New York: Harper and Row, 1977.

———. *Being and Time*. Trans. John Macquarrie and Edward Robinson. New York: Harper and Row, 1962.

———. *Hegel's Phenomenology of Spirit*. Trans. Pavis Emad and Kenneth Maly. Bloomington: Indiana University Press, 1988.

———. *Kant and the Problem of Metaphysics*. 5th ed., enl. Trans. Richard Taft. Bloomington: Indiana University Press, 1997.

———. "The Origin of the Work of Art." In *Poetry, Language, Thought*, trans. Albert Hofstadter. New York: Harper and Row, 1975.

———. "Poetically Man Dwells." In *Poetry, Language, Thought*, trans. Albert Hofstadter. New York: Harper and Row, 1975.

———. "The Question concerning Technology." In *The Question concerning Technology and Other Essays*, trans. William Lovitt. New York: Harper and Row, 1977.

———. *Schelling's Treatise on the Essence of Human Freedom*. Trans. Joan Stambaugh. Athens: Ohio University Press, 1985.

Hölderlin, Friedrich. *Essays and Letters on Theory*. Trans. T. Pfau. Albany: State University of New York Press, 1987.

Holly, Michael Ann. "Interventions: The Melancholy Art." *Art Bulletin* 89, no.1 (March 2007).

————. *Panofsky and the Foundations of Art History*. Ithaca, NY: Cornell University Press, 1984.

Husserl, Edmund. "The Origin of Geometry." In *The Crisis of the European Sciences and Transcendental Phenomenology*, trans. David Carr. Evanston, IL: Northwestern University Press, 1970.

Iversen, Margaret. *Alois Riegl: Art History and Theory*. Cambridge, MA: MIT Press, 1993.

————. *Beyond Pleasure: Freud, Lacan, Barthes*. University Park: Pennsylvania State University Press, 2007.

————. "Retrieving Warburg's Tradition." In *The Art of Art History: A Critical Anthology*, ed. Donald Preziosi. Oxford: Oxford University Press, 1998.

————. "What Is a Photograph?" *Art History* 17, no. 3 (1993): 101–18.

Jakobson, Roman. "Quest for the Essence of Language." In *On Language: Roman Jakobson*, ed. Linda R. Waugh and Monique Monville-Burston. Cambridge, MA: Harvard University Press, 1990.

————. "Shifters, Verbal Categories, and the Russian Verb." In *Russian Language Project*. Cambridge, MA: Harvard University Press, 1957.

Johnson, Galen A. "Phenomenology and Painting." In *The Merleau-Ponty Aesthetics Reader*, ed. Galen A. Johnson, trans. Michael B. Smith. Evanston, IL: Northwestern University Press, 1993.

Jones, Caroline. *Eyesight Alone: Clement Greenberg's Modernism and the Bureaucratization of the Senses*. Chicago: University of Chicago Press, 2005.

Kant, Immanuel. *Critique of the Power of Judgement*. Trans. P. Guyer and E. Matthews. Cambridge: Cambridge University Press, 2000.

Kemp, Martin. *The Science of Art: Optical Theories in Western Art from Brunelleschi to Seurat*. New Haven, CT: Yale University Press, 1990.

Kemp, Wolfgang. "Fernbilder: Benjamin und die Kunstwissenschaft." In *Walter Benjamin im Kontext*, ed. Burckhardt Lindner. Frankfurt am Main: Syndikat, 1978.

Klibansky, Raymond, Erwin Panofsky, and Fritz Saxl. *Saturn and Melancholy: Studies in the History of Natural Philosophy, Religion, and Art*. London: Thomas Nelson, 1964.

Koerner, Joseph. *The Moment of Self-Portraiture in German Renaissance Art*. Chicago: University of Chicago Press, 1993.

————. "The Shock of the View." *New Republic*, April 26, 1993.

Krauss, Rosalind. "Notes on the Index," pts. 1 and 2. In *The Originality of the Avant-Garde and Other Modernist Myths*. Cambridge, MA: MIT Press, 1986.

Lacan, Jacques. *The Four Fundamental Concepts of Psychoanalysis*. Ed. Jacques Alain-Miller, trans. Alan Sheridan. New York: W. W. Norton, 1981.

————. "The Mirror Stage as Formative of the Function of the *I* as Revealed in Psychoanalytic Experience." In *Écrits*, trans. Bruce Fink. New York: W. W. Norton, 2006.

————. "Seminar XIII: L'objet de la psychanalyse." Seminar presented May 4, 1966.

Lang, Karen. *Chaos and Cosmos: On the Image in Aesthetics and Art History*. Ithaca, NY: Cornell University Press, 2006.

Lévi-Strauss, Claude. *Introduction to the Work of Marcel Mauss*. Trans. Felicity Baker. London: Routledge and Kegan Paul, 1987.

———. *Structural Anthropology*. Harmondsworth, UK: Penguin Books, 1968.

———. *The Way of the Masks*. Trans. Sylvia Modelski. Seattle: Jonathan Cape, 1983.

Lyotard, Jean-François. *Discours, figure*. Paris: Éditions Klincksieck, 1971.

———. "The Dream-Work Does Not Think." Trans. Mary Lydon. In *The Lyotard Reader*, ed. Andrew Benjamin. Oxford: Blackwell, 1989.

———. *The Inhuman: Reflections on Time*. Trans. Geoffrey Bennington and Rachel Bowlby. Oxford: Polity, 1991.

———. *The Postmodern Condition: A Report on Knowledge*. Trans. Geoff Bennington and Brain Massumi. Manchester: Manchester University Press, 1984.

———. "Taking the Side of the Figural." In *The Lyotard Reader and Guide*, ed. Keith Crome and James Williams. Edinburgh: Edinburgh University Press, 2006.

Malabou, Catherine. *The Future of Hegel: Plasticity, Temporality, and Dialectic*. London: Routledge, 2004.

Mead, George H. *Mind, Self, and Society: From the Standpoint of a Social Behaviorist*. Chicago: University of Chicago Press, 1934.

———. *The Philosophy of the Act*. Chicago: University of Chicago Press, 1938.

Melville, Stephen. "Division of the Gaze, or Remarks on the Color and Tenor of Contemporary 'Theory.'" In *Seams: Art as a Philosophical Context*, ed. Jeremy Gilbert-Rolfe. Amsterdam: G+B Arts, 1996.

———. "The Temptation of New Perspectives." *October* 52 (Spring 1990).

Merewether, Charles, ed. *The Archive*. Cambridge, MA: MIT Press, 2006.

Merleau-Ponty, Maurice. "Cézanne's Doubt." In *The Merleau-Ponty Aesthetics Reader*, ed. Galen A. Johnson, trans. Michael B. Smith. Evanston, IL: Northwestern University Press, 1993.

———. "Eye and Mind." In *The Merleau-Ponty Aesthetics Reader*, ed. Galen A. Johnson, trans. Michael B. Smith. Evanston, IL: Northwestern University Press, 1993.

———. *The Phenomenology of Perception*. Trans. Colin Smith. London: Routledge and Kegan Paul, 1962.

———. *The Visible and the Invisible*. Ed. Claude Lefort, trans. Alphonso Lingis. Evanston, IL: Northwestern University Press, 1968.

Metz, Christian. "The Imaginary Signifier." In *Psychoanalysis and Cinema: The Imaginary Signifier*. London: Macmillan, 1982.

Michaud, Philippe-Alain. *Aby Warburg and the Image in Motion*. Trans. Sophie Hawkes. Cambridge, MA: MIT Press, 2004.

Mitchell, W. J. T. *Iconology: Image, Text, Ideology*. Chicago: University of Chicago Press, 1986.

Morris, Robert. *Blind Time Drawings, 1973–2000*. Ed. Jean-Pierre Criqui. Göttingen, Germany: Steidl, 2005.

———. "The Present Tense of Space." In *Continuous Project Altered Daily*. Cambridge, MA: MIT Press, 1994.

———. "Writing with Davidson: Some Afterthought after Doing *Blind Time IV, Drawing with Davidson*." *Critical Inquiry* 4 (Summer 1993).

Moxey, Keith. "Art History's Hegelian Unconscious: Naturalism as Nationalism in the Study of Early Netherlandish Painting." In *The Subjects of Art History*, ed. Cheetham, Holly, and Moxey.

Mulvey, Laura. "Visual Pleasure and Narrative Cinema." In *Visual and Other Pleasures*. London: Macmillan, 1989.

Nancy, Jean-Luc. *Hegel: The Restlessness of the Negative*. Trans. Jason Smith and Steven Miller. Minneapolis: University of Minnesota Press, 2002.

———. *The Muses*. Trans. Peggy Kamuf. Stanford, CA: Stanford University Press, 1996.

———. "Sharing Voices." In *Transforming the Hermeneutic Context: From Nietzsche to Nancy*, ed. Gayle Ormiston and Alan Schrift. Albany: State University of New York Press, 1990.

———. *The Speculative Remark (One of Hegel's Bon Mots)*. Trans. Céline Suprenant. Stanford, CA: Stanford University Press, 2001.

Nietzsche, Friedrich. *The Birth of Tragedy and The Case of Wagner*. Trans. Walter Kaufmann. New York: Random House, 1967.

Novotny, Fritz. *Cézanne and the End of Scientific Perspective*. Excerpt, trans. Kimberly Smith, in Wood, *The Vienna School Reader*.

———. *Cézanne und das Ende der wissenschaftlichen Perspektive*. Vienna: Schroll, 1938.

Olin, Margaret. *Forms of Representation in Alois Riegl's Theory of Art*. University Park: Pennsylvania State University Press, 1992.

Panofsky, Erwin. "The Concept of Artistic Volition." Trans. Kenneth J. Northcott and Joel Snyder. *Critical Inquiry* 8 (Autumn 1981): 17–33.

———. "The First Page of Giorgio Vasari's 'Libro.'" In *Meaning in the Visual Arts*.

———. "The History of Art as a Humanistic Discipline." In *Meaning in the Visual Arts*.

———. "The History of the Theory of Human Proportions as a Reflection of the History of Styles." In *Meaning in the Visual Arts*.

———. "Iconography and Iconology: An Introduction to the Study of Renaissance Art." In *Meaning in the Visual Arts*.

———. *The Life and Art of Albrecht Dürer*. Introduction by Jeffrey Chipps Smith. Princeton, NJ: Princeton University Press, 2006.

———. *Meaning in the Visual Arts*. New York: Doubleday Anchor Books, 1955.

———. "On the Relationship of Art History and Art Theory: Towards the Possibility of a Fundamental System of Concepts for a Science of Art." Trans. Katharina Lorenz and Jas' Elsner. *Critical Inquiry* 35 (Autumn 2008): 43–71.

———. *Perspective as Symbolic Form*. Trans. Christopher Wood. Cambridge, MA: MIT Press, 1997.

———. "Zum Problem der Beschreibung und Inhaltsdeutung von Werken der bildenden Kunst." In *Deutschsprachige Aufsätze*, vol. 2. Berlin: Akadamie Verlag, 1998.

Panofsky, Erwin, and Fritz Saxl. *Dürer's Melencolia I: Eine Quellen- und Typen-Geschichtlicje Untersuchung*. Studien der Bibliothek Warburg 2. Leipzig: B. G. Teubner, 1923.

Papapetros, Spyros. "The Eternal Seesaw in Warburg's Revival." *Oxford Art Journal* 26, no. 2 (2003).

Peirce, Charles Sanders. "Icon, Index, Symbol." In *Collected Papers*, vol. 2, *Elements of Logic*. Cambridge, MA: Harvard University Press, 1960.

———. "Logic as Semiotic: The Theory of Signs." In *The Philosophy of Peirce: Selected Writings*, ed. Justus Buchler. New York: Harcourt Brace, 1940.

Pensky, Max. *Melancholy Dialectics: Walter Benjamin and the Play of Mourning*. Amherst: University of Massachusetts Press, 2001.

Pinkard, Terry. *Hegel: A Biography*. Cambridge: Cambridge University Press, 2001.

Podro, Michael. *The Critical Historians of Art*. New Haven, CT: Yale University Press, 1982.

Potts, Alex. *The Sculptural Imagination: Figurative, Modernist, Minimalist*. New Haven, CT: Yale University Press, 2000.

Preziosi, Donald, ed. *The Art of Art History: A Critical Anthology*. Oxford: Oxford University Press, 1998.

Radden, Jennifer, ed. *The Nature of Melancholy from Aristotle to Kristeva*. Oxford: Oxford University Press, 2002.

Rampley, Matthew. "Mimesis and Allegory: On Aby Warburg and Walter Benjamin." In *Art History as Cultural History: Warburg's Project*, ed. Richard Woodfield. New York: G&B Arts, 2001.

Readings, Bill. *Introducing Lyotard: Art and Politics*. London: Routledge, 1991.

———. *The University in Ruins*. Cambridge, MA: Harvard University Press, 1996.

Richter, Gerhard, ed. *Benjamin's Ghosts: Interventions in Contemporary Literary and Cultural Theory*. Stanford, CA: Stanford University Press, 2002.

Richter, Gerhard, and Robert Storr. *Gerhard Richter, October 18, 1977*. New York: Museum of Modern Art, 2002.

Riegl, Alois. *Die spätrömische Kunstindustrie nach den Funden in Österreich-Ungarn*. Pt. 1. Darmstadt: Wissenschaftliche Buchgesellschaft, 1973.

———. *Group Portraiture of Holland*. Trans. Evelyn M. Kain and David Britt; introduction by Wolfgang Kemp. Los Angeles: Getty Research Institute for the History of Art and the Humanities, 1999.

———. *Late Roman Art Industry*. Trans. Rolf Winkes. Rome: G. Bretschneider, 1985.

———. *Problems of Style: Foundations for a History of Ornament*. Translation of *Stilfragen: Grundlegungen zu einer Geschichte der Ornamentik* (1923), trans. Evelyn Kain. Ed. David Castriota. Princeton, NJ: Princeton University Press, 1992.

Rifkin, Adrian, ed. *About Michael Baxandall*. London: Wiley-Blackwell, 1999.

Rose, Jacqueline. "The Imaginary." In *Sexuality in the Field of Vision*. London: Verso, 1986.

Rosenberg, Harold. "The American Action Painters." In *The Tradition of the New*. Chicago: University of Chicago Press, 1960.

Sartre, Jean-Paul. *Being and Nothingness: An Essay on Phenomenological Ontology*. Trans. Hazel E. Barnes. London: Methuen, 1957.

Saussure, Ferdinand de. *Course in General Linguistics*. Trans. Wade Baskin. New York: Philosophical Library, 1959.

Schapiro, Meyer. "The Apples of Cézanne." In *Selected Papers*, vol. 2, *Modern Art, 19th and 20th Centuries*. London: Chatto and Windus, 1978.

———. "Eugène Fromentin as Critic" (1963). In *Theory and Philosophy of Art: Style, Artist, and Society*. New York: George Braziller, 1994.

———. "On Some Problems in the Semiotics of Visual Art: Field and Vehicle in Image-Signs." In *Theory and Philosophy of Art: Style, Artist, and Society*. New York: George Braziller, 1994.

———. "On the Aesthetic Attitude in Romanesque Art" (1947). In *Romanesque Art*. London: Chatto and Windus, 1977.

———. *Words and Pictures: On the Literal and the Symbolic in the Illustration of a Text*. The Hague: Mouton, 1973.

Schapiro, Meyer, and Lillian Milgram Schapiro. Interviews (July 15, 1992–January 22, 1995) with David Craven. *RES* 31 (Spring 1997).

Schopenhauer, Arthur. *The World as Will and Representation*. Trans. E. F. J. Payne. Vol. 1. New York: Dover, 1969.

Shapiro, Gary. *Archaeologies of Vision: Foucault and Nietzsche on Seeing and Saying*. Chicago: University of Chicago Press, 2003.

Sontag, Susan. "Against Interpretation." In *Against Interpretation and Other Essays*. New York: Farrar, Strauss and Giroux, 1966.

Steinberg, Leo. "The Philosophical Brothel." *October* 44 (Spring 1988).

———. "Velázquez's *Las Meninas*." *October* 19 (Winter 1981).

Steinberg, Michael P. "Aby Warburg's Kreuzlingen Lecture: A Reading." In Aby Warburg, *Images from the Region of the Pueblo Indians of North America*, trans. Michael P. Steinberg. Ithaca, NY: Cornell University Press, 1995.

Surber, Jere O'Neill, ed. *Hegel and Language*. Albany: State University of New York Press, 2006.

Warburg, Aby. "Dürer and Italian Antiquity." In *The Renewal of Pagan Antiquity*. Los Angeles: Getty Research Institute, 1999.

———. "Pagan-Antique Prophecy in Words and Images in the Age of Luther." In *The Renewal of Pagan Antiquity*. Los Angeles: Getty Research Institute, 1999.

Wind, Edgar. "Aby Warburg's Concept of *Kulturwissenschaft*." In *The Eloquence of Symbols*, ed. Jaynie Anderson. Oxford: Clarendon, 1983.

Wölfflin, Heinrich. *The Art of Albrecht Dürer*. Trans. A. Grieve and H. Grieve. London: Phaidon, 1971.

———. *Principles of Art History: The Problem of the Development of Style in Later Art*. Trans. M. D. Hottinger. New York: Dover, 1950.

Wollen, Peter. "October 18, 1977." In *Paris Manhattan: Writings on Art*. London: Verso, 2004.

———. *Signs and Meaning in the Cinema*. Bloomington: Indiana University Press, 1972.

Wood, Christopher, ed. *The Vienna School Reader: Politics and Art Historical Method in the 1930s*. New York: Zone Books, 2000.

Wood, Paul. "Genius and Melancholy: The Art of Dürer." In *The Changing Status of the Artist*, ed. Barker, Webb, and Woods,.

Wyss, Beat. *Hegel's Art History and the Critique of Modernity*. Cambridge: Cambridge University Press, 1999.

Zelevansky, Lynn. *Picasso and Braque: A Symposium*. London: Thames and Hudson, 1993.

INDEX

Page numbers in italics indicate illustrations.

14754775R00144

Made in the USA
San Bernardino, CA
03 September 2014